✔ KU-546-755

The marketing and public relations handbook for museums, galleries and heritage attractions

Sue Runyard and
Ylva French

The marketing and public relations handbook for museums, galleries and heritage attractions

ALTAMIRA
PRESS
A Division of Rowman & Littlefield Publishers, Inc.

© The Stationery Office 1999

Sue Runyard and Ylva French are hereby identified as authors of this work under the terms of Section 77 of the Copyright, Design and Patents Act 1988.

A Library of Congress CIP catalogue record has been applied for.

First published in Great Britain in 1999 by The Stationery Office

ISBN 0 11 702649 2

First published in the USA by Altamira Press, a Division of Rowman & Littlefield Publishers, Inc.

ISBN 07425 0407 7

Typeset by Graphics Matter Limited, Lowestoft
Printed in the United Kingdom for the Stationery Office
J87495 C20 9/99

Published in North America by Altamira Press, a Division of Rowman & Littlefield Publishers, Inc.
1630 North Main Street, #367 Walnut Creek, California 94596

www.altamirapress.com

Published in the UK by The Stationery Office and available from:

The Publications Centre
(mail, telephone and fax orders only)
PO Box 276, London SW8 5DT
Telephone orders/general enquiries 0870 600 5522
Fax orders 0870 600 5533

www.tso-online.co.uk

The Stationery Office Bookshops
123 Kingsway, London WC2B 6PQ
020 7242 6393 Fax 020 7242 6394
68-69 Bull Street, Birmingham B4 6AD
0121 236 9696 Fax 0121 236 9699
33 Wine Street, Bristol BS1 2BQ
0117 926 4306 Fax 0117 929 4515
9-21 Princess Street, Manchester M60 8AS
0161 834 7201 Fax 0161 833 0634
16 Arthur Street, Belfast BT1 4GD
028 9023 8451 Fax 028 9023 5401
The Stationery Office Oriel Bookshop
18-19 High Street, Cardiff CF1 2BZ
029 2039 5548 Fax 029 2038 4347
71 Lothian Road, Edinburgh EH3 9AZ
0131 228 4181 Fax 0131 622 7017

The Stationery Office's Accredited Agents
(see Yellow Pages)

and through good booksellers

iv

CONTENTS

Foreword
'A MARKETING TALE'

Marketing and public relations are an essential part of museum practice these days. Public relations has been on the scene for a while – even if not at a very sophisticated level. The discipline of marketing is more of a latecomer, but has already demonstrated an ability to contribute to the forward planning process, management and performance of museums. This book, which is a newly conceived venture, combines the joint experience and insights of Sue Runyard and Ylva French, showing how museums can use the tools which are offered by these two interrelated activities. It combines 'nuts and bolts' advice with theory, ethics and an array of case studies drawn directly from museum and heritage attractions' experiences on both sides of the Atlantic. I recommend it to any newcomers to the field, but also to aspiring and experienced managers who want to glean ideas on how to improve their own museum's performance in these areas.

I have my own tale to illustrate the place which marketing occupies in Tyne and Wear.

Once upon a time (in fact, in about 1990) there was a big museum service. Its collections – of art, history, science and archaeology, natural history and lots of other things – were very good. Most of its staff worked very hard, and many were experts in all sorts of ways.

But all was not well. The museum staff were not always sure why they were there and some of them, because they weren't sure, worked on their own little projects, not talking very much to their colleagues. Nobody ever told them what they were supposed to do, and worse, nobody ever asked them what they thought. They weren't very happy.

Because of this the museum service seemed a bit lazy, and not doing very much. So, it wasn't very popular with people. Not that many visited. Worse, the politicians who paid for the museums, did not like them very much either. They started taking money away each year. The newspapers, when they wrote anything at all about the museums, weren't that nice. The radio and television stations weren't interested at all.

So the museums, like museums sometimes do, had a review. Then another. Then another. But this didn't really work. Finally as part of a last-ditch attempt to save the museum service from disaster, it was decided to hire a professionally qualified person to 'do some marketing'. Before then, 'marketing' had meant some leaflets and posters to go with temporary exhibitions, but it hadn't been seen as an important part of making the museums work, and nobody had had

Enjoying the Discovery Museum. Courtsey of Tyne and Wear Museums.

any proper training. The trouble was, this new marketing person, whose name was Alex Saint, had an awful lot to do. She had twelve museums to worry about. And in any case, she was quite junior and didn't have a lot to say.

But a strange thing started to happen to the museum service. Quite a few people left, and some new ones came with new ideas. The staff started to feel a bit better, and they were encouraged to say what they thought. They certainly had lots to say! A new sense of purpose developed and the museums did some interesting new displays and exhibitions. Marketing became quite an important part of what the museums did, and the rest of the staff started to understand this. Alex was joined by another marketing person, then another, then another. This was all very unusual, and some people said it would end in tears.

But soon the museums were attracting more visitors. The newspapers began to take a real interest and so did the radio and television. Best of all, the politicians became friendly again and started to say nice things about the museums, instead of nasty things.

And do you know what? The more risks the museums took, and the more really good work they did with things like exhibitions, and education, and outreach, the more important marketing became and the marketing department just grew and grew.

Now, where there was once just Alex, there are eight marketing people who do all the fund-raising as well as all the other marketing things. The chief marketing person is now very important in the museum service, but so are the rest of them! Lots of people visit the museums, and many of them are people who would never have dreamed of visiting once upon a time. The politicians think the staff are brilliant, and they have even started giving them more money to spend. What do you think of that?

The marketing people spend a lot of time attending meetings with other staff, so that marketing ideas are always part of what everyone else does, and so everyone understands what marketing is about, and why it is so important. And they are good at their jobs, which helps a lot. Only recently, the most important newspaper in the museum service's region said in its editorial comment, of all places, that the reason why museums are so full of visitors (well over one million every year) is not just because of all the exciting things that happen in them, but also because of 'some sophisticated marketing which would be a credit to a top ad agency'. Isn't that good?

That's the end of our story (so far). And we hope that they all live happily ever after.

David Fleming
Director, Tyne and Wear Museums

THE AUTHORS

Sue Runyard is a former head of public relations at the Victoria and Albert Museum, Natural History Museum and J. Paul Getty Museum. She was seconded to the Cabinet Office during the 1980s to work for the Minister for the Arts and Minister without Portfolio. For nine years she was marketing and development advisor to the Museums and Galleries Commission. She has held visiting lectureships in five European universities and is a former trustee and serving associate trustee of the Museum of Science and Industry in Manchester. She is currently director of Museums Without Walls, a California-based consultancy which works with museums in the USA and Europe. She is the author of several publications in the museums and galleries field.

Ylva French started her career in tourism as public relations officer for the Hong Kong Tourist Association; she returned to the UK to work as press officer for British Caledonian Airways before becoming head of public relations at the London Tourist Board for ten years. She started her own communications agency, Ylva French Communications (YFC), in London in 1988; clients include major heritage and tourism organisations such as the Heritage Lottery Fund and British Tourist Authority, tourist destinations, trade exhibitions and hotel groups as well as museums. YFC administers The Campaign for Museums and organises Museums Week; she also led the project team which launched the 24 Hour Museum. She is the author of the *Blue Guide to London*, *London for the Disabled Visitor* and *Public Relations for Leisure and Tourism*.

Sue Runyard

Ylva French

INTRODUCTION

Museums, galleries and the majority of heritage attractions operate in a world where the established laws of supply and demand do not on the whole apply. No market research was conducted to establish the British Museum, for example, or the Worthing Museum and Gallery; even new, independent museums have frequently been created by enthusiastic collectors for whom the idea of marketing is unknown territory.

Museums may welcome and want visitors, but they also have other objectives such as looking after the heritage for future generations, providing a teaching resource and perhaps also acting as a research organisation. Increasingly the public sector wants them to become more commercial and apply ways of measuring their performance which are more appropriate to the commercial world. This means that museums and galleries have to operate in a more commercial way in terms of attracting visitors and encouraging them to spend money, while at the same time effectively defending their more diffuse and longer-term objectives for the benefit of society as a whole.

To survive and thrive in the 21st century, museums, galleries and not-for-profit heritage attractions will have to apply increasingly sophisticated marketing techniques to attract visitors in a sometimes highly competitive environment. At the same time they may have to use persuasion (i.e. public relations) to defend and explain their role for the public good, which the short-term policies of local authorities, government and others may unwittingly be destroying.

> It is now widely believed that there are more heritage attractions in the UK in the late 1990s than can be economically sustained as currently constituted and marketed.[1]
>
> 1989/90 is seen by many established museums as the peak year for volume of demand which few have been able to attain in the late 1990s.[2]
>
> Against a background of slowly growing demand overall for visitor attractions generally in the 1990s, the capacity of museums has continued to increase, defying the normal logic of the leisure market within which the majority have to compete.... More significantly, many museums are so small they lack the means and the facilities to be competitive in the modern world.[3]

We believe that the principles and practical advice contained in this book will give more museums, galleries and heritage attractions a better chance to be among those which thrive in the 21st century.

What this book covers

This book sets out clearly the principles which define marketing and public relations and how they apply to cultural institutions. It covers marketing for the institution as a whole as well as for individual exhibitions, events or new galleries.

New marketing opportunities, direct marketing through mail, internet and other means, are also covered. Public relations strategy for the institution, defending its status and brand, its funding and reputation, is the subject of the latter part. It includes such important issues as crisis communications and some aspects of sponsorship. Public relations as a marketing tool is just as important and is frequently perceived as the low-cost way for museums and galleries to reach their audiences. This book considers how methods and means are changing as the media continues to fragment. Throughout the text, the reader will find short synopses of successful or unsuccessful implementation of marketing and public relations techniques.

Notes

1. Middleton, Professor Victor. (1998). *New Visions for Museums in the 21st Century*. AIM (Association of Independent Museums), p.55.
2. Ibid, p.23.
3. Ibid, p.23.

Chapter 1 WHAT IS MARKETING?

'Marketing is the management process which is responsible for identifying, anticipating and satisfying customer requirements profitably' (Chartered Institute of Marketing).[1]

Marketing means:
- *looking outwards, not inwards*
- *constant awareness of what is happening in your market place*
- *asking, not telling customers what they want*
- *caring about processes as well as products*
- *communicating all this through the organisation*

'We don't have marketing, we have information', said one famous national museum in the UK in response to a question from a journalist writing about the marketing of museums. The truth is that museums and galleries in the business of attracting funding and visitors require both marketing and public relations and if they don't know that, they are not managing either to their best advantage. The latest Domus (Museums and Galleries Commission 1998) survey showed that just 29% of museums owned up to having a formal marketing policy.[2] *Many more will, of course, be involved in 'publicity' of various kinds and may be unsure when promotions become marketing – something this book aims to put right. Some may even feel 'marketing' to be an alien concept too close to the first definition above, i.e. meeting 'customer requirements profitably'.*

So what is marketing about and how does it relate to the day-to-day promotional activities most museums and galleries are involved in?

'Marketing is simply the strategic and systematic approach to audience development which meets the overall objectives of the museum and galleries.'

Marketing as a business concept developed in the commercial field. It is steeped in jargon and tainted by the commercial approach to growth and profits which is not necessarily harmonious with the objectives of public sector or semi-public sector organisations. The second description of marketing above is much more in tune with the thinking in museums and galleries today. Let's look at it more closely.

Looking outwards, not inwards

Museums have traditionally focused on their collections and developed their management philosophy on what is good for the collection and the institution, often without reference to other organisations, the public at large or visitors to the museum. A commitment to marketing will force the organisation to look outwards, to build links with museums and organisations, schools

and universities, and its committed visitors, and to build new audiences. In effect, by adopting a marketing-led approach to its management strategy, museums become part of the local and wider community, as expected by government and other funders, and help to ensure that their collections survive in a competitive environment.

Constant awareness of what is happening in your market place

Half of Britain's 2500[3] museums have been established since the 1960s. This phenomenal growth has been accompanied by the expansion of a widening range of heritage attractions, theme parks, science parks, nature reserves and historic houses, not to mention garden centres and, over the last few years, the rise of Sunday shopping. The year 2000 will bring a crop of new Lottery-funded attractions to this wonderful choice of things to do – wonderful, that is, for the public. No wonder museums are reeling from the impact of this huge competition for leisure time.[4] Awareness of what is going on in the immediate area in terms of competition as well as in the wider world is therefore essential. Museums are part of the tourism industry. Interacting and sharing information with others in the same industry at events organised by regional tourist boards and at national events can be very useful.

The composition of the existing and potential market is also changing; population changes are creating an older population, and tourism is bringing larger numbers of overseas visitors to Britain. Information is available to help museums and galleries define their market. In 1999 the Museums and Galleries Commission started an important annual bench-marking survey of visitors and non-visitors to museums. The tourist boards carry out national and regional surveys of visitors, available usually for a charge. And museums and galleries must do their own research to assess their existing visitor profile and set targets for the future.

What is on offer to the public is also becoming increasingly more sophisticated. What does the public expect in terms of 'entertainment' and how can museums keep up? The museum community is getting much better at sharing ideas and approaches to interpretation, display and educational activities. A number of award schemes such as the Gulbenkian and the conservation awards have helped in this. The annual Museums Association Conference and museums and heritage shows also have an important role to play in stimulating the sharing of information.

Asking, not telling customers what they want

This is a difficult one for museums, which are traditionally authoritarian organisations, based on research and knowledge. How can they change the habits of a lifetime and listen rather than tell? The short answer is: research and ask. Once visitors arrive at the museum, we can assume that they want to see something of the collection. But do they want it presented in the way that your exhibition staff have decided that it should be done? Is there a way of asking visitors and getting reactions and feeding this back into what you do and how you deliver the experience?

At the Tate Gallery they introduced a complete re-hang, entitled New Displays, each January in order to show paintings in storage and inject new interest into the gallery. However, a visitor survey showed that visitors were totally bemused, could not see the point of the re-hang and missed their favourite pictures. A complete re-think of this strategy followed to communicate more effectively the purpose of New Displays.

In setting up a new permanent exhibition of African Art, the Horniman Museum carried out a year-long consultation programme involving Africans and Afro-Caribbeans in the UK, as well as museum curators in those countries. This has produced a revolutionary approach to interpreting the African collection in the new gallery which opened in 1999. Further research will be carried out to measure response.

Caring about processes as well as products

You may think that you know all about customer care. Well, it is questionable. For example, 20% of museums do not have a toilet for use by the public. And what is the most commonly asked question as people enter a museum – 'Where are the toilets?' Such practical matters aside, there has been a revolution in museums and galleries around the country, as an increasing number of museums train their warders, security staff and attendants of visitor services in customer care. Simple customer-care programmes run by the tourist boards, such as 'Welcome Host', are a good starting point for small- and medium-sized museums who cannot run their own training programmes.

The importance of 'the process', from the moment visitors telephone to ask for information, to the walking out of the door, cannot be underestimated. On a recent visit to New York, a potential visitor rang two museums to see if they were open – it was New Year's

Day. The first call to the Frick Collection was answered by a real person who said 'Very sorry, but we're closed, but welcome on the following day'. The second call to the American Museum of Natural History took almost five minutes and involved listening to long recorded messages before getting to another 'press button' choice, and finally a statement which said that the museum was open every day of the year except Christmas and Thanksgiving. The right information was available but the delivery was laborious and alienating, whereas the Frick was live, direct and friendly. (Recorded messages can be very good and to the point – and are better than no answer at all. Just make sure they are user-friendly.)

Word-of-mouth recommendation is the museum's most valuable asset, as every survey will show, and should be safeguarded in the process of delivering the 'product', as well as in the exhibitions and facilities provided for the enjoyment, education and entertainment of visitors.

More about 'products' follows.

Communicating all this throughout the organisation

When we say 'look outwards' not 'inwards', we are not forgetting the importance of moving everyone inside the organisation along the same path towards greater marketing and audience awareness. This can be a painful process as the experiences in Chapter 2 illustrate. Where an organisation moves from a totally collections/buildings-focused management policy to a marketing-orientated approach, there will inevitably be some people who cannot adapt to the change.

Equally, when new marketing initiatives are launched, the staff at every level have to be informed, committed and involved, to make a success of a re-positioning, a new gallery or exhibition, a new way of charging etc. Ways of communicating successfully with staff and other internal colleagues depend very much on the size and culture of the organisation and will be discussed later.

Developing a marketing strategy

The marketing process is illustrated in Figure 1. Chapters 2–5 look in detail at the process of arriving at a marketing strategy. There may well be more than one marketing strategy – one for the organisation as a whole, and others, perhaps longer or shorter term, to meet specific objectives in particular areas. Each new product launch will require its own marketing plan, which should sit comfortably within the

Figure 1 The marketing process

framework of the overall marketing strategy. Some of the terminology and how it translates into the museum and heritage world is explained below.

The product can be the organisation as a whole or the different elements which make up the experience; it can also be more the tangible products, for example the museum's own publications, other saleable items, corporate hire, the education service, the library and so on. Each of these products should be identified in the marketing strategy. Each will have its own characteristics and **product life cycle**. From the shelf life of the guide-book to the freshness and relevance of each exhibition and gallery display, the strategy should attempt to indicate when each product has 'peaked' and will need to close, be redeveloped or re-launched in some way. In some areas where new

technology is involved in interpretation, for example, the product life cycle may be quite short as techniques and fashion move on. More traditional displays may on the other hand be longer lasting in their appeal.

The environment in which the museum or heritage attraction operates has already been referred to and is crucial to its success. The use of a **SWOT** approach (strengths, weaknesses, opportunities and threats), or TOSW as the order in which some prefer to carry out this exercise, will reveal immediate pressures and opportunities as well as changes in the external environment which will affect the museum or gallery. The pressures will be greater on those in tourism hot-spots where the cost of entry to the market is high, for example Bath, London, New York, Washington. To launch a new attraction, museum or even new gallery in such a competitive environment requires comparatively larger budgets than in regional towns and cities where a new exhibition will be much more newsworthy.

The existing and potential market is the starting point for **segmenting the market** – a buzz word in today's marketing environment. Museums should feel comfortable with this approach which is closely linked to **audience development** (see Chapter 8). Where commercial organisations generally segment the market to obtain the greatest return for the smallest investment in marketing terms, museums and galleries can adopt the same techniques to reach segments of the market for other, social and political reasons, developing the appropriate **product-fit**. Segmenting markets according to postcode and lifestyle has become a whole industry in itself. Museums should be familiar with at least the jargon involved here (see Chapter 6). As part of this process, the **communications life cycle** needs to be taken on board (see Figure 2). This useful tool will help you to make the right decisions about how to approach particular segments of the market or new audiences. Where are they in terms of awareness? Do they have any kind of knowledge of your museum? The marketing plan should aim to move the targeted segment along the communications life cycle in stages and not go for the impossible.

At this point in the marketing strategy, new ideas and input from others, in developing products as well as strategies, will be essential. No one can afford to stand still or repeat the mistakes of the past. Creative and practical input from staff, consultants, friends, users of the museum, and other partners should be part of the strategic process.

Figure 2 Communications life cycle

From here the process moves to defining the strategy, the positioning and the definition of the **unique selling proposition** (USP). This is a useful, if not always completely realistic, exercise for museums with so much on offer, but it will focus everyone's mind on what your museum, gallery or heritage attraction has which is unique. This positions the museum or gallery clearly in the market place as it is now and where you want it to be in the future. The strongest 'offer' should be the USP and lead in the publicity material; it could be the architecture of the building, the 18th-century collection of paintings, the natural history collection, or just one object that people would travel across the world for, whether the *Mona Lisa*, the first computer, a Gutenberg Bible, the Rosetta Stone or something much humbler but, none the less, outstanding. The Victoria Albert Museum holds many world-class treasures; when children were asked to choose their favourite item at the museum, 'The Tiger Eating a Man', a 19th-century mechanical toy from India, came out on top.

As we will see in 'Designing the marketing strategy' (Chapter 4), you may, for good reasons, decide not to use your strongest selling point (fear of overcrowding, for example). You may also want to develop different USPs for different market segments – the gardens for garden lovers, the education service for schools and lifelong learners, and so on. This is 'product-fit'. This leads on to developing the marketing mix based on the mythical four Ps which form the basis for the marketing plan. They are:

- *Product* – as already mentioned above
- *Place* – not necessarily where you are, but more about your place in the market and the distribution of your offer
- *Promotion* – the promotional activities which will be outlined in the marketing plan
- *Price* – what to charge for admission and other services and products you offer.

There is much more to the marketing plan than the four Ps as we will discover later.

The overall marketing plan and each part plan will need to be carefully budgeted. Later we will look at some specimen *budgets* for different types of marketing plans. When agreed, the implementation stage gets under way, preceded by an *internal communications* process which is the foundation for success.

The marketing strategy does not end there – *evaluation and research* should be built into the process of implementation so that the information is available for the marketing strategy process to be continuous.

Where does the *marketing budget* fit in the overall museum budget? Many museums have bits of marketing activities tucked away in different budgets; over-eager curators and exhibition officers have been known to commit the equivalent of a whole year's marketing budget on printing over-sized and colourful posters for obscure exhibitions, leaving very little for the day-to-day printing or distribution, not to mention giving in to pressures from advertising salespeople representing newly launched guides and magazines.

Make sure to bring all marketing expenditure together under one heading and central control. Spell out clearly the sub-divisions, including the staffing and consultant costs. Commitments on the marketing budget should only be made following approved procedure and should be controlled by the director or marketing manager.

Finally, marketing is about inspiration and creativity – an ability to raise your organisation above the stream of communications with which we are all bombarded. It will only thrive in the right climate, where marketing has been brought into the centre of the organisation, becomes a team effort, and where the marketing staff have a remit to be creative and be allowed to make mistakes from time to time. No one person can be inspired the whole time – but good marketing managers should be able to recognise inspiration when they see it!

Notes

1. Chartered Institute of Marketing's definition of marketing.
2. Quoted in *Museum Focus* (1999), Issue 2. Museums and Galleries Commission.
3. According to Victor Middleton, 'There are not 2500 museums in the UK but more like 1500 in the sense that both Government and the target audience would immediately recognise them. Beyond that there are many mostly small additional collections'.
 Middleton, Professor Victor. (1998). *New Visions for Museums in the 21st Century.* AIM (Association of Independent Museums), p.15.
4. Ibid, p.58.

Chapter 2 THE MARKETING AUDIT: INTERNAL FACTORS

In compiling a new marketing strategy or reviewing one which is outdated, it is easy to go straight to work without considering internal factors which have an impact on the product, the experience and how it is delivered to customers. The internal marketing audit looks in detail at these considerations, while the external audit (see Chapter 3) considers what others are doing and the trends in the market place.

When asked to name the reason for lack of success in museum projects, most consultants will mention 'internal constraints'. This is not always a question of the consultant blaming the client, nor is it a euphemism for 'the personalities involved at the museum were so incredibly difficult, we couldn't achieve anything'. It is often a cry from the heart, that the museum had a poor understanding of its own agenda, fuzzy lines of communication, and an inadequate sense of priorities. Being immersed in the day-to-day operation of an organisation sometimes makes it difficult to stand back and take a dispassionate view.

Achieving good marketing means improving on current performance, and this requires knowledge of how you are performing in the first place. There are lots of quick fixes in the marketing world – throw some money at a problem, increase advertising, schmooze the press, appoint a marketing officer – but none of this is much good without a strategy. Like every other aspect of professional work in a cultural institution, marketing needs to be sustainable and sustained. It needs firm foundations of knowledge and information, and the ability to measure its performance and learn from experience. This can only be done by thoroughly understanding your business and your customer/visitor base. Such knowledge is a starting point and a bench-mark to measure future performance and growth. It is also the foundation stone of the marketing strategy.

Does this sound like a dose of medicine? It is no more so than the painstaking research which goes into every respectable piece of academic work. And the discoveries you make along the way can make the blood run faster. When the Natural History Museum in London took a long cold look at itself 20 years ago, the scientists who managed the institution were aghast to discover that the educational attainment level of their visitors was fathoms below what their exhibitions were geared for. People came to gaze in awe and satisfy a few crumbs of curiosity, but the mission was not being fulfilled; knowledge was not being shared and disseminated. The museum then embarked on a 20-year programme of renewal and adjustment, gearing their exhibitions to the visitors' needs (see Case Study 1). On a more mundane level, base-line information provides the ammunition for every management decision, from desirable opening

hours to what kind of food to serve in the café. Take the medicine: it will make you stronger!

What is an internal marketing audit?

An internal marketing audit is a quantified report on the status of the organisation at a given point in time in relation to how it delivers its external marketing objectives. It examines:

- the physical and perceived location
- the visitor experience from every angle (the organisation as 'product')
- visitor profile and response
- internal resources and communications
- the promotional programme.

This is a huge agenda. It may require searching out information which does not exist in a readily accessible form. When the metropolitan district councils of England were dissolved, leaving local museums high and dry without funding, audits were required to assess how much it cost to run each individual museum and find out who was using them. Not only did such information not exist, several museums had never been responsible for paying their own electricity bills and had no idea how to budget for their power needs, let alone work out who their visitors were. When the Long Beach Museum of Art in California decided to double its size and work harder to attract the tourism market, it had no quantified information as to how many tourists were already coming. They found out fast and established a bench-mark for future progress (see Case Study 2). Hard information puts you in the driving seat.

Who should do the audit?

There is a great deal to be said for hiring a third party to carry out the audit, because it brings a detached eye to the scene. Also, if information is disclosed which causes discomfort, management can distance itself from the process, while still making use of the findings! Truly secure and confident managers will make the audit an open and collaborative process, with or without outside help, and engage the assistance and participation of all members of staff. If everyone understands what's going on and participates, it makes any action much easier to implement. Front-of-house staff certainly need to share their views and experience. If this takes the form of venting frustrations, then the audit has a dual benefit and can contribute towards positive change.

The process itself will include interviews with staff at all levels and fact-finding through existing documentation. The size and complexity of the organisation will affect how long this takes to accomplish. Certainly the first such audit will take several months. The most efficient way to do it is to make it part of the business-planning process, so that results can be of immediate use in annual reports or forward plans.

The museum and its mission

The audit will present a picture of the organisation, describe the scope of its collections and/or display, give its historical and present-day purpose and include any major services or programmes which have been developed. It will describe how the museum or cultural centre is set out and how it presents itself. It will paraphrase the mission statement and describe the intended audience or audiences. The funding base will be described in such a way as to explain how growth and change can or cannot take place; achievements and opportunities will be outlined, as well as constraints and limitations. Throughout the report a SWOT analysis approach will be taken: a cataloguing of strengths, weaknesses, opportunities and threats. The tone of the report will be as if written for a reader who comes to the subject afresh. This allows everyone to remind themselves of the purpose of the institution and the key objectives, to re-focus on true priorities.

Visitor profile and response

If you do not know who your visitors are, you cannot design meaningful marketing or audience development programmes, the subject of much of this book. Visitor research on a continuous basis is essential in building the profile of visitors and understanding changing trends. Accurate visitor numbers are crucial to measure peaks and troughs and, hopefully, year-on-year growth. Free museums usually overestimate visitor numbers – not surprisingly there are dramatic drops when admission charges and accurate counting are introduced. Income from shops and cafés should be monitored and compared year by year.

The list of topics to be covered in visitor surveys could be endless, but surveys will only be valuable if they are manageable and are carried out every year with most of the same questions to provide new trends. The research should include the following:

- age or age group, gender
- whether visiting solo or accompanied
- home postcode (zip code)
- educational attainment
- language spoken at home
- what motivates the visit
- previous knowledge of museum/frequency of visit
- method of transport
- reading/viewing/listening habits
- whether the experience was satisfactory, i.e. if the visitor would recommend it/or come again.

The postcode is important as it will give useful information on the geographical spread of your audience and also on the status and average household income of the residential district [through information provided by organisations such as CACI through Acorn (A Classification of Residential Neighbourhoods) profiling system]. More information about setting up research is to be found in Chapter 9 and Appendix 2.

The visitor experience

Every aspect of the visitor experience will need to be examined – from the visitor's point of view – using visitor research findings, staff interviews and direct observation. If no visitor research is available, now is the time to do it, in conjunction with the early stages of the audit. Detailed comment is needed on:

- the nature of the arrival and welcome
- customer care, from cleanliness to staff training
- methods of quality assurance
- internal attitudes towards the public
- key visitor satisfactions and complaints.

When tackling this huge and rather subjective area, it can be useful to do two things: prepare a framework for the study, possibly based on the suggestions of this book or other published guidelines (see Appendix 2); and ensure as much objectiveness as possible by using specific research findings and by quoting visitors. If the museum has a written customer care policy, it should be referred to and tested. If it does not, the audit could form the occasion to compose one, and to examine staff training opportunities. Broadly, the audit will try to answer the following:

- Does the museum conduct regular, consistent visitor surveys?
- What do such surveys tell us?

- Do all members of staff share the customer care mission?
- How wholeheartedly does the management support good customer care?
- Have physical access issues been addressed?
- Are cultural and intellectual differences between visitors being catered for?
- Are safety procedures being followed?
- Is staff training proving effective?
- Are front-of-house staff properly supported by others?
- Are good lines of communication in place for complaints, suggestions and information sharing?
- What systems are in place to monitor quality of care?
- Does information material serve the public well?
- Does directional signage work in terms of circulation and finding your way around?
- Do the exhibitions, displays and the museum/attraction as a whole deliver a satisfactory experience – or even more ('I would recommend it to a friend')?
- Has the 'experience' reached its peak in the product life cycle? How much longer before it will need to be 'tweaked' or completely remodelled?

The audit will examine every element of the visitor experience (and will also help to identify perceptions among those who do not visit), the general effectiveness of outreach programmes, and any unfulfilled areas of potential. It will focus on the structure of the organisation as it impinges on the visitor. For example, effective information exchange from within can make for clear communication with visitors. Efficient budget control and technical maintenance make for smooth-running public services. A good human resources department will assist individuals to fulfil their own potential, and will ensure that the needs of particular job descriptions are well met by appointed individuals. The internal engine drives external appearances.

Any perceived shortcomings in the visitor experience in terms of displays, interpretation and temporary exhibitions may need a radical and more long-term approach involving exhibition and attractions consultants as well as the re-training of in-house staff.

Location

There are some things that can rarely be changed, like the geographical location of the building or site. If the museum of lesser-known-bits-and-pieces was situated on Miracle Mile, Fifth Avenue,

Trafalgar Square or Prince's Street, it would probably get double the visitors with no effort at all! In real life, many cultural centres have to fight their location – in reality or in public perception. The wonderful Dulwich Picture Gallery in London, Aston Hall in Birmingham, the Museum of Culinary Arts in Rhode Island, and Plymouth Plantation outside Boston are not in the middle of anywhere, nor are they well served by public transport.

The response to this situation is to make yourself so well known that people are motivated to visit, or provide some form of transport, or relocate. What about venues which are perceived as being off the beaten track? Visitors to New York's Metropolitan Museum of Art may never reach The Cloisters, as they simply find the journey too daunting. Even seasoned Londoners may tell you that the Bethnal Green Museum of Childhood is at the back of beyond (12 minutes from central London on the Central Line). Los Angelenos will tell you that the Getty Center is impossible to get to on its hilltop eyrie. Perceptions can make for powerful inhibitions, but they can be changed. The important issue here is to understand the nature of those perceptions among various sectors of the population. Given the information, the problem can be addressed. Public information literature can help if succinctly expressed and clearly laid out, but it may need some kind of public awareness campaign to turn the tide of opinion.

Every method of arrival by visitors should be examined. Available transport methods should be researched to see how they affect existing travel patterns and what opportunities there are for short- and long-term improvements.

Signage is a word that will be found engraved on many a museum marketing consultant's heart. When asked whether standardised advice can be given to client organisations, most consultants will agree that advice needs to be tailored and specific, with one exception: signage. Improved signage at and around cultural sites will always improve the experience, visibility and business. Signage must be appropriate in style but never discreet. A discreet sign is an invisible sign. The purpose of a sign is to be seen. The audit should enumerate and describe the signage as it exists, and make recommendations for improvements based on real visitor experience.

Opening hours and days are crucial to access and need to be part of an internal review. We are moving towards a seven day a week, 24-hour society, and museums need to keep pace. Comparisons should be made with the competition, and comments from visitors on this topic

should be taken into account. But there is also an internal job to do here, as staff have to move towards different shift systems and re-schedule some work which would normally take place when the museum was closed. This may require customer care training, including for the cleaners.

Current and past marketing activities

The review should consider current and past marketing activities, the resources devoted to these and the success and failures, if measured. The internal review is a good opportunity to consider printed material and other forms of communication, e.g. the website, with groups of staff and visitors to see how they perceive the messages, the visual images and the overall impact of the museum's or gallery's brand. Public relations activities should be reviewed at the same time.

Internal resources and communications

Budgets can be difficult to pin down for museum curators without direct budgetary control. However, sensible decisions about allocating resources and boosting marketing cannot be taken if the director does not have a clear understanding of existing budgets and how they are allocated. In the past, museums with operational budgets of all sizes – including substantial public funding – have been able to get away with inadequate budgetary controls. This is hardly the case now and it will certainly not be so in the future. At the same time, museums and galleries, which are supported through public funds, are also required to raise their own income from admission charges, shops and cafés. They must have a clear understanding of the true costs before pricing their products and also be able to benefit from the museum's success in these areas (see also Chapter 4).

Museum buildings are designed to make it difficult for staff to communicate, as most of them are shut away in remote corners of huge buildings. Modern offices are open-plan; management by walking around is still considered one of the most acceptable methods, and certainly communication is much easier when eye-to-eye contact can easily be established without special meetings having to be set up. Separated also by great streams (from time to time) of the public, it is not surprising that museum staff are generally not good at communicating with each other.

Institutions with these communication problems (which are shared by the educational sector, for one) have to make special efforts to make sure that communications work up and down and sideways.

Chapter 17 has been devoted to this subject as we as authors working with museums see this problem as a major obstacle to effective marketing and public relations in museums, galleries and heritage attractions. The audit is there to establish where the particular problems lie, how lines of communications work or do not work and what ideas the staff have for how they can be improved. This is probably the most sensitive part of the review and is certainly best carried out by an outsider.

What do you do with the marketing audit?

Do not place it upon a shelf and allow it to gather dust! The internal audit can be the starting point for the audit as a whole and for the marketing strategy. It can also provide good fodder for all kinds of activities. The report should be disseminated among all who have an interest – probably the whole staff. It is advisable for the director and key managers to have a chance to comment at draft stage, and to discuss any curious or controversial features with the person or team who carried out the audit. On one project, the director asked for deletion of a finding that revealed a shocking number of personal calls being made by front-of-house staff while visitors stood waiting. He decided to tackle the problem separately from the auditing exercise. Probably each department in the museum could use the report as the focus for internal discussion about implications and actions arising.

When feedback has been collected and absorbed, the scene is set for the formal planning process including preparation of the external review (see Chapter 3). You may choose not to tackle all of the issues simultaneously or immediately. Resources and workload may be a factor. The most useful thing that an audit can provide is a clear sense of priorities, so that both long- and short-term strategies can be designed, ideally with a chance for every section of the museum to contribute towards them and to move in the same general direction.

CASE STUDY 1 Natural History Museum, London

The case of the Natural History Museum in South Kensington during the 1970s and 1980s has been selected because it presents an extreme instance of what can happen when a museum addresses change and finds itself in internal conflict. Heart and head are willing, but each part of the body is trying to move in different directions. For the National History Museum, the challenge became intense for many reasons, but a great contributory factor was the size and age of the institution (nearly 800 employees and over 100 years of history). However, many of the scenes are recognisable in much smaller organisations. The following words are a re-expressed version of papers written by Dr Roger Miles, museum consultant and former head of public services at the Natural History Museum, to whom the authors are greatly indebted.

The gathering storm

The Natural History Museum is housed in a venerable purpose-built Victorian 'cathedral', which is protected by law from alteration and which houses one of the world's great, if not greatest, collections of natural history. Born out of the collections of the British Museum, where once visitors had to ring the doorbell for admittance, the 'new' museum was scarcely user-friendly. There were acres of display space and no public lavatories whatsoever. More importantly, the exhibits were displayed according to obscure divisions of the natural world which made little sense to non-specialists and made no allowance for new interpretations. A mission which was always twofold – research and display – had, over many decades, become subsumed into a research role which lacked vibrancy and displays which were dominated by separate scientific departments. To the public, the museum was a national landmark, a fossilised zoo which was regarded with some affection but which contained old-fashioned, deeply technical and unenlightening exhibitions.

The challenge of change

In the early 1970s the museum, overdue for change, made long-term plans to rationalise the displays. This move was led by a director who had worked in the museum for 35 years, had taken a keen interest in the galleries, and was concerned about the huge gap between the views of the visiting public and the messages the museum sought to

convey – as demonstrated by visitor surveys. The programme would take at least 20 years, not just because the areas were vast and money was limited, but because the scheme was ambitious in that it addressed a gradual but complete transformation from a Victorian system of looking at science to one which would be relevant to the everyday lives of the visiting public.

The challenge was immense because it involved a total overhaul of most of the galleries, and the debate centred on conceptual presentations as much as upon individual descriptions. At its root was a struggle for power which was at times made worse by indecisive leadership who did not back the decisions made. The staff was dispersed in nooks and crannies throughout the labyrinthine building, communication was poor and goals were not commonly agreed.

The first exhibition to be tackled was a fortuitous choice: human biology. As none of the scientists could lay claim to specialist knowledge in this area, the newly formed exhibition team could cut its teeth on a new subject in a new way. The award-winning exhibition was loud, colourful, interactive and a million miles from what had gone before. The museum had turned a corner, attracting new audiences and forging strong links with teachers and their students. However, the next step was for exhibition planners to enter the hallowed domain of resident scientists and attempt to bring equally lively presentation to the natural world. Around this time, the museum decided to open its first press relations office.

A double crisis

With new exhibits on dinosaurs, human evolution, cladistics and evolutionary theory, the museum hit national and international news headlines. Architectural historians and those who had loved the stuffed animals found the new exhibitions hard to take. Scientists, mostly outside the museum, objected to the use of cladistics (a method of biological classification, at the time a hot topic of debate) as the smuggling of Marxism into the country's educational system, and also, even more vociferously, to what they saw as the lack of support for Darwinian theory. Controversy raged in the press and media, with savagely expressed views which were deeply obscure to the general public but wounding to the scientific community within the museum.

Headlines of the day				
Museum of errors	Dinosaurs versus barbarians	Dinosaurs and ape-men rear a Marxist head	Where the rows never become fossilized	Le Scandale du British Museum

A nervous director and board of trustees found themselves committed to a long-term programme of change, with a warring staff and no internal consensus. The whole exhibition policy seemed dangerous because of its ability to attract debate. Compromise was the inevitable outcome, throwing a few bones in every direction and pleasing no one. In a few months, the work of a decade was almost undone. The long-lasting controversy eventually became muddled, lost the interest of the media and began to blow over. In marketing terms, the warfare had secured coverage of the museum in a wide range of national and international media, but the corporate message had never been one of pride in achievement – more a matter of ducking and diving. An opportunity for fame and fortune was wasted!

The second crisis, as the 1980s drew to a close, was a financial one, which deeply changed the internal culture of the museum. For over 100 years, the museum had received more or less adequate funding from central government. This had created a somewhat cloistered environment in which people enjoyed a 'jobs-for-life' attitude, a lack of work pressure, and a suspicion of 'outsiders' – who were, by definition, ignorant of the ways of the museum and lacking in status.

Internal tensions

There is undoubtedly a difference in the internal culture between the curatorial profession and the profession of interpreting to the public. Nearly every museum recognises differences in behaviour and attitude between these two groups. Much of the task of museum management is to do with resolving the tensions which can arise and extracting the best value from each group.

Attributes of museum staff academics, curators and scientists	Attributes of interpreters, marketers and PR personnel
We are at pains to be accurate and take time to get it right.	They are painfully slow.
They are too quick and superficial.	We deliver on time.
We identify with our peers.	They are only interested in their own reputations.
We have empathy with our peers.	We have empathy with the public.
We can contribute exhaustive information.	They exhaust us with their information.
We can go on supplying information.	It's our job to lose excess information.
We follow interesting diversionary leads.	We must stick to the job in hand which can lead to great ideas/discoveries.

A forward plan

With the economic recession and a Thatcher government which was tackling Civil Service re-organisation and expecting publicly funded bodies to become more self-sufficient, a wind of change blew in from the outside. The order of the day was to justify all expenditure in terms of exactly what was being delivered for public benefit. A funding deficit of over £1 million was identified, and the first corporate plan in the museum's history was drawn up. In order to write the plan, a small interdisciplinary senior management team was formed, including a senior scientist, an administrator and Roger Miles, as head of public services and creator of the exhibition scheme. Also, for the first time, the museum used the services of an outside consultant to help them through the process.

The discipline of corporate planning meant that the global function of the museum was surveyed in a 'cost–benefit' mode and measured against the museum's mission. Every possible means of raising income was appraised, and an important component of the plan was the introduction of admission charges. This decision shifted the whole emphasis of the museum's use of resources and internal structure. Suddenly it was important to have attractive exhibitions and a clean, well-maintained building. There was new investment in public facilities,

exhibitions and 'front-of-house' activities. Every year the practice of surveying visitors at last paid off, putting the museum in touch with the public who were supporting the museum through taxes and through the new admission charges.

New times

The next corporate plan had to do more to bridge the funding gap. This time the permanent staff was reduced by 12%. This is never an easy decision, but the inter-disciplinary team had a rational framework for their choice and stood shoulder-to-shoulder through the difficult times. The new director made considerable effort to communicate with senior and middle management and to keep them working together. (Previous directors had made use of a private door to enter and leave the museum, thus avoiding contact with the staff.)

> Staff need and expect a clearer internal focus ... You cannot inherit a deficit and turn it around without disturbing people's lives and cherished notions.[1]

The Natural History Museum was now committed to a different kind of future. Even the source of its government funding had changed from a budget intended for scientific research to one intended for museums – a shift which would have been unthinkable in earlier times. The museum now generates at least one-third of its income, some £20–25 million. This is made up of trading income and admission money, some sponsorship, and – interestingly enough – fee and grant income from scientific activities and exhibitions and education. This multi-million-pound mix was completely untapped prior to 1987, the year when admission charges – and major changes in internal structure and attitude – were introduced.

> Traditionally, curators have run museums: they have been the largest group among the professional staff, and have had the power to determine policy, regarding not only collections and research but all other aspects of the work including the public galleries. The shift from museum as repository to museum as resource changes all that. Corporate management, with all functional divisions equally represented in the management team, leads to better discussions, better decisions, and a better-managed, more outward-looking museum.[2]

Old internal weaknesses

No consensus on museum mission

Poor internal communications

Failure to address key issues

Management fails to publicly support policy

Too many people involved in decision-making

Too many long meetings to no purpose

The shift

Corporate planning process forces consensus on mission

Formation of inter-disciplinary senior management team

Key issues begin to be identified

Public services given greater status and greater share of resources

Policy decisions get pinned down in written plan

Decision-making process becomes formalised (collaborative but swifter)

Time limit placed on many meetings

New strengths

Clear mission, clearly communicated and shared

Improved internal structure and communications

Key issues addressed

Management stands up for policy

Better team spirit

Public services improved

Attendances grow

Income stream created

Sense of pride/achievement = better morale

It was a long haul, and, of course, the struggle to raise money, protect lines of communication and use resources appropriately continues.

Self-help is exhilarating. The senior management team which tackled the first corporate plan was a tight-knit group which formed a bond of friendship and good humour in the face of many challenges. This camaraderie created exactly the right atmosphere for resolving conflicting interests.

I was once preparing a lecture on the management of change, when the museum administrator quipped that there was no such

topic. You introduce change and then try to put out the fires. Given the plasticity of human behaviour, which means that you can never truly anticipate how people will respond, there's a lot of sense in this. But there is no substitute for having a vision, clear lines of communication and a good team spirit.[3]

Notes

1. Malcolm Rogers, director, Museum of Fine Arts, Boston, who cut 55 posts during his first year in office, and more in 1999, quoted from *Museums Journal*, October 1995.
2. Dr Roger Miles, museum consultant and former head of public services at the Natural History Museum (composed for this case study).
3. Ibid.

Chapter 3 THE MARKETING AUDIT: EXTERNAL FACTORS

The environment in which a cultural organisation operates has a shaping hand in its future. Economic and social factors are a matter of geography, whether it is a question of a national museum dealing with government funding and national policies, or a local museum trying to survive in a small town or rural community. From neighbourhood relations to core funding, a museum needs to be on the alert for the politics of the situation. Marketing is a discipline which needs to be in tune with both internal and external politics, developing strategies which aid the institution's long-term goals and which are built on a thorough understanding of the existing and the available market.

When marketing sometimes seems to be mainly concerned with booking space, organising print, writing copy and sitting on the telephone, it may be difficult to keep your eyes on the longer-term strategies. Most marketing officers agree that the dimension which gives them the 'buzz' about the job — and the energy to keep pushing through the pedestrian work involved — is having long-term goals and devising creative ways to reach them. Many of the goals will be dictated by external factors:

- *funding environment and policy changes*
- *population and demographic trends*
- *city and rural planning*
- *economic environment*
- *leisure and tourism environment*
- *competitors*
- *audience awareness*
- *local perceptions.*

All of these factors are linked. Plans to build a new road can have as much impact as a change in political leadership.

Building networks and gathering information

It is already apparent from these pages that the authors firmly believe in the power of information. In marketing terms, gathering and understanding 'foundation' information is critical to success. So how does one keep in the swim on all these issues? Building networks is a good way to pick up developing news — and, of course, reading selectively but voraciously.

The internal network is of fundamental importance. Colleagues should be sharing information through internal meetings and every other available means. External networks need a more strategic

approach. When new in a post, it's a good idea for marketing officers to spend some time getting around the community and introducing themselves. You can segment your networking constituency in exactly the same way as you segment your audience. Contacts will be needed in the public information branches of the main funding bodies; the key leisure and tourism attractions; the tourist board or convention and visitors bureau; the local press and media. (Quite aside from publicity needs, there is no better person to know what's going on in an area than the editor of the local newspaper.) So introduce yourself on the basis of wanting to put a face to a name. You will probably need to work with such people anyway, but getting on to a good footing can be helpful to both parties for information flow, and for sounding out ideas that will have wide-reaching implications.

Read the newsletters of the organisations whose interests intersect with yours. This does not make for the most thrilling bedtime reading, but if you develop the art of 'scanning', you'll be able to home in on the items which are of real interest to you and pick up the internal culture and thinking of the organisation at the same time. Community issues can be discovered from local newspapers and newsletters, and one visit to a neighbourhood association meeting will tell you a great deal about who the key players are, how issues get handled, what people really care about, and how you might be able to handle your own local issues as they arise.

> When the huge new Tate gallery was being planned on the banks of the Thames in a residential area of London, the gallery issued a booklet to local residents to describe the project and the kind of impact it would have on the area. They explained the building schedule and parking issues, and followed up with information about the kind of public services that the new facility would be offering. They kept residents informed through the press, local schools and direct mailing, and planned special access arrangements for neighbours to see the new gallery on opening.

American neighbourhood associations are on the whole more outspoken and more demanding than their UK counterparts, and it can take a great deal more work, at a more sophisticated level, to handle local relations. Planning applications are the catalysts for local disputes in both countries and need to be carefully presented on ground which has already been prepared. Knowing what the hot topics are beforehand can help considerably in devising schemes that

take into account local requirements – or at least in having your arguments to hand. Developing trust and mutual understanding are the highest goals here, and time and commitment are needed to achieve them. When things get confrontational, you may need a good lawyer on the team!

In planning a major re-model of the museum in Malibu, the J. Paul Getty Museum knew that neighbourhood relations would be critical in obtaining planning consent. Over a period of years, before and during the various planning application stages, they cultivated a dialogue with the local community. Here are some of the things they did:

- Strategised and agreed common language to describe the project.
- Prepared descriptions and visual material.
- Employed consultants to assess environmental impact.
- Talked with individual leaders of the community.
- Attended 'town hall' meetings.
- Issued press releases about future plans.
- Invited neighbourhood associations to special briefings.
- Gave press interviews.
- Placed 'advertorial' inserts in the local press.
- Invited neighbours to private views.
- Started a 'hot line' for enquiries.

Assessing the funding environment

Identify your main sources of funding and examine trends and performance in that sector. Look at the real value of the grant or budget over a number of years. Has it held its value in real terms? What factors have affected the funding body during that period of time? What factors are likely to affect it over the next few years? Once you have a view of the practical and political climate in which you are operating, you can decide what kind of strategic action you need to take. If your museum has a well-written forward plan, you will not need to do your own research; policy will be described in the plan, and you can take it and shape it into a marketing/public relations strategy of your own.

If your source of revenue funding is holding its value or increasing over a number of years, you will need to maintain efforts to communicate achievements and demonstrate the value received for

that money. If your funding is falling in value, or threatened, you will need to step up your action and design a lobbying campaign to reverse the situation. There will be a greater sense of urgency, and more resources will go into this part of your activity. You may be planning a major capital investment – raising funds from Lottery bodies, the European Commission, private and public investors and members of the public – and will need a campaign to meet these specific needs.

All of the tools in the marketing and public relations arsenal will be needed. There is an argument for saying that no museum can ever lose out by basing the whole of its strategy around the need to secure and increase existing sources of funding. Consider the reasons. People who grant funds are influenced in the following ways:

- reputation of the museum
- compatibility with their own political agenda
- your track record
- first-hand experience
- perceived style
- perceived effectiveness
- influential advocates
- press/media coverage
- word of mouth
- presentation of grant applications
- pressure from and activities of 'competitors'.

By meeting your visitor and other targets, achieving good media and word-of-mouth coverage, conducting tenacious public relations lobbying, shouting your achievements, sharing your mission and goals and networking effectively, you will give your organisation the best chance of success. All of these activities are things that you need to do anyway.

Policy changes within funding bodies

We have already looked at the need to keep abreast of trends by reading, looking, listening and networking. The truly effective museum will also be looking for ways to influence those trends rather than simply responding to them. Take a look at potential changes in power, ownership and personalities. Broadly speaking, the non-political nature of museums should allow them to be friends with everyone. Don't just court today's power brokers – look at individuals who are on their way up. The nature of western politics means that

elected representatives do try to represent the interests of the majority, and they wish to be well briefed. If you can capture the attention of up-and-coming politicians and officials, there's a strong chance that they will be interested in receiving a knowledgeable briefing about museum matters – as long as you can keep it as informative, factual and statistical as possible, and not simply make it a plea for more funds. This is dealt with in more detail in Chapters 10 and 11.

Population and demographic trends

Shifts in demographics in western European countries and the United States are quite dramatic, as the indigenous population ages and moves to the suburbs or the countryside, while second and third generation immigrants present a much younger age profile. Political changes on a national or global scale can lead to a sudden swelling in a particular ethnic group. As some forms of industry close and others flourish, the character of an area can change fast. Economic changes can lead to total, and sometimes rapid, re-shaping of demographics. A new road, airport, ferry or bus route can bring a new public into your midst – or drain them away.

Getting information about the composition of your local or regional catchment area takes some work, but should be available from a number of sources. The town hall or library are good places to start. In the UK, the Office of Population Censuses and Surveys holds official statistics on each part of the country, as well as nationally. The central government Statistical Office holds some interesting figures also, but may be less accessible. (If you work for a government-funded organisation, you may have more luck.) In the USA, both town halls and libraries hold information, but there are also many excellent business information services where you can buy the information you need, for example InfoUSA and the ABI (American Business Information). There is also a lot of free information available on the worldwide web if you have the time and enthusiasm to cruise and search for it. National and regional/local tourist boards also collect and disseminate information on day visitors in your area as well as on staying visitors.

One useful source of information is the world of advertising. If you can persuade a member of a reasonably sized advertising agency to talk to you, you may discover some remarkable things about your region. This is an industry that thrives on detailed information about demographics and behaviour patterns. When new products are test-marketed, a particular region or regions will be chosen because of their characteristics: age ranges, income levels, car

ownership, available income or leisure habits. It can provide a remarkable insight to view your region through the eyes of an advertiser.

The sort of information that you need about your area is as follows:

- breakdown of age groups
- projected trends of these age groups
- numbers of schoolchildren and schools and projected trends
- numbers of retired people, estimated and projected
- income level breakdown
- occupational breakdown/trends
- educational attainment levels
- ethnic mix/breakdown
- growth trends
- people with disabilities/trends.

City and rural planning

Major new developments may have an impact on the future of your organisation. Consider the plight of the north London museum, which due to local road building found itself marooned in the middle of a roundabout! Not all cases are so extreme, but a simple change in traffic direction can affect your accessibility or even your 'passing trade'. It pays to keep a watchful eye on developments in this area. You may even need to enter the game with planning requests of your own, to improve traffic flow or achieve a pedestrian crossing.

There may be a proposed plan to build a major new visitor attraction or a shopping mall, either of which could influence attendances at your museum. There may be an opportunity for you to have a presence or involvement in some way. If a building development is proposed immediately adjacent to your property, you may be in line to benefit from a planning gain of some kind at the developer's expense – such as improved access arrangements or shared car parking. A big new employer entering the area may be a potential sponsor. A new school may be a new educational partner. A new hotel could bring a new audience.

Economic environment

Museums need good sensitivity to the economic fortunes of the surrounding area, and to trends in tourism, when forecasting revenue income from admission charges and spending in shops and cafés. But more than this, potential and existing sources of major funding are

affected by the economic fortunes of the local area, especially local authority funding. Your pricing structure and the programming you offer should be influenced by the fortunes of the surrounding community. Sudden massive lay-offs in the local workforce could mean that the nature and scheduling of activities you offer need to be altered and that free days need to be introduced to retain your local audience. If an area is starting to flourish after recession, you want to be sure that your museum shares in the benefits.

Leisure and tourism environment

Cultural tourism is being increasingly recognised as a driving economic force. Museums have an important part to play. It is now well established that the strategic siting of a museum can help to rejuvenate run-down urban areas, and that investing in existing museums can help to bring new interest and status to their locality. Spending by day visitors alone can bring £8.50–33 ($16–64) per head into the surrounding area – quite apart from any money spent in the museum itself. Once a museum starts to generate overnight stays, the economic impact can be dramatic. Also museums, galleries and other cultural institutions can add to the perceived status of an area, helping to fill hotels and drive up room rates. As the leisure and tourism industry grows – and just wait until those baby boomers hit retirement age – the support which cultural institutions lend to an area becomes increasingly important. This is why the tourism industry needs museums and galleries.

Museums and galleries need the tourism industry in order to connect with their markets. Local tourist boards and convention and visitors bureaux really know the available markets. They are busy bringing people into the area, and working on a scale which an individual museum cannot afford. They have much information to share and opportunities to offer. The mutual benefit which the two sectors can derive from one another is great, so it really is worthwhile spending some time to learn the language and getting to know what drives tourism, and what the opportunities are for museums.

Your area may be in the process of seeking more tourists. If so, you can play your part in achieving success and join in some of the promotional activities that will be going on. Tourist boards and convention and visitors bureaux will be able to tell you a great deal about tourism trends and the movement of tourists within your area, and they will be able to connect you with in-bound tourism providers, group travel organisers, hotels and concierges. They will

know what big conference groups are coming to town and will have a long-term view of future prospects. This can be your most rewarding area for networking, and you should consider becoming a member of your local tourist board. But don't be surprised if you are approached to take advertising space in promotional material – for more than you could ever afford. Tourism people sometimes don't understand the non-profit nature of museums and need to be told about slim budgets and reminded that a visit to a museum generates only modest income compared to a visit to a hotel. Nevertheless, examine such offers carefully, because they may be of great value.

Research in leisure trends

Leisure activities may be part of the local council provision or part of the commercial world. Either way, you will be perceived as a leisure activity by many people. Some museums and galleries are funded by local parks and recreation or leisure departments. You need to know what's going on. What are the trends in various parts of the leisure market? Are cinema attendances growing? What are they charging? What do users of outdoor recreation areas do on wet days? How are people moving around, what are they spending, and what are their customer care and service expectations? Museums need to measure up to expectations and standards in these areas – not fall short of them. And all the time you will be looking for new partnerships: opportunities where two organisations working together can achieve more than by working separately.

Your local authority may be carrying out detailed research into leisure trends. National research is carried out by commercial organisations such as the Henley Centre for Forecasting. Summaries are published in the leisure media (*Leisure Management, Leisure Week*) and the full reports are for sale. The Museums and Galleries Commission (soon to be the Museums, Libraries and Archives Commission) has started an annual survey into museum visitors and non-visitors (for an extract from the 1999 survey, see Appendix 1), which is available to all heritage attractions.

Competition

The authors believe that museums are not in competition with one another in the conventional sense. A great visit to one museum will encourage a visit to another. We have a never-ending product to offer and have much to gain by boosting attendance at other museums as well as our own. So collaboration, information sharing and partnership is definitely the way to go.

That said, museums need to be very aware of 'competition'. There are lots of options for people's leisure time, and a great deal is spent on advertising to attract attention. If we think about the circumstances in which people visit museums, it's often the 'What shall we do today?' situation. Every member of a family or group needs to be pleased in some way or another. Ease of access, value for money and the pleasure to be derived are all part of the decision-making process. Educational value is also a factor, but is rarely enough on its own. Let's face it, people like to have fun in their leisure time, and somehow museums need to look as though they have some fun to offer.

Competition is not always obvious. Today, it could just as well be the local garden centre, with its café and playground, or Sunday shopping which is taking people away from your museum. Take a look around. What leisure choices do people have in your area? What do they have to pay, and how accessible are the venues? Most importantly, what is the special feature that your museum has to offer − the thing that sets it apart from the competition and makes it different, special or curious in some way? Can your most successful competitors help you in any way − by joining with you in a marketing scheme, or carrying your leaflets or posters? What do you have to offer them? Maybe they have themed programmes coming up to which you can contribute?

When 'the big' Van Gogh show came to Los Angeles, three other LA museums brought out their Van Goghs or re-positioned them in displays which were complementary to the main exhibition at the Los Angeles County Museum of Art. The Los Angeles Convention and Visitors Bureau, which has a cultural tourism department, helped the museums to put together and distribute a promotional brochure to publicise looking at Van Gogh in and around the city. (They had also masterminded hotel packages and special travel programmes through their membership.) In this way, one big exhibition was made even bigger and created a sense of excitement for the whole area.

Audience awareness and local perceptions

How is your museum perceived by different segments of your public? In addition to our regular, essential visitor surveys, how we all wish that we had endless funds to find out more about public perceptions! Non-visitor surveys can rarely be afforded, and focus groups using funding bodies and opinion formers are unheard of. There are cheap and simple ways of testing public awareness. It is possible to purchase

single questions on omnibus surveys – regular surveys which the commercial sector conducts to test product awareness and buying habits. Or you could work with a local business college looking for a real-life project to cut its teeth on. A few weekend afternoons with a simple survey form down at the shopping centre should reveal some interesting findings (see also Chapter 7).

When outside consultants work on the preparation of a business plan, they usually get the opportunity to meet with some of your key VIPs and opinion formers. They can ask questions which you cannot, and sometimes they will be given a more candid response than would ever be given directly to the museum. This has real value and can help you to identify key public relations messages for the future.

The results

The external audit is an important piece of research. It is not designed to gather dust on the shelf but to form the basis for both your marketing and public relations strategy. It will also need regular input as situations change.

CASE STUDY 2　Long Beach Museum of Art, California

In 1999, Long Beach Museum of Art prepared its first business plan prior to embarking on the construction of a new building on the same site. Looking into the future to try to assess the operational environment, they found both threats and opportunities that were quite outside their control. The town was in the process of re-inventing itself, from an area that was perceived as 'run-down' to an exciting tourism destination. The construction of a new aquarium had taken courage − raising finance in the teeth of opposition to provide a star attraction. It worked. Investment in the area was gathering pace; new leisure and shopping facilities were burgeoning. The convention centre was doing good business. Hotel occupancy was around 70%. Public and private funding was being invested in improvements to the waterfront area, refurbishment of a marina village and more new shopping centres. There was a growing sense of self-confidence in developing the town further, and increasing revenues from sales taxes were helping to restore city finances.

The museum's grant from the city is a significant portion of their income, but it had not risen to keep pace with inflation. With the city slowly beginning to prosper the outlook might have seemed rosy, but the museum's SWOT analysis (of strengths, weaknesses, opportunities and threats) revealed some areas of concern.

SWOT analysis, Long Beach Museum of Art (External factors in italic)
Strengths
Team/human resources
Collection
Location
Mixed economy
Membership factors
Reputation/track record
Ability to draw visitors from large distances
Educational outreach
Appeal to all adult age groups
'Feel-good' factor

Weaknesses

Small visitor base

Dispersed visitor base

Low ratio of return on effort

Need for more curatorial support

Periods of closure

Location

Car parking

Lack of awareness of nature of collection

Relatively narrow appeal of collections

Threats

Possibility of failure to raise sufficient money for re-launch

Possibility of failure to raise sufficient money for maintenance/new service

Collections management

Small staff/big goals

Lukewarm support from city

Possible perception of failure to achieve 'success' status

Possible perception of failure to serve diverse audiences

New museum projects in locality

'Burn-out'

Opportunities

Opening of new building – multi-faceted

Programme mix

Increased marketing

Increased publicity

Increased advertising

Increase in admissions money

Increased rental hire

Higher profile attracts more funding

Chance to prove a 'success'

Lack of awareness of Friday evenings to be corrected

The items (in italics above) over which the museum had no direct control provided a set of targets to be addressed by the business plan and, later, by the marketing strategy. The museum's location is a fixed thing and appears as both a strength and a weakness. Visitor surveys revealed the public's almost overwhelming response to the beautiful

site, on a cliff overlooking the ocean. But as the museum is a couple of miles off the beaten path for most visitors to town, this great asset is also a challenge to ensure that access is easy, to promote the museum vigorously and to offer strong incentives to visit.

The museum's reputation and track record are, in this instance, very positive within a narrow but important band of people. The relatively narrow appeal of the collections appear juxtaposed under weaknesses – not everyone responds to the appeal of contemporary art, perhaps especially in a town which is targeting a mass audience. But a good reputation and track record are the most important characteristics that a museum can possess: if they were not present, it would take massive effort and a long period of time to turn things around. The narrow appeal of the collections can be addressed with creative programming.

The ability to draw visitors from large distances is a great strength, but one which may not be known or fully appreciated by opinion-formers. As this presents the museum with a chance to inform the city of its value in bringing in visitors, it is also an opportunity in disguise.

Car parking is a fundamental right of the Californian, who almost lives in his/her automobile and has few public transport options! The museum was well aware of its lack of parking and had plans to improve matters. Lack of awareness of the nature of the collection was a feature of public perception that the museum would address, for example through the construction of a new building to show more of the collection.

The four highlighted threats are all bound up with the museum's relationship with the city. There was a lot of respect for the museum, but no real recognition of the part that it could play in assisting the city to gain its own objectives. When it came to putting money on the table, the support could only be described as lukewarm. The museum was doing sterling work through its community and outreach programmes, but these were not high-profile activities and were not getting the recognition they deserved. As the exhibition programme was specialist in nature rather than popularist, there was no great enthusiasm among non-art-lovers. The combination of these three factors led to a fourth threat. The city needed to fill 30% of its rooms with non-conference business, a market that is classically comprised of family holidaymakers, short-break leisure visitors and small groups. In order to attract this market, the city needed to prove that it had a sufficient array of attractions. San Diego, just a couple of hours to the

south, with its wonderful array of beaches, a zoo, Sea World and ... museums, was doing exactly that. High-grade cultural facilities are what is needed to support a bid for higher spenders, as the growth of cultural tourism is proving around the world. Theoretically, the museum was in a good position to benefit from all this, but what if it seemed too familiar, too lacking in charisma, just a little too far off the beaten track? Maybe the city would decide to invest in newly invented or imported cultural attractions. (One is reminded of the advent of Jorvik in York, a town that already possessed a fine museum with a remarkable collection.) Having identified these threats, the museum could consider a variety of actions to defend its opportunities and re-position itself within public (and official) perceptions.

These threats and weaknesses, familiar to many museums, could, once identified and considered, be turned into opportunities. Wherever public awareness is low, or perceptions are incorrect, vigorous and sustained marketing and public relations can help to correct the situation. It has become a cliché to say that a problem is an opportunity in disguise, but sometimes it really is true!

Chapter 4 DESIGNING THE MARKETING STRATEGY

The internal and external audits have provided a mass of information for your marketing strategy. What follows is a step-by-step guide to analysing this information, gathering additional information about the specific project and designing a marketing strategy for anything from an exhibition or event to the opening of a major building, including guidelines on budgeting. It will also provide the basic structure for a marketing strategy submitted as part of a funding application and Lottery bid.

- Assemble information.
- Describe the product. Find angles/special interests.
- Describe the environment. Opportunities and threats.
- Define the potential market.
- Segment the market.
- Brainstorm with colleagues. Take input.
- Develop the marketing mix (design a plan to reach each segment using all appropriate tools).
- Check against budget.
- Review/revise.
- Produce as costed/time-pointed plan.
- Gain approval. Communicate to others.

Figure 3 The marketing strategy

Assemble the information about the project

It sounds obvious, and it is, but sometimes we are handed information in a piecemeal fashion. A thorough briefing is needed from those involved – planners, curators, designer/architect, collaborating scholars and sponsors – because you need to know their expectations. Also, if you are receiving an exhibition from another museum, it's useful to hear from their marketing team how things went and what worked most successfully for them. All of this information is needed as early as possible. Major projects need one- to two-year lead times, sometimes more. Unfortunately, the information which the marketing officer needs first is often the last to be decided: dates and hours; admission, concession and group travel arrangements; and information on ticketing if applicable. Years in the job and persistence are your best allies in convincing your colleagues that this basic information is what you need at least a year ahead!

The briefing stage is an opportunity for management to express their expectations. The project may have a high priority within the museum mission. This is the occasion for the museum director to spell out reasons for doing the exhibition in the first place. It may be that academic reputations are at stake, or that this was conceived as a way to develop new audiences. The marketing officer needs to know these reasons, but hopefully will have participated sufficiently in the planning process to know much of this already – and to have contributed to the underlying policy.

No detail is too small for the marketing team to want to know: method of arrival of objects; details of installation; scholarly input; background to the material, the people or the building scheme. Power is information – sleuth on!

Describe the product

When this research is done, it's normally useful to set out a written description of the project, which can be referred to again and again throughout the planning process. It needs to be broken down into sections for easy reference, and to be jam-packed with facts, correctly spelt names and contact information. This is not intended to be an academic treatise, but a marketing reference document that breaks down every component of the project into subjects. There may already be documents in existence which have been used for planning. By all means plunder the existing material, but begin to sift and segment the information for your own purposes. (The chemical composition of a compound used in conservation, for example, may be of no interest, but the fact that it was developed in the Louvre is a useful background detail.)

As each nugget of interesting information is sifted out and set down, ideas will occur, and particular 'angles' or stories will present themselves. This is the most fun! Creative interpretation is one of the most rewarding aspects of museum or arts marketing work.

Describe the environment

This is where previous research into the external environment will be useful. Positioning the product is the place where the dreams and aspirations of the museum meet the realities of the outside world. There are a number of additional questions to be asked:

- Is there anything about this project which is unique or new?
- When was something similar last done, and what success did the project have?

- Is the news value local, national or international?
- Who would travel for two hours or thirty minutes to see this?
- Will the product deliver on the promise?
- Is the timing good or bad? What else is going on?
- Are the opening hours useful? Who is available to come?
- What is the quality of the experience? Will there be good word of mouth?
- Are museum expectations realistic?
- Is the pricing right for the intended market (still being defined)?
- Is there enough time to deliver the audience?
- Does the museum need to adjust other services in order to enhance the visitor experience?

Define the potential market

The answers to some of these questions will begin to describe who is available to participate in this exhibition or event. But the key question is: 'Who is going to be interested?' Hopefully the answer will consist of a list of different types of people, with their different interests and levels of awareness. Include every sort of person you can possibly think of.

Sometimes, part of your intention will be simply to gain attention for the museum's activities. Not everyone who hears about the particular exhibition or event will come, but they will receive the message that interesting things go on in the museum. This helps general perceptions in a positive way. Targeting overseas or remote media is a way to contribute towards perceptions.

Segment the target market

Organise the list of potential markets in rational clusters. At this stage, you may decide to drop some less promising groups of people, but, on the whole, keep most included at this stage. Every list will be different, but 'art lovers' and 'families' are two categories you may consider (see next page). Some of these segments overlap. Don't worry about the repetition at this stage.

Art Lovers	Families
Existing visitors to museum	Households with school-age children in locality
Members of Friends' organisations	Consumers of family entertainment
Visitors to other museums and galleries	Leisure day-visitor families in locality
Members of various arts societies	Family VFRs (tourists staying with friends and family in the area)
Readers/viewers of arts media	
Attendees at other arts venues	Visitors to family attractions in area
Art school students	Families shopping at local centre or mall
Further education students in arts classes	Customers of local family restaurants
Browsers of museum websites	Members of children's clubs, such as Saturday clubs, sports clubs, media/membership clubs
Customers of artists' supply stores	
Cultural tourists	Customers of toy shops

Brainstorm with colleagues

Share your thinking with colleagues. Ask: 'What am I overlooking – and what ideas do you have?' The human resources locked inside museum staff are phenomenal! There will be all sorts of creative ideas available. The key question is always: 'How would you reach that group?' Often people will be able to suggest specialist newsletters, trade and professional organisations with membership lists, or a coffee bar or clubhouse where notices can be pinned up.

Colleagues may also have ideas for unusual or unpredictable promotional activities. Marketing folk tend to reach for tried and tested methods, but colleagues can sometimes think 'outside the box'. Gather everything in for consideration.

At this stage you may decide to use this project, event or exhibition to bring in new audiences who may not necessarily meet your income-generating targets but who do meet greater, social objectives. (For more ideas, see Chapter 8.)

Objectives and strategy

Define the objectives at this point, add the positioning statement and spell out your strategy. The objectives should be precise and are a way of evaluating your marketing activities for this specific project. Constraints and challenges which are beyond your control but may affect the outcome of the marketing strategy should be flagged up here; alternative scenarios should be provided where, for example, a delay in construction could seriously affect the impact of the marketing strategy and the targets set.

From your 'wish-list' of potential markets, you must focus on the achievable, using the communications life cycle (Figure 2) as a useful way of deciding who can be successfully targeted within the available budget. Now is the time to design tactics and look at the most effective ways to reach each of these target markets. Whether by public relations, leaflet distribution, visiting speakers and events, direct mail, posters or advertising, there will be some action, judged to be effective, which will cost time and money or a combination of both. This is where less cost-effective methods may be jettisoned in favour of more productive, more cost-effective actions. Clear thinking is needed at this point. Colleagues may be puzzled why you have decided to do no advertising at all, or why you have given up trying to reach some small segment of the potential market. Time, effort and cash are limited, so they need to be used where they will get best results. This is the true value of the strategic approach.

Visitor targets should be set for different target audiences (and ways of measuring these should be established). Targets for increased turnover in the shop and café have to be agreed and media coverage targets set (see Chapter 16).

The positioning statement is based on the product analysis – a summary of the key messages broken down by each audience group. The overall message should be consistent, but there are different angles which will be more attractive to individual segments.

The strategy sets out the overall approach, the timetable and the tactics, including marketing mix, budget and evaluation,

Develop the marketing mix

The marketing mix is the blend of different marketing ingredients for a given product. The mix is decided by the way in which you choose to reach your different target markets, some methods being more effective than others with particular segments of the public. There are many different ingredients to choose from, the main ones being:

- **Public relations:** press and media relations; opinion forming; general public relations.
- **Advertising:** printed media; radio and television; advertising on public transport; poster campaigns; street banners; billboards; other (on-package, on-ticket, bumper stickers, sky-writing, blimps!).
- **Printed materials:** leaflets; flyers; brochures.
- **Promotional items:** bookmarks; tent-cards for restaurants; children's place mats for restaurants; matchbooks; other ideas (be creative, but always with distribution costs in mind!).
- **Signage:** banners on/outside museum; street signs; Automobile Club road signs; any other.
- **Trade fairs and exhibitions:** any relevant shows.
- **Group and travel trade promotions:** direct mail to tourist board and convention and visitors bureaux (CVB) members; direct mail to tour bus companies; briefings for staff of tourist information offices; concierge briefings; taxi-driver briefings; CVB events and promotions.
- **Partnerships:** joint marketing schemes with other attractions and hotels; with transport/airline companies; with local restaurants and pubs.
- **Direct marketing:** direct mail to useful lists; telephone sales.
- **Merchandising:** souvenirs and bags in museum shops to promote event.
- **Other:** websites, your own and others; speakers' bureaux to offer speakers to local organisations; anything else you can think of.

Notice that posters are listed under advertising rather than printed material. This is an effort to break the habit of museums regarding posters as an art form rather than as a hardworking form of advertising.

Pricing structure

At the strategy stage you need to decide on your pricing policy. Non-charging museums frequently need to charge for special exhibitions, and charging museums may decide to have a special charge for a major event or exhibition. Heritage attractions and independent museums have little choice when it comes to charging, but they may have very little idea of how to design a price structure.

There are two approaches: working from costs or charging according to the prevailing market conditions. For non-profit-making attractions, working out the true cost of each visitor may not be very easy or helpful, but it is a good discipline to work out the cost of

special events and activities, including an element for overheads. Only by doing this can a proper evaluation be carried out of the success or otherwise of special activities.

Most public sector attractions base their prices on a mixture of 'What can we get away with?' and 'What do others charge?' On the whole, the latter is the preferred route. Make sure you are equating like with like; you will also need to take public perceptions into account. You are not doing your museum any favours by undervaluing the experience you offer in relation to commercial attractions in your area. There are more effective ways of safeguarding public access to your attraction – for example by offering concessions, free days during the week, free hours at the end of the day, season tickets for residents (successfully introduced by the National Maritime Museum in Greenwich), free entry for a year with each admission (as at The National Museums and Galleries on Merseyside).

The pricing process should also include the cost of the catalogue or guide, audio tapes, merchandising and any special offers in the café. Including the guide or audio tape in the price of admission can be an attractive way of softening the impact of charging.

Start with the adult price and then list your concessionary prices. It may seem a good idea to have one reduced price for all categories, but it is actually better to differentiate between, for example, children and pensioners, as this is a simple way of keeping track of different types of visitors. You will also need a price for groups. Use a nearby commercial attraction as a comparison; the differentials between categories may be right for you or you may have to adjust it to suit your audience. Remember that concessions to UK nationals must now also apply to all visitors from EU member states. Family tickets which include one or two adults, plus three to four children are a useful marketing tool when individual prices are fairly high, especially for family-orientated exhibitions. If your event or special exhibition is most likely to appeal to an older audience, don't hesitate to introduce a realistic charge (a large proportion of people over 60 benefit from an additional pension and other incomes) and look at other ways of accommodating the less well-off.

The benefit of being a Friend is usually the free admission to events and exhibitions. You need to consider how this is going to work in practice. A small museum may find that special events are filled by enthusiastic Friends, who in effect have not paid and make the few paying visitors feel like outsiders. Consider introducing a charge for Friends for certain events, even at a reduced rate. A very popular

exhibition may attract huge numbers to the private view, and a large number of complaints. The Tate has learnt from the Picasso exhibition a few years ago and now staggers private views, with Friends receiving invitations for only one or two of the available slots. The Royal Academy thought it had planned it well for the Monet exhibition in 1999, with free pre-booking for Friends during the exhibition, but it did not foresee the large numbers who turned up, as usual, for the Friends' preview and queued for hours, with many not getting in at all.

The pricing debate

Nearly all heritage attractions charge (all National Trust and English Heritage); three-quarters of independent museums make a charge. Half of military museums charge and approximately one-third of all local authority museums. Virtually all museums in the United States and in the rest of Europe charge. National museums in the UK are now in a curious position: more than half have introduced charges in the last decade. Other have held out, although charging, sometimes heavily, for special exhibitions. The UK government is now in the process of abolishing charges for those national museums which already charge and safeguarding others from having to charge in the future. Already children under 16 have been given free entry (as from 1 April 1999) and free entry for senior citizens is due to follow in 2000. It is not at this point (April 1999) clear whether the government will achieve its aim to make all national museums free because of the costs involved: not only does the government have to make up for the lost income, but also for the opportunity to reclaim VAT. Does it matter?

> There is overwhelming agreement amongst museums that, as a matter of principle, admission charges should not be levied. This rate of preference for free admission among museum providers is much greater than that among the general public.[1]

> If we are confident in the delivery of the experience, it is not only necessary to put a price on the visit but it is important that we do so. An admission charge will ensure that the visitors put a value on the experience. Museums are not just places to pop in to or for casual visits; they are more significant places. Also the museum that delivers a charge for the experience will need to see that it delivers a value against that price expectation.[2]

The 1999 MORI research carried out for the Museums and Galleries Commission confirms that charging is not a major issue when it comes to deciding on a museum visit; 'not interested' was the main reason for not visiting (see Appendix 1).

Admission charges, when properly managed as part of a marketing strategy, work for the museum not against it – introducing discipline in the collection of information, particularly visitor numbers, and in the targeting of markets and promotional activities generally. Computerised admission systems will provide a wealth of information, relieve staff of tedious counting and checking and remove the uncertainties associated with manual counting of visitors (many of the dramatic falls in visitor numbers reported when charging was introduced resulted from a prior overstating of visitor numbers).

In local authority museums, the problem of retaining the income generated by the museum is a major obstacle to the staff embracing charging with any kind of enthusiasm. The incentives need to be built in to ensure that revenue generated by the museum in attracting additional visitors and more income for the shop and café, directly benefits the museum in terms of additional investment in facilities and marketing activities. This requires some imaginative thinking on behalf of local authority leisure services departments, but many are now seeing the benefit of such an approach.

Charging for museums and galleries is now a fact of life, as it is already for heritage attractions across the country. Museums and galleries need to develop a positive approach to charging and make it work for them, and not against them, in marketing and audience development.

Budget

What proportion of the overall museum budget should be spent on marketing? And how much should a museum spend on marketing individual exhibitions? Figures vary. No accurate figures exist but most UK museums probably spend less than 4% of their income on marketing. This would be laughable in the commercial sector, but attitudes in museums are changing only slowly. Few museums and galleries can afford to sit back these days and wait for visitors to arrive – as this book clearly illustrates. It is not simply a question of increasing attendances but equally about raising profile. Public bodies like the Museums and Galleries Commission and the Arts Council of Great Britain have recommended a figure of 9%. (This figure does not include staff salaries or product improvement.)

Admission-free museums face just as strong a challenge to market themselves as others. Even a museum which feels that it has quite enough visitors may not be at capacity at certain times of the day or year. It may wish to re-shape its audience profile in some way and definitely needs to address all its other audiences to secure its future.

Often museums do not include all marketing expenditure under one heading in their budgets. Various departments or sections of the museum may be spending resources on activities that fall under marketing, but for historic reasons the budgets have not been unified. Consistency and control are important factors in marketing, which means that it is more efficient, and indeed essential, to have as much spending as possible under a single budget.

Sponsors will take a close interest in marketing plans right from the start of the relationship. Because they know that marketing is what delivers success, they will be looking for real commitment and skill in this area. Sometimes a sponsor, or even an additional sponsor, can be persuaded to help with advertising costs if it contributes towards their own corporate advertising.

There are three cost centres for marketing:

- **Product:** Spending on operating and improving programming, services and facilities. This includes customer care training.
- **Personnel:** Salaries and fees for the people who do the work. The amount of support staff needed for the marketing office is usually grossly underestimated. It is a labour-intensive activity driven by deadlines.
- **Working budget:** To cover printed materials, office supplies, design services, advertising; public relations, including media, may be a separate public relations budget.

Deciding how to spend the marketing budget is what this book is all about: objectives must be married to ways and means. Standard formulae should be avoided.

Production of the marketing plan

Now the refined, costed marketing mix is turned into a written-up, time-pointed plan, working backwards from ground zero – the opening date. A diary date needs to be identified for each action according to the necessary deadlines, and the plan needs to be sorted into chronological order. This now becomes your day-by-day, week-by-week action plan. With senior management behind you, it then needs to be communicated to all who will have some involvement in it.

From this point on, it's plain sailing – all you and your team have to do is perform the thousand and one tasks you have identified!

Implementing marketing activities

A marketing strategy can be implemented in several different ways depending on the size of the organisation and the budget. Here are some different models:

- *Large museums and heritage attractions*: Marketing manager and supporting team (depending on size of budget) report to director and are responsible for marketing strategy, budgeting and implementation. There may be occasional input from consultants in the strategy process, and specialists – e.g. advertising, promotional, direct mail agencies – may be employed for specific campaigns and activities.
- *Medium-sized museums and heritage attractions*: Marketing and public relations function may be combined in one person working closely with the director; or the marketing and development role may be combined with public relations handled by an external agency (more specialist).
- *Small museums and heritage attractions*: Director or deputy may take on marketing and public relations function with assistance from outside consultants as appropriate.

Consultants can be useful in developing a marketing strategy from scratch or for reviewing an existing one, as the in-house marketing officers may (a) find it difficult to step away from their day-to-day jobs to concentrate on this or (b) not have the necessary level of strategic skill or ability to view the organisation from outside.

Consultants lists are held by the area museums council, regional arts boards, tourist boards, the Museums and Galleries Commission (Museums, Libraries and Archives Commission from April 2000) and the Arts Council. In the United States lists of consultants or recommendations can be obtained from convention and visitors bureaux and sometimes from regional museum associations.

Select a small number of potential consultants on the basis of recommendations from other museums, appropriate experience and some knowledge of your part of the country. Talk to them on the phone or in person and also check with one or two previous clients. In the end, the most important prerequisite is that you feel you can work with them, so the preliminary meeting is essential. You may have to set up a bidding process, depending on the size of the contract, but you should not necessarily take the lowest price; it is better to give

consultants an approximate budget on which to base their proposal. Make sure you agree a realistic timetable and then stick to it. Consultants like clear briefs and the opportunity to review progress with the client; they will usually be happy to produce a draft report for discussion which can be amended to suit other purposes you may have – for example, influencing funders, by flagging up issues for the future.

Do not be surprised if consultants propose training for directors, trustees and staff in order to raise their awareness of marketing issues and the importance of customer care. Most museum consultants want to see their clients shine and become more self-reliant. They will see their own success very closely bound up with yours. In order to profit fully from marketing opportunities, therefore, they may suggest various forms of staff development. In particular, media and presentation training is something which may be suggested and should be taken on board.

> The authors (consultants and communications specialists themselves) believe that museums should strive to attain the appropriate in-house professional marketing and public relations support for day-to-day activities. This means paying competitive salaries and integrating the marketing function within the museum staff structure. Smaller museums and attractions may achieve the same results by employing, on a regular basis, a freelance marketing professional who bases him/herself at the museum for a certain number of days. Outside consultants, marketing communications and public relations agencies have very specific roles to fulfil in preparing long- or short-term strategies, stepping into a crisis situation and boosting the resources of the institution in certain situations (for example, for major events or exhibitions), or in providing an ongoing professional service which the museum or gallery simply cannot afford to set up in-house. (This applies particularly to media relations, parliamentary lobbying and public affairs advice.)

Notes

1. *To Charge or not to Charge?* (1998). Summary report of survey commissioned and undertaken by the Glasgow Caledonian University. Museums and Galleries Commission.
2. Michael Jolly, Chairman and Chief Executive, The Tussauds Group, speaking at the Royal Society of Arts Museum Week in 1998, quoted in *RSA Journal* **4** (4) (1998), p. 75.

CASE STUDY 3 Penshurst Place and Gardens, Kent

This case study is based on the entry for the Kent Marketing Awards in 1993. Penshurst Place and Gardens won an award in this and in the Chartered Institute of Marketing Awards in the same year.

When the Second Viscount De L'Isle took over Penshurst (in Tonbridge, Kent) after his father's death in 1991, it was clear to him that there was great potential – not only to increase visitor numbers but, more important, to increase income in order to maintain this historic property for his own family's benefit as well as that of the nation.

Ylva French Consultancy was appointed at the end of 1991 by Adrian Gilpin, the new business manager at Penshurst Place, to review current marketing activities and to formulate a marketing strategy for the next three years (under the Department of Trade and Industry marketing initiative) which would go hand in hand with other improvements.

The marketplace

During the 1980s there was a steady growth in domestic and overseas tourism in the UK. Day trips increased as discretionary spending grew. Attractions throughout the south-east of England benefited from this almost unlimited growth in demand. At the same time, the corporate hospitality sector expanded and benefited historic houses such as Penshurst which could offer something different.

The picture in 1991, as the recession set in, was quite different: day visitors, tourists and the corporate hospitality market – as well as banqueting and special events – were all affected.

Penshurst competes with many distinguished historic houses and other attractions within a few miles. In good times this can be an asset, with visitors combining visits to several places of interest in one day; in bad times it is a disadvantage as disposable income allows only one visit.

Visitors to area attractions, 1990	
Leeds Castle	540,000
Drusillas	330,000
Hever Castle	300,000
Chartwell	182,000
Knole	80,000
Penshurst	82,000

The marketing challenge

The challenge for the next five years was not just to overcome the negative impact of the recession but to build on Penshurst's strengths and position it in the first division of Britain's stately homes.

Marketing performance

After a full year of implementing the new marketing plan, all performance indicators showed an improvement on 1991 and on budget forecasts.

Overall numbers were up by one-third, making a total of 122,000 visitors, including those coming to special events. Ticket sales had increased by 25% on 1991. Sales in the shop were up by one-third and revenue from special events was up by 62%.

A major London-based tour operator responded to the increased marketing activities by including Penshurst Place in a three-day-a-week tour programme out of London's major hotels.

Use of marketing techniques

Setting new objectives and targets

Britain's heritage is fragile and Penshurst Place is no exception. Growth in visitor numbers and income had to be achieved without substantially increasing the wear and tear on the house. Research for the marketing strategy had identified the potential of the gardens. Visits to gardens generally were increasing faster than for most other attractions, and it was decided to plan for growth in the number of visitors to the gardens.

Visitor research

One of the first recommendations of the new marketing strategy was to look more closely at visitors to Penshurst, as no research of this

kind had previously been carried out. The results of the visitor survey will guide future activities.

Corporate identity

A new corporate identity was developed for Penshurst Place and Gardens, the first step being to change the name and use 'Gardens' in all printed material. All material was redesigned to carry the new logo.

Opening dates and hours

As a first step towards better communications and maximising income in the restaurant it was decided to introduce a simple pattern of opening days and times. Monday closure was discontinued and the house opened seven days a week from 1 April 1992. Admission charges were slightly amended to increase the differential between the 'House and Gardens' and 'Gardens Only' tickets and a garden season ticket was introduced.

Advertising and listings

An ongoing programme of evaluation of guides and listings publications was started and research was carried out into any other guides that could include Penshurst. The budget allowed only a limited programme of advertising in major guides and local newspapers.

Direct mail

Direct mail activities were introduced for the first time and aimed at three groups: coach and tour operators, special interest and garden societies, and local businesses (for banqueting and Christmas parties).

Trade fairs

The marketing plan also called for a higher profile at international events. It was decided to take a stand at the British Travel Trade Fair in Birmingham at the end of March 1992 and at the World Travel Market 1992, joining forces with the South-East England Tourist Board and a limited number of other attractions.

A Penshurst video

For the first time, a corporate video was produced for Penshurst. This was shown to the trade at World Travel Market 1992 and will be used at future trade fairs as well as at individual client presentations.

Special events

Events organisers were contacted and ideas for new events explored. Some of these may not be established until economic conditions generally improve.

Innovation and exploration

Familiarisation visits

As part of the general familiarisation programme, targeted journalists, tour operators and events organisers were invited on the first day in March 1992. This included an opportunity to try country pursuits. In May, 'Opera in the Gardens' was featured.

Garden season ticket

As part of raising the profile of the gardens and encouraging repeat visitors, a garden season ticket was introduced at £10 per person, including a companion, at the start of the 1992 season. Approximately 300 season tickets were sold in the first year and each season ticket holder made an average of three visits to the grounds with a companion.

Special promotions

A series of special promotions with targeted media were set up and evaluated. Other offers entered into included the South-East England Tourist Board's short-break promotion for 1993, an ASDA superstore promotion and a coupon offer with a major car rental company.

Garden tours programme

The garden tours programme was launched at World Travel Market 1992 to continue the focus on the gardens. Pre-booked groups are offered an expert-guided tour and a choice of refreshments.

Media activities

Following the series of familiarisation visits, individual journalists and editors were invited to Penshurst and provided with up-to-date press material and photographs. The media coverage obtained in the first year was consistent with the message and with the effort put in to reach targeted media.

An active programme of contacts with film producers resulted in one film for television, *Covington Cross*, being partly set at Penshurst.

Chapter 5 THE MARKETING PLAN: TRADITIONAL TECHNIQUES

This chapter sets out in detail the various elements of the marketing plan, focusing mainly on tried and tested techniques for delivery. Tourism is covered in Chapter 6, new techniques – from direct mail to the internet – in Chapter 7 and audience development in Chapter 8.

There is a logical approach to implementing the marketing plan, whether from scratch or for a special exhibition, but as soon as the plan is formulated and approved, action will probably need to begin immediately on urgent or already overdue items. Here is an **urgent action checklist**.

- **Corporate identity/logo:** Name/title to be agreed; existing or new identity to be adapted or developed before the next step.
- **Printed materials:** Agree print schedule; consider new requirements, quantities and distribution (don't simply repeat previous formula).
- **Special partnerships including sponsors:** Make sure sponsors' requirements on print and logos are taken into account; if sponsors are not confirmed, work out final print deadline for bringing sponsors on board; set up other special partnerships with television, education, the transport and tourism industries.
- **Urgent space bookings:** Book any special positions required for the media, particularly poster sites (London Transport poster sites can be booked up to a year ahead); street banners may need planning permission or space may need to be booked well in advance.
- **Specialist and other group travel organisers:** It is never too early to notify the group travel market of interesting opportunities; make sure you have all the facts they require – prices, any special deals, information on pre-booking, guided tours, parking or other arrangements.
- **Tourist boards:** Supply them with all the above details for events listings and promotional guides as well as other marketing opportunities, such as trade fairs.
- **Media:** Production companies work more than a year ahead on documentaries and special programmes; media partner deals also need to be set up well in advance.
- **Incentives:** A spectacular or very unusual exhibition or venue may be just the thing for an incentive company (see below); these need a long time to develop.

Once all the most urgent matters are dealt with, follow your detailed marketing plan and detailed timetable on a day-to-day basis.

Public relations

As part of the marketing plan, media activities are closely geared to marketing objectives and to the key markets identified as the priority for the particular product or exhibition. This may be different from the public relations thrust of the museum or gallery as a whole. Particular attention will also have to be paid to the requirements of sponsors.

The importance of starting media contacts early has already been stressed: commissioning producers and production companies work 12–18 months ahead. You may know of an existing television documentary on the subject of your exhibition or event. If you can persuade the television station that your event is going to attract great public attention, they may consider re-broadcasting the programme to coincide with it. The next task is to persuade them to link it with your event by some announcement at the beginning or end of the broadcast. Museums have something to offer in exchange for such co-operation. As they have a ready audience visiting each day, a membership list, and newsletters and printed materials due for distribution, they can offer pre-publicity for a special broadcast, which will help to secure a viewing audience. Again, for everything to fall into place in the schedule, planning has to start very early.

Press kits need to be considered, designed and produced to take account of the 5–6 months' lead time required by the quality long-term magazines. It's no good if they arrive on the editor's desk the day the magazine is laying out the issue you are targeting – the idea needs to be planted much earlier. Sometimes a magazine may wish to commission their own photography rather than use the material supplied by the museum. This takes time to organise. See also Chapter 13.

Advertising

Most museums and heritage attractions maintain modest advertising budgets. They buy space at an educational discount wherever possible and prepare artwork as specified. Generally such advertising is done without much planning as to which audiences are being targeted. Advertising should be part of the general marketing strategy and has a major role to play in marketing plans for specific events and exhibitions.

It can actually save time and money to go to an outside agency – preferably one that specialises in museums, the arts or non-profit accounts. Advertising agencies can help in the selection of media to

reach key audiences at the most advantageous price, bringing it altogether into a media plan. They can normally negotiate better rates and will usually agree to cover their fee from the discount they earn in buying space – depending on the size of the overall budget. They do charge for design and artwork. Advertising really is a specialised area. It has to work very hard in order to be effective, and there are many insider tips, rules and tricks to make that happen. The most common mistake made by museums is to overload the advertisement with too much copy. Simplicity is the key to success.

When choosing where to advertise, you need to refer to your marketing objectives and target markets. Readership needs to be matched to these as closely as possible. This is where your own visitor research can be helpful in telling you what visitors are reading. Friday and weekend papers tend to be kept around the house longer than the others, and holiday editions may be kept for several days. There is often no extra charge for weekend and holiday editions.

Printed media

Research shows that editorial coverage is more effective than advertising space – between three and ten times more effective, depending on which research reports you follow – but the most dynamic combination is a blend of editorial coverage and an advertising campaign. Paid and unpaid publicity working together is a very strong combination. When planning a major campaign, ensure that both elements are present.

There are two different kinds of space: **classified**, which is small print advertising, usually occupying a column width; and **display**, which is a larger space, usually incorporating images as well as words. Classified advertising is useful for niche (very narrowly targeted) marketing of coming events or personal appeals.

The sizes of advertisements in newspapers are usually expressed in column centimetres, according to column width. Thus, a 10 centimetre double is a space that measures 10 centimetres in depth by two column widths across. Of course, a column width is different in each newspaper. Smart planning can result in a campaign that requires as few pieces of artwork as possible, allowing some marginally smaller advertisements to float in slightly larger spaces. There are cost savings in limiting the number of pieces of artwork – but this cannot be taken to extremes.

Certain advertising spaces in newspapers are for regular arts/museums/exhibition spots and usually located close to editorial

space that covers the same topic. Right-hand pages usually cost more than left-hand pages, because of the way newspapers and magazines are flipped through. Covers – inside front, inside back and back – are expensive precisely because they are more noticeable. For the same reason, space above the horizontal fold in a broadsheet paper is sometimes more expensive than space below the fold. When offered a wide array of choices, it is usually sensible to opt for a position that is close to editorial copy which is vaguely on the same subject area. Readers who turn to the pages giving film and exhibition reviews are the people who get out and about and participate in cultural offerings, so it's a good idea to think about who is reading what and why. The newspaper or magazine should provide a profile of their readership; if you are dealing with an agency, it will provide you with a complete breakdown.

Distribution is key to whether advertising messages reach the audience they are intended for. Many publications that are free to the public seem like a good deal for advertisers, judged on print-run alone. But how many people pick up free papers from those piles left around in public places? Sometimes a lot; sometimes very few.

Printed advertisements for a single museum, or an exhibition, should all have a house style that follows through to other printed material. It is a mistake to design a particular advertisement for a particular publication without visual similarity to other advertisements in other publications. By all means give particular advertisements an added twist to suit the readership. For example, young readers need to have their attention grabbed in a different way – possibly with different images – from a middle-aged or elderly readership. It is sometimes possible to find one visual image that works well for all – an ideal situation. As the effectiveness of advertising is built upon repetition, similarity of style and presentation in each advertisement is very important, even if the featured image changes.

Advertising in black and white on newsprint presents particular challenges. There is a tendency for everything to become grey and blurry, so clear contrast is needed to achieve a good result in 'halftone'. The simplest trick to make an advertisement stand out is to run a box around it, to separate your material visually from everything else on the page. Also, if dealing with photographs of three-dimensional objects, consider cutting them out against a white background to add impact.

Occasionally museum advertisements attract controversy and thrust

the museum into the headlines, creating all sorts of extra unpaid publicity and public attention. This usually happens by accident. It would be difficult to deliberately court controversy through an advertising campaign, as there is always a danger that the policy would backfire. However, when deciding upon wording and images for advertisements – and when presented with topics which seem cheeky or rather more outrageous than the museum's usual style – it's probably a good idea to err on the side of cheekiness and risk, because most museums play it too safe, using dull and predictable advertisements that fade into the background.

If you are asking readers to take a particular action resulting from reading an advertisement – such as making a booking or clipping a discount coupon – a monitoring number can be added to the corner of the artwork which will allow you to identify which advertisements are proving more successful.

> The National Museums and Galleries on Merseyside took expensive, paid spaces in the London press, to try to attract the attention of Londoners. Local people from Liverpool found this a controversial move – the museums spending serious money to attract Londoners rather than the local audience. The resulting press coverage about the 'protest and outrage' secured editorial space on a scale that the museum has never since equalled.
>
> The Victoria and Albert Museum triggered long-lasting vocalising in the press about their advertisements (posters) which spoke of this august institution as 'an ace caff with a great museum attached'. It takes a mature and self-confident management to weather such storms with good humour!

Television and radio advertising

Television advertising requires a substantial amount of spending to be effective. The fact that a museum can afford to buy a mini-campaign doesn't mean that it will be successful in breaking through to the viewers' consciousness. We are bombarded with screen advertising, and it takes expensive repetition to register a fact in people's minds. The Manchester Museum of Science and Industry has advertised successfully on regional television several times. It takes small slots at peak viewing times just before major public holidays. The message is kept short and punchy, with sound effects for atmosphere and

entertainment value. Attendance is carefully monitored after campaigns, and only if there is a noticeable increase will the exercise be repeated. Through a flexible agreement with the broadcasting station, the museum can monitor weather conditions and decide at the last minute whether extra advertisements will be worthwhile.

Radio -- especially local radio – is more affordable. Listeners to local talk radio are often people who take a lively interest in what is going on and what is available locally, and limited but repeated advertising campaigns for museums can be very effective. Timing is important. It may be tempting to go for the cheaper times, but it is much better to reduce the length of an advertisement to the shortest possible, and go for the times when most people are listening. Again, Fridays and Saturdays are interesting because these are the times when people are thinking of weekend leisure activities.

Some radio and even television channels will occasionally give space/time free to non-profit organisations in the area. Known as PSAs (public service announcements) these are offered by publicly funded broadcasting stations in the UK and the USA. The times of these free broadcasts may not be the best, but they should certainly be taken advantage of.

Transport advertising

This is an attractive form of advertising because you often have a captive audience: commuters and visitors standing on platforms, at bus stops or stations, or travelling on escalators or inside buses and trains, have lots of time to read the advertisements in front of their noses. Normally you have to buy a quantity of spaces. Single sites are rarely any use, because repetition of exposure is needed, but any museum located on a particular underground or overground train station may like to take an individual site to say 'welcome to X town, home of the X museum'. Most commonly, packages of sites in different locations will be offered. Some locations will be great, others not. Read the small print, and check the location out on foot if necessary.

Street banners

As towns begin to recognise the cash value of cultural tourism, street banners become more popular. They add a sense of celebration and decoration. These sites are usually fixed to lampposts along main streets, and they work wholly and solely on repetition. One banner on one post would be a nonsense. A whole row of identical banners is

unmissable whether travelling by foot or by car. The right design in the right place can give great value. The most common mistake is to crowd the banner with print: no one can read small print while they speed by. A great banner is one that is simply eye-catching and conveys an essential message with the minimum number of words.

The first time you plan banners on or adjoining your own building you will probably have problems with planning permission, particularly if the building is listed. It is worth taking a long-term approach and going through the hoops required to make banners possible; it's a great way of providing a 'temporary' colourful sign on a building when permanent signs are not allowed.

> When the Getty Center in Los Angeles opened to the public in December 1997, the town was papered with costly banners. The several different designs were beautifully executed but too varied to register as repeat advertising. At the same time, the Fowler Museum, a less well-endowed museum, used street banners and achieved a much more powerful effect by simply having one bright colourful design repeated again and again. Sometimes, a large budget does not guarantee wise use of resources!

Printed material

Think 'reader' with every piece of printed material produced. What is the context? Too often we produce one piece of print to do a thousand jobs for us. What a perfect world it would be if we could have a custom-made piece of print for every market we are targeting! Different languages, different levels of interest, different age groups, and different styles could all be accommodated. This is rarely possible. But at least we can remind ourselves that by targeting a public that is less familiar with the subject matter, we are being more inclusive of a wide audience. Visual appeal, brevity and simplicity of language are our best allies.

We need to make printed material work really hard for its living. For a start, it usually needs to be attractive enough to be picked up and read voluntarily. If the context is a brochure display stand, full of upright narrow brochures, not only is the size dictated by the rack but only the top third of the front face of your card or leaflet will be visible – so you have a space measuring about 5 by 8 cm in which to attract the attention of browsers, and other brochures will be shouting equally loudly for attention. Balancing the need to be bold and

succinct without becoming brash and vulgar is an interesting exercise. Everyone draws the line in a different place. Museums can usually succeed by taking one step closer to 'brash and vulgar' than they would normally be comfortable with!

Posters are advertisements and should generally be treated accordingly. However, they can also be regarded as works of art and collectors' items; that decision should be made at the outset and the budget planned accordingly.

The need for a house style is obvious. Memorability has everything to do with repetition, and little to do with diversity! Each piece of print should have a recognisable relationship to the next. Designers sometimes like to play with graphics, printing sideways, fading out, or half obscuring letters and words. In some contexts this can work – but the acid test is instant legibility.

Photographs should have an accompanying photo credit, either for the photographer or the owner of the copyright. If in doubt over copyright, try not to use the picture in question: it can be expensive if you use a photograph without prior permission. Individual photographers, the Condé Nast organisation, the Disney Corporation and others can be very tough on individuals who reproduce without permission or without photo credits.

Many months ahead of the Victoria and Albert Museum's exhibition on 'The Garden', a box frame was designed, as though made of clipped hedging, which was used for all pieces of print thereafter, including the poster and advertising spaces. A universal design which is simple and flexible can be introduced into all sorts of materials, from labels in the exhibition to bags in the shop, to napkins and menus in the restaurant. Such an approach strengthens the branding or recognition of the product.

Designers should be carefully briefed. Whether working in-house or with an agency it is essential to prepare a brief, with details of the target audience, budget, every instance in which the logo or style will need to work and the various print requirements. The designer will need to know the range of proportions and scales required. It can get expensive if you need to go back to an outside designer at a later stage with new applications for the artwork. Here is a checklist of possibilities:

- advertisements (all possible shapes and dimensions)
- bags and shop items
- compliment slips
- exhibition labels and panels
- flyers
- invitation cards
- letterheadings
- posters
- postmarks
- press kits
- public information leaflets
- tickets.

Print pitfalls

The pitfalls of print production are many and varied. Here is some advice, born of painful experience, to help you avoid errors:

- Make a schedule of delivery times, printing deadlines, design and artwork dates. Get everyone to agree these and then work to it.
- Confirm budgets and check as you go along that additional expenditure is not being incurred.
- Ask those who have to approve designs or artwork (including your sponsors) to sign off (approve with signature) by a particular date.
- Make copies of everything before it leaves your hands.
- Create quiet time to proofread with a colleague who is unfamiliar with the text.
- Check everything at every stage. Ask questions. Check again.
- Leave time in the schedule to correct mistakes.
- Work with intelligent designers.
- Work with good printers (not necessarily the cheapest).
- Have a simple contract with the printer (a detailed order will do) and make them correct mistakes which are their fault.

Some common terms used in print production

Art paper: A smooth paper that is good for reproducing photographs. Coated papers can give even better results. The weight or thickness of a paper is measured in grammes per square metre (gsm). Never use a weight of paper less than 135 gsm unless the designer assures you that it will work. Some forms of poster, intended for hoardings or billboards, have to be of particular thinness in order to be pasted on. This will be specified at the time of booking a space. Textured papers can add to the style of a finished product but can make printing

results a little unpredictable. If using recycled paper, print a recycled paper mark on the finished piece.

Artwork: Artwork is increasingly being produced on disk, with rough guidelines for the printer to position the text and illustrations. This generally avoids the problems of old-fashioned artwork, which sometimes had different colour separations, was mounted on board and, with full instructions, was handed to the printer for reproduction. It had to be carefully handled and stored between use. Computer disks avoid these problems but create their own difficulties in terms of occasional incompatibility between designers and printers; there is no guarantee that mistakes do not creep in and everything should be checked at proof.

Bled off: When a picture or image goes right to the edge of the paper – and is in fact slightly trimmed – this is described as being bled off.

Character: A single letter from the alphabet.

Dummy: A mock-up of a proposed piece of printed material – especially useful where folds or pagination are involved. Sometimes **printer's latin** is used to simulate text and display the typeface. It is simply a jumble of meaningless letters.

Font: Refers to the style of typeface (derived from old printing techniques).

Gutter: The inner margin in a bound book or booklet. (Text has a habit of disappearing into the gutter.)

Halftone: Shades that are not a solid colour, usually reproduced in a series of small dots (look closely at your newspaper). The density of a halftone is expressed as a percentage. Therefore, if describing a print in black and white, an 80% halftone is nearly solid black, while a 20% halftone is much closer to white.

Offset-litho: The commonest form of printing for posters and leaflets.

Pantones: An internationally used system for identifying every colour and shade imaginable. Each colour is identified by a number, guaranteeing the same colour in Japan, Sydney, New York or London. Designers and printers have Pantone colour swatches, which allow you to choose from a rainbow of samples. 'Standard' colours are the cheapest, but may not offer the subtlety that museums need. Pantone colours can be matched to cymk (see Process printing) if necessary.

Paper sizes: International paper sizes (not used in the USA) are 'A' sizes. A1 measures 841 mm deep by 594 mm across. Cut this in half and you have A2; in half again and you have A3; in half again and you have the most common size, A4 or letter size (slightly larger than US

'letter' size). DL is a standard sized leaflet – A4 folded in three. Publishing houses and advertising agencies will use different size systems; you will hear of demi-octavo, jumbo, crown and elephant. Always ask for dimensions or examples.

Perfect-binding: A flat spine, allowing the title to be printed on the bound edge.

PMT (Permanent Mechanical Transfer): This is a crisp, highly defined, densely printed original print, often used for logos, from which other versions can be printed. A clear photocopy is not a substitute. They are increasingly being replaced by disks. Press and marketing offices should hold stocks of PMTs of logos or emblems that they commonly use on print and disk, both for their own use and to give to other organisations that are required to reproduce the logo.

Process printing: This method is used for higher quality full-colour printing. Computerised scanning equipment separates the different colours needed to print the full picture. The colour separations are then printed separately. The smallest number of printings you can have to achieve full colour is four: cyan (blue), magenta (red), yellow and black (known as cmyk). Really high-quality results, needed for true reproductions of art, require many printings of different colours and the process becomes very costly.

Proofing: For black and white work, such as newsletters, faxed or e-mailed proofs will usually be adequate. Colour work with text is also proofed in black and white first for copy-check. For colour works there are three stages of proofing: digital cromalin, cromalin produced from film, and wet proofs which require film and plate. For speed and cost use cromalin, but costs are coming down for wet proofs, which are done on paper and are therefore closer to the final product. Colour proofs have to be returned so that the colours can be matched as printing starts. Try not to make changes to the text on colour proofs – it can become very expensive. All corrections should have been done at black and white proof stage.

Reverse out: Instead of printing words or images in solid colour, the space around them is printed, leaving the paper to show through (not recommended for easy reading).

Saddle-stitch: A binding using staples or stitching in two or three places.

Distribution

The printed material is only as good as its distribution. There is a great tendency to ignore this – along with the increasingly high costs of

effective distribution. Each market segment identified in the plan will need some method of distribution for printed materials. Distribution agencies will deliver leaflets to tourist information centres, arts centres and a variety of other outlets including hotels and offices. Compare costs and reach with your market segments and budget.

Certainly, the method of distribution should have been considered at the time the printed material was being designed. No piece of printed material should be included within the plan unless there is a well-considered method of distribution identified for it.

Promotional material

There are all sorts of small, inexpensive items that might be used as part of a promotional campaign. Usually these are 'giveaways', which are overprinted with your information to increase awareness and word of mouth on your museum, exhibition or event. Items that you might consider include:

- bookmarks
- decals for cars
- key-rings
- matchbooks
- mousemats
- napkins
- overprinted balloons
- paper place mats for children's meals in restaurants
- pens or pencils
- pins or badges
- postcards
- stickers
- tent-cards (to stand on restaurant tables).

The Santa Barbara Museum of Art promoted its Chinese exhibition through a special restaurant promotion in the town and in surrounding areas. They distributed Chinese fortune cookies for participating restaurants to give to diners. Each fortune cookie contained a motto based on the exhibition; some contained a free pass to the exhibition.

Signage: access and visibility

Signage is a most important factor in successful marketing. A museum that is clearly identified will more successfully attract passing trade.

Visitors who have come in search of the museum also need confirmation that they are in the right place and should be able to find the entrance easily. Ideally, motorway or freeway signs should clearly indicate which exit to use for your museum. Prominent signs in bus and train stations should announce that you are now in the home of the 'X' museum. Street signs should direct road and foot traffic towards the museum.

City authorities can sometimes be resistant to increasing signage. Museums in some towns often remain virtually unknown, simply because the council will not allow adequate signage. The answer is to take a long-term view: lobby, complain and keep representing your cause. Ask the local tourist board or convention and visitors bureau to help you. Enlist the support of the Chamber of Commerce and individual town councillors. Make yourself known year after year until you get what you want. Meanwhile, it is possible that temporary signs – such as banners outside the building – are allowed. Make full use of this possibility by ensuring a changing succession of very prominent banners.

A small museum in rural England was not allowed to put up even temporary signage for special events. All they were allowed was a discreet sign at the gate giving the name of the institution. But they discovered that they could get away with tying a big bunch of balloons to their sign on days when they were having special events. Passing traffic became curious to know what was going on, and they drew in more visitors. It also looked very celebratory and welcoming. Bunting, small flags or streamers can act in much the same way.

Internal communications

With every major project there will be a need to communicate plans to colleagues. Maybe there is already some mechanism in place to let staff know what is happening, or perhaps meetings will need to be held with groups of staff. Certainly, good word of mouth and a sense of anticipation start with staff, their friends and families.

Budgeting

Finally, each activity needs to be costed, together with all expenses necessary to accomplish it. At this stage, a limited budget may mean that some ideas cannot be implemented – but at least they have been

identified. If extra funds become available, the planning work has been done, and it can be clearly seen how the additional activity contributes to the whole marketing effort. Deciding what to keep and what to omit can be a challenge, but you should be guided by the cost per head to deliver. For example, when trying to decide whether to spend money on transport or radio advertising, consider first whether one method is better than another at delivering the market segments you are targeting. If this does not decide the matter, look at how many exposures each advertisement will have. If one method reaches many more people time after time, for the same or less money, then the choice is made accordingly.

Consolidate, communicate and evaluate

When all is written down, costed and approved, it's time to let a wider circle of colleagues know in broad terms what you intend to do. They will be able to do their jobs better if they have a general idea of what actions are being planned and what the objectives are. In particular, front-of-house staff need to know what's going on, so that they can be prepared and can answer questions from the public more intelligently.

At each stage the plan should be evaluated, and changing circumstances fed back into the implementation. Rapid action may need to be taken if visitor numbers are disappointing; this could include street leaflet distribution, fax outs and telephone marketing (see also Chapter 7).

CASE STUDY 4 'Eternal China' exhibition in California

The Santa Barbara Museum of Art decided to hold its most ambitious exhibition, 'Eternal China: splendors of the first dynasties', in the summer of 1998. The museum usually attracted about 120,000 visitors per year. For this exhibition the stated target was to achieve 95,000 visitors in the 14-week period. The town is a popular, up-market tourist destination, known for its lovely climate, beaches, shopping and old-town charm. The museum is situated on the main shopping street, but three blocks north of the path most visitors take. This exhibition signalled a new future for the recently extended museum – both in terms of the ambitious scale of the exhibition, with its accompanying financial outlay, and in terms of connecting with the tourism business of the town. The aim was to work productively with the local convention and visitors bureau, the Chamber of Commerce, hotels, concierges and visitor information office representatives.

By the end of the 14-week period 130,000 people had attended the exhibition and about $1 million had been taken in the shop alone. The exhibition was regarded as a great success and heralded a more ambitious future programme of exhibitions. The museum commissioned an economic impact survey (see Case Study 10) which further demonstrated the contribution the museum could make to the local economy.

Nature of the exhibition

Boilerplate descriptions were prepared for use on printed materials. Three different lengths were used to suit different circumstances, and the curatorial staff were asked to approve the brief, short and long descriptions so that the press office had pre-approved copy to work with. A credit line was prepared and approved, ready for use in all circumstances; and a brief description of opening times and charges was devised for consistent use on all printed material.

Brief: An exhibition of ancient Chinese terracotta warriors and other sculptures from the re-discovered tombs of Xian, most of which have not been seen in the USA before.

Short: An exhibition of ancient objects uncovered from the imperial tombs of Xian in China, where they had lain buried for 2000 years. Most of this material has never been seen in the USA prior to this exhibition in Dayton, Ohio and Santa Barbara – the only West Coast showing. The sculptures include life-size terracotta warriors made to provide the First Emperor with an army of soldiers in death as in life.

There will be large horses and horsemen, two full-size reproductions of horse-drawn chariots and a host of other treasures in gold, silver, bronze and jade. Visitors will be invited to discover how to conduct an archaeological excavation using an interactive display, and children will be able to participate in a simulated 'dig' in a new children's exploration room. The objects on display represent some of the most significant achievements of China's 5000-year-old civilisation, and interest in the exhibition — the most ambitious ever staged by the museum — is expected to be high. Pre-timed tickets will be available through Ticketmaster and direct from the museum, with a 'fast-track' for members.

Long: An exhibition of ancient objects uncovered from the Imperial tombs of Xian in China. A worldwide sensation was caused when in 1974 archaeologists began unearthing a terracotta army of 8000 life-size warriors buried in a series of underground halls. They were part of the burial rites of the great Qin and Han emperors who ruled China from 221 BC to AD 220. These objects represent the most significant cultural achievements of China's 5000-year-old civilisation. The items selected for the US exhibition will show the artistic dynamism of Chinese sculptors in an age when Caesar and Cleopatra ruled the countries around the Mediterranean and 1000 years before Marco Polo travelled the route from West to East.

There will be 11 life-size terracotta warriors, including standing and kneeling archers, a general, officers, charioteers, a cavalryman and cavalry horses, none of which have been exhibited in the USA before. Many other objects will be on show, including terracotta animals and other treasures in gold, silver, bronze and jade. There will also be full-size reproductions of chariots and horses, the originals being too fragile to travel from China. The exhibition will show visitors some of the wonders of these mysterious tombs and will invite them to join in an interactive display to discover how such an excavation is carried out. Children will be able to explore the subject, touch real objects and participate in a simulated 'dig' in a new children's discovery room.

The exhibition, which is also going to Dayton, Ohio, will have its only West Coast showing at the newly re-modelled and expanded Santa Barbara Museum of Art. It is the most ambitious exhibition ever staged by the museum, and, to cope with anticipated public interest, timed tickets will be on sale in advance from Ticketmaster and the museum. Members of the museum will enjoy special concessions and 'fast-track' admission.

Credit line: The exhibition has been made possible by Leslie and Paul Ridley-Tree, with additional support from Northern Trust Bank of California. Promotional support has been received from KEYT [a local TV station].

Dates, hours and charges:

Open dates: 21 July–18 October 1998

Open hours: Tuesdays–Sundays 10.00–18.00

Friday 10.00–21.00

Monday 10.00–18.00 (premier viewing only)

Admission: Adults $10

Seniors $8

Students and children (6–17) $6

Groups $8 per person, 20 person minimum

Premier viewing, Mondays only, $15

Audio-tour free with admission. Tickets available in advance from Ticketmaster and directly from museum. Memberships start at $45 and include complimentary tickets to the exhibition. The museum store will open an additional shop at the end of the exhibition and will carry a wide selection of Eternal China gifts. The exhibition will be accessible to wheelchairs, with wheelchairs available on site.

Café: 10.00–16.00 (Fridays until 20.00).

This information was the result of much strategising on the following issues:

- whether the museum should open late one evening (never previously attempted)
- what price to charge (exhibitions previously included in general admission price for museum)
- how to offer a good deal to tour groups
- how to create a quieter viewing time for those prepared to pay a premium (on Mondays)
- how to increase membership
- whether to charge extra for the audio-guide
- how to favour young people
- whether advance ticket sales was a good way to go.

Situational analysis

Existing market

The museum had a core of loyal support from members, but the

existing market was insufficient to achieve the numbers targeted for the exhibition (95,000).

Potential market

It was calculated that there was a large enough market to meet the target almost on the doorstep of the museum – visitors to Santa Barbara, most of whom walk up State Street to within two blocks of the museum. We suspected awareness of the museum was low and carried out a simple street survey to test awareness (and to investigate the effectiveness of street banners). The low awareness level was proved and was addressed by a number of methods – the most important aimed at establishing better street presence for the museum. Simultaneously, the museum membership was given advance warning and advance booking capability. Numerically speaking, the market was assessed as being primarily Santa Barbara visitors and secondarily local residents.

The street survey also revealed that the usual street banners – which in conservation-conscious Santa Barbara are not allowed to carry wording – had very little meaning to visitors. This resulted in successful lobbying of the town authorities to allow a limited amount of lettering for the Eternal China street banners.

Perceptions

The **positive** associations at work for the exhibition were:

- ancient China
- tombs (mystery, secrets, spookiness)
- importance of the exhibition/significance of the objects
- most of the material never previously seen in the USA
- fun for children in discovery room
- attractive/engaging opportunity for learning
- anticipated interest in China sparked by Disney's forthcoming film *Mulan*.

But there were also **negative** associations:

- display of Chinese sculptures sounds inaccessible to the uninitiated
- memory of previous exhibitions on similar theme – may sound 'old hat'.

It was the task of the marketing campaign to accentuate the positive and correct the negative associations.

Tourism

The key to success (numerically) was locking into the tourism activity of Santa Barbara. There were meetings with the local convention and visitors bureau in order to identify key contacts and opportunities and enlist support and enthusiasm.

Transport/access

Most visitors to Santa Barbara arrive by car, which made parking and freeway/street signage an important part of the marketing strategy. Group tours arriving by bus are a significant part of the traffic during the summer season, and these were addressed at source through bus and tour companies. Air and rail travel are small but growing sectors. In-flight magazines, airport displays and leaflets at train stations were all part of the campaign.

The museum is easily reached by pedestrians and by local transport. Advertisements on street shuttles and trolley buses were a key feature of the strategy, in view of their ability to reach people at the more crowded, lower end of the main street.

Other venues

Visitors to Santa Barbara go to the shops, hotels, restaurants, mission, zoo and marina as well as to outlying destinations, including Hearst Castle, villages on the tourist route, the wineries and the Madonna Inn. Rack cards and posters were distributed to all of these places.

Customer welcome

The customer welcome at the museum had proved to be good under circumstances of low pressure, but it was anticipated that there needed to be good preparation for customer care under duress. As the pre-booked ticketing arrangements and queue control were reckoned to be the likely trouble zones, plans were made to avoid and deal with problems which might arise.

Site flow

Arrival, purchase of tickets, queuing, treatment of the members, and access to lavatories, shop, restaurant and the remainder of the museum were all considered to be important. Detailed plans were made and the staff were briefed.

Signage

There is very little street or freeway signage in Santa Barbara. This was considered to be one of the most serious factors affecting attendances at the museum. The town is a conservation area and reluctant

to introduce public signage. Some signage was promised but not delivered, and this made the prominence of the street banners and posters even more important. The design was 'pumped up' to achieve maximum impact.

Human resources

On the museum staff there was an experienced press officer with established lists and a talented marketing officer with a heavy workload. Consultants were retained to work closely with both, to maximise all resources and avoid duplication of effort. Extra volunteers were recruited to help handle the hoped-for crowds.

Financial resources

A promotional budget of $150,000 was allocated. In the event, much more was spent, the extra resources being used for advertising.

The visitor mix

With a county population of just over 350,000 (90,000 in town), the tourism component of the visitor mix would prove crucial. We anticipated that one-quarter of the attendees would come from Santa Barbara and the immediate vicinity; one-quarter would come from within day-trip distance; and a half would be overnight visitors to town (whether holidaymakers, business travellers or visiting friends and relatives). If the museum succeeded in bringing its message to a

Chinese warriors meet local worthies at the Eternal China exhibition. Courtesy of Hal Boucher, Santa Barbara, California.

SWOT analysis for exhibition

Strengths

Exotic subject: good story, slightly ghoulish

High Street location

Tourists on doorstep
Engaging material for children

Lots of press angles

Santa Barbara convention and visitors bureau will help/advise
Slight familiarity of material

Opportunities

Draw in tourists
signage
Strengthen ties with tourism organisations
Increase general awareness of museum
numbers
Make cultural/economic contribution to
Santa Barbara
Engage future interest of children
Increase membership

Raise revenue through shop
Alternative (business) parking at weekends?

Weaknesses

Slight familiarity (there have been other similar exhibitions)
Lack of signage to museum
Competitive attractions abound – beach and shopping
Lack of awareness of museum

Threats

Failure through lack of

Potential problems with ticketing system
Staff/systems over-whelmed by large

Quality of service suffers = bad word of mouth

million Santa Barbara visitors during the run of the exhibition, we reckoned we would need to achieve a conversion rate of about 8% to meet the target. This was a challenge because of competing attractions in the area and meant that the visibility and accessibility of the museum was crucial.

The marketing brief

- achieve attendance of 95,000
- enable increase in membership of Santa Barbara Museum of Art (SBMA)
- enhance image of SBMA within community
- demonstrate ability of SBMA to hold major exhibitions to potential donors/sponsors
- improve position of SBMA as a tourist destination within Santa Barbara
- contribute towards financial success
- achieve press coverage commensurate with importance of exhibition.

Target markets

Visitors to Santa Barbara were considered to be the most significant portion of the target market numerically. Residents of the area were considered the most significant for the membership drive. This required a two-pronged approach. The target markets fitted into five clusters:

- **Visitors to Santa Barbara** – day trippers, vacationers (overnighters), business visitors;
- **Locals** – residents of Santa Barbara County, residents of outlying areas, members and regular visitors, opinion formers, VIPs and potential donors;
- **Youth** – children and their parents, children in school groups;
- **Special interest groups** – members of arts/historical societies and clubs, members of other museums;
- **Asian communities in California**.

Reaching target markets

Street presence was the biggest factor in converting those who had heard of the exhibition into real-life visitors. No matter how good the information campaign, it was considered essential to make it easy to find the exhibition and drift in. This was a common factor for all sectors of the target market.

DAY TRIPPERS TO SANTA BARBARA

- street signage
- shuttle/trolleybus advertising
- models or maquettes out front
- general media editorials and broadcasts
- newspaper advertising

- rack cards in local convention and visitors bureaux and tourist information offices
- matchbooks or tent-cards in restaurants
- small posters in shops and local public libraries
- giant models on State Street
- rack cards or posters in parking lots and lifts.

Coach tour operators were informed/persuaded about the exhibition while planning their summer schedules.

VACATIONERS IN SANTA BARBARA
- all of the above, plus wider coverage in national newspapers and magazines
- travel press
- Amtrak (rail) tie-in
- airline magazines
- display at airport
- hotel rack card dispensers
- material in hotel bedrooms
- concierges' suggestions
- matchbooks or rack cards in trailer parks and campsites
- rack cards at other holiday destinations in area.

BUSINESS VISITORS TO SANTA BARBARA
- all of the above
- business press
- small posters in local businesses.

RESIDENTS OF SANTA BARBARA AND VICINITY, VISITING FRIENDS AND RELATIVES
- all of the above
- local press
- school trips
- cinema advertisements.

RESIDENTS OF OUTLYING AREAS
- all of the above
- widespread local newspaper coverage.

MEMBERS
- mailing to members
- special viewings
- free/discounted tickets.

OPINION FORMERS, VIPS, POTENTIAL DONORS
- mailed invitations
- special tours and presentation packs
- re-visit standing lists (each senior member of staff to add new, special contacts)
- special preview for Chamber of Commerce.

CHILDREN AND THEIR PARENTS
- all of the above
- competitions for children in local newspaper
- 'bring your parents/family' discount cards handed to school groups
- children's paper place mats for restaurants.

CHILDREN IN SCHOOL GROUPS
- marketing effort to link with Education Department.

Corporate identity

An image of a kneeling archer figure emerged as the key logo. It worked well in confined spaces because it was compact . The friendly face of a warrior was also used.

Signage

The museum kept pressing the importance of this issue. We made plans on the assumption that formal street signs were going to be inadequate and, in effect, the local council did not supply street or freeway signs in time for the exhibition.

Printed materials
- press folders
- stationery (fact sheets, various releases, information sheets)
- rack cards
- rack card holders
- small posters
- photographs (slides and sleeves, transparencies, xeroxed sheets of photo selection)
- tickets
- promotional items
- banner for outside museum.

Distribution

The convention and visitors bureau provided its membership list and a great deal of other useful information. A list of local tour guides, bus operators, Chinese restaurants and car rental agencies was also

obtained, and a major museum in nearby Los Angeles supplied a list of group tours.

Tourism projects
- planned and implemented advance press trips for before opening
- detailed attention to distribution of rack cards
- distribution of tourism briefing packs
- tourism partners found for special offers
- restaurants informed and brought in as partners – special menus offered
- late season hotel breaks, rack card displays and concierge discounts introduced
- advertising purchased on local trolley buses
- special concierge briefings arranged
- special viewings for tourism operatives in Santa Barbara
- promotional deal struck with local airport
- mailing to coach operators about forthcoming exhibition – special discounts, early information
- other museums allowed promotions to their memberships, or included material in their mailings.

Pricing
Entrance to the museum was $4. Advance purchase tickets went on sale through Ticketmaster outlets and through the museum. Anyone buying an exhibition ticket got free entry to the rest of the museum. Purchase of tickets included an audio-tour, which softened the blow of an unusually high charge for this exhibition and created the perception of added value. A separate children's tour, or quiz sheet, was considered but rejected on logistical grounds – timing and crowding . But a children's activity gallery was attached to the exhibition, with free access. Members were allowed instant access (i.e. no waiting in line) and two free tickets.

Yield
The yield was calculated in advance on 90,000 attendances as outlined in Table 1, shown with a simplified pricing structure.

Table 1 Anticipated yield through pricing structure

Category	%	Equals	Price	Yield	Price	Yield
Adults	48	43,200	$10	$432,000	$10	$432,000
Seniors	10	9,000	$9	$81,000	$8	$72,000
Youth	10	9,000	$5	$45,000	$8	$72,000
Under 6	5	4,500	Free	–	Free	–
Family	5	4,500	$6 approx[a]	$27,000	$7 approx[b]	$31,500
Group	10	9,000	$8	$72,000	$8	$72,000
School tour	10	9,000	$3	$27,000	Free	–
Special[c]	2	1,800	$8	$14,400	$8	$14,400
TOTAL	100	90,000	–	$698,400	–	$693,900

[a]Family rate of $25, for two adults plus up to four children.

[b]Proposed new family rate of $30 for one or two adults with two to four children.

[c]A non-advertised category for card-holding museum professionals, academics and researchers.

In the event, the pricing structure was simplified as much as possible, the target attendance was overtaken, and the yield was greater than the projected calculation.

Membership drive

A membership audit was undertaken. It was proposed that the bulk of the membership be offered two free tickets to the exhibition in addition to a preview reception, plus the ability to skip the queue. Extra free tickets were reserved for the highest echelons. Concessionary tickets were fixed at $8, on a par with other concessionary rates. As a special offer to assist the membership drive, extra free tickets to the exhibition were offered to any member introducing a new member.

Advertising campaign

The following were the components of the advertising campaign:

- shuttle and trolley buses
- local newspapers
- selected out-of-town newspapers
- magazines which get picked up by visitors
- cinema advertisements
- public service announcements on local radio
- a very small amount of TV advertising on the local station (matched by the station, which gave tremendous coverage).

Media campaign

The goals of the media campaign were to:

- increase attendance
- showcase the museum.

The primary targets were visitors to Santa Barbara, Santa Barbara residents and residents within a two-hour drive. Secondary targets were far-flung West Coast residents who might be considering a trip. Actions taken included:

- media list reviewed and updated
- angles for different stories for different publications developed
- press kits assembled and distributed
- special long-term press kit issued early
- local press release issued
- special concentration on art and history magazines
- special concentration on travel/tourism press
- special concentration on local press within Santa Barbara day-trip catchment
- secondary concentration on San Diego and San Francisco markets and others
- secondary concentration on Asian community groups in California
- special concentration on airline magazines
- secondary concentration on national and international press
- local TV and radio tie-in negotiated
- special mailing to concierge and hotelier newsletters
- electronic media alerted
- special concentration on children's media
- feature stories about individuals working on the exhibition
- food and shopping angles invented
- schedule of photo opportunities prepared
- created photo opportunities with scale reproductions of warriors (later sold in shop)
- created photo opportunities with local school
- created photo opportunities with visiting celebrities
- special efforts with *Los Angeles Times* (high readership)
- publicised last day in advance – stayed open until last visitor came (at midnight)
- ensured museum web page was updated with Xian information.

Monitoring/evaluation

Use of the Ticketmaster advance purchase system allowed complete

analysis of results and of zip codes of customers. This revealed that projections as to where people would come from was broadly correct, although the Los Angeles market proved vital. An economic impact study proved the value of the exhibition to the local economy.

Other promotions
- tried to persuade Walt Disney Corporation to hold special *Mulan* screening
- joined with other regional attractions on joint promotions
- worked on restaurant promotion.

In the event Disney would not co-operate, but other attractions carried posters and rack cards. There was a special restaurant promotion: Chinese restaurants in a wide area were sent promotional leaflets and posters. Restaurants in Santa Barbara (not just Chinese) offered a special menu, and the museum supplied fortune cookies with special messages about the exhibition – and an occasional free pass – inside.

Emergency plans
If projected targets for the first few weeks were not met, plans were in place for extra advertising. In fact, targets were met, but fears that the audience would drop off prompted some additional advertising expenditure.

CASE STUDY 5 Fishbourne Roman Palace and Gardens, Sussex

This marketing plan for Fishbourne Roman Palace and Gardens (near Chichester, Sussex) is part of a marketing strategy prepared in conjunction with Lords Cultural Resources for a planned Heritage Lottery Fund bid and should be read in the context of an attraction going through a major redevelopment. It is presented here courtesy of Lords Cultural Resources, Fishbourne Roman Palace and Gardens and Chichester Council.

Marketing plan

The marketing plan has been divided into four phases: phase 1 marks the stage at which the outline Heritage Lottery Fund application has been cleared and the full application submitted; phase 2 covers the refurbishment phase; phase 3 covers the re-launch; phase 4 is the ongoing marketing plan.

Phase 1

To be implemented by Fishbourne Roman Palace and Gardens and the Sussex Archaeological Society.

Objectives	Activities
• Maintain visitor interest and visitor numbers.	• Maintain promotional activities.
• Support fund-raising strategy.	• Use public relations to highlight events at Fishbourne Roman Palace and Gardens.
	• Encourage Friends to expand their numbers for extra support in fund-raising drive.
	• Create a database from existing visitors by *actively encouraging* visitors to leave their name and address for regular information.

- Launch of fund-raising appeal – opportunity for media coverage.
- Maintain interest by supporting sponsorship events and activities (and support offered) through public relations activities.
- Start regular news bulletins (quarterly) on progress for regular visitors; distribute through all museums, libraries and to growing mailing list including local residents.
- Plan for temporary exhibitions at other venues.
- Plan celebratory event once Heritage Lottery Fund grant is announced.

Mosaics at Fishbourne Roman Palace, Sussex. Courtesy of Fishbourne Roman Palace.

Phase 2: refurbishment stage

To be implemented by Fishbourne Roman Palace and Gardens, the Sussex Archaeological Society and public relations agency; budget £5000+ for initial public relations programme.

Objectives	Activities
• Maintain interest in Fishbourne Roman Palace and Gardens. • Continue support for additional fund-raising. • Plan for re-launch.	• Produce relevant temporary publicity material and news releases. • Use public relations to highlight and find other interesting aspects of repair and conservation work; aim to have one story every two months in local newspapers. • Continue news bulletins (quarterly) reporting on progress, etc. Distribute through other sites and library as well as mailing list. • Take every opportunity to give talks to local groups about Fishbourne Roman Palace and Gardens; maintain regular communications with local residents. • Maintain programme of temporary exhibitions in various venues highlighting Fishbourne Roman Palace and Gardens. • Report regularly on fund-raising successes. • Plan the new educational programme and marketing. • Plan the first stage of the marketing programme.

- Plan the promotional programme to individual visitors and residents, including revamped corporate identity and print style.
- Decide on opening hours, pricing and other facilities and services.
- Plan improved signposting.
- Plan the promotion of the new café to a wider audience.
- Train staff in preparation for re-launch to play a more active role in interpreting the building and the displays.

Phase 3: re-launch 2001–2

To be implemented by Fishbourne Roman Palace and Gardens, the Sussex Archaeological Society and public relations agency; budget £10,000 (part of £15,000 re-launch budget).

Objectives	Activities
• Use the re-launch to focus on Fishbourne Roman Palace and Gardens and create a real buzz so that everyone in Chichester and local area knows about it.	• Plan and implement special opening event(s). • Use flyers and posters around the town. • Implement local radio advertising campaign. • Use mailing list and invite all those who have followed progress, including local residents.

- Fly banners and pennants for the special opening.
- Create news and photo opportunities.
- Consider any angle which would put Fishbourne Roman Palace and Gardens into the national spotlight.

Phase 4: ongoing marketing plan from 2002

To be implemented by Fishbourne Roman Palace and Gardens, the Sussex Archaeological Society and Chichester Council; budget £25,000.

Objectives	Activities
• to increase audiences as per marketing strategy.	
Local residents The marketing campaign aimed at local residents will need to be planned in detail to take account of developments that take place between now and the year 2002. Chichester Council's own leisure marketing strategy at the time will be crucial in providing a framework for the marketing plan.	• Leaflet (new style) and distribution. • Direct mail through the new database and through Chichester Council. • Media – news stories at regular intervals for local media. • Advertising – for special events. • Local television/internet and other forms of communication may then be in place to target residents more directly.
Day and staying visitors	• Partnership leaflet (new style) and distribution. • Public relations programme directed at tourist magazines and national and

	regional travel writers in UK and overseas.
	• Familiarisation visits for tourist information centre staff.
	• Liaison with and promotion to the travel trade.
	• Advertising for special events.
	• Promotional activities with tourist boards.
Group and travel trade	• Implement an intensive programme to group and travel trade.
	• Familiarisation visits for trade, NADFAS (National Association of Decorative & Fine Arts Societies) and special interest tour organisers.
	• Produce a group/travel trade manual featuring group products.
	• Use the internet to market and receive bookings for these products.
	• Take part in group trade fairs: Excursions, British Travel Trade Fair (individually or jointly as budget allows).
	• Do mailings and editorial with *Group Leisure* and *Group Travel Organiser* magazines.
	• Maintain this programme through a dedicated officer

who builds relationships, creates a database and keeps in regular touch with the market.

- Liaise with the Southern Tourist Board and other tourist boards, councils, etc., to create joint visits and co-operative marketing opportunities.
- Target local and regional English language schools.

Schools and educational groups

- Identify the topics which will bring additional schools in on organised workshops.
- Consider how many more workshops can be added into the current structure.
- Seek funding for education packs which would meet unaccompanied groups' needs.
- Look at ways of using the gardens for formal workshops.
- Identify topics which will appeal to those outside formal learning.
- Create programmes in conjunction with adult learning institutions and for self-learning.
- Market the new products to schools in the region and through public relations to the adult market in the area.

CASE STUDY 6 Advice from an advertising professional

Arthur Cohen, Principal of LaPlaca Cohen, the New York-based advertising agency which specialises in working with museums all over the USA, offers the following advice:

We need to remember that advertising is the primary conveyor of institutional identity beyond the walls of the museum, and that it offers a chance not only to communicate, but to connect and learn. Advertising is an opportunity for internal consensus building; it puts the mission into action, and provides its greatest value as an informed outsider.

There are some key questions that the museum needs to address when preparing to brief an advertising agency – setting the ground rules:

- What is the agency being hired to do?
- What are the goals for the relationship?
- How do these goals relate to the museum?
- How do these goals relate to the museum's marketing and institutional objectives?

When briefing the agency you need to provide the following information – or, in some instances, arrive at the information by discussion with the agency:

- Define the assignment.
- Content: What is the project about? (background/history)
- Context: What is its stature relative to other projects?
- Concerns: What are the sensitivities and preferences?

You will need to define the objectives:

- attendance (numbers/composition)
- public awareness
- publicity goals
- define the deliverables
- define the measurements of success

During the process of preparing the advertising campaign you will need to define the roles: identifying who the key players are in the museum and the agency; setting parameters, procedures and means of

access; and setting guidelines for feedback, review and the approval processes. These are essential steps to save time, confusion, delay and money as the work progresses.

Some museums have concerns about how to evaluate the creative work presented by the agency. Can the agency work with a small group of informed individuals, or will they be answerable to a huge committee?

- Who gets a say?
- What are the evaluation criteria?
- How does the advertising relate to other museum communications?
- How can the feedback be offered most constructively (avoiding a dead end)?
- How will consensus be established and decisions finalised?

Establishing the production schedule is an important task for early in the process.

- Estimate a timetable for development, approval and production.
- Establish production deadlines by working backwards from target media delivery dates.
- Define the appropriate preparation time for the agency.
- Assign internal review and approval dates.
- … and stick to them.

You will need to identify the audience.

Define the core audience:

- members
- frequent or regular vistors
- local 'stakeholders'

Define other target audiences:

- age
- ethnicity
- family status
- geography
- others (scholars, students, etc.)

Working with the agency, you will begin to distil the message by looking at shared audience insights and by utilising focus group and research findings. Together, you will be searching for key selling propositions. Your task will be to persuade the non-insider (in five words or less) of your

key message. Defining the word-of-mouth in 'sound bites' will help you to do this. You will need to balance the different agendas at play, incorporating the curatorial perspective, but using externally-defined 'hooks' and 'hot buttons' to motivate your audience.

Allocating the budget can be done in a number of different ways:

- as a percentage of total annual income or seasonal spending
- by region/geography
- by media
- by audience
- in relation to 'comparables' (other museums' spending, or your own previous spending).

Evaluating the results can be done on a number of fronts:

- establish a baseline
- adhere to objectives and strategies (don't change part-way through!)
- recognise indicators of success
- interpret the measurements
- qualitative (intercepts, focus groups, etc.)
- quantitative (door counts, revenue, etc.).

Always take what you have learned and apply it to the future.

Reasons to continue advertising:

- To build a relationship with an audience.
- To maintain visibility and public awareness.
- Staying on the radar screen.
- More efficient to maintain than to launch and re-launch.
- To evolve an institutional message over time.
- Building the brand.

Chapter 6 TOURISM MARKETING

Tourism is a growth industry, and museums are in the business of tourism. Cultural tourism has proved itself to be an economic generator. Museums contribute to this generation of wealth. Spending in the vicinity of museums and other cultural venues on petrol, food and related services can be as high as £40 per head per day visitor. Such a dynamic combination means that museums should be in the thick of local planning and tourism policy issues. As investment in tourism is taken more and more seriously, tourism marketing becomes increasingly important.

Your marketing plan will have identified the extent to which your museum, gallery, heritage attraction, special exhibition or event may have a tourism appeal; here is what you can do to tap into the growing number of overseas and domestic tourists on long and short breaks.

Contact with tourist boards and convention and visitors bureaux

It is important to see tourism as a long-term market development and to start by making contact with the local tourist board or convention and visitors bureau – or renew contacts where they have lapsed. (It is a good idea to join as a member if you can afford it.) Your first contact should be the local or regional tourist board; for a major event likely to attract international audiences, you can make direct contact with the British Tourist Authority or your national tourist board.

Initially, look for some marketing input and advice and establish which trade fairs and promotions the regional tourist board is actively involved in and from which you may benefit. Make sure they know of your plans and facilities; encourage them to visit by including them in your special events and private views.

You also need to establish good contacts with the tourist information staff and work out the best ways of getting your printed material distributed. Find out about new media and technology developments in the tourist information centres and about promotions highlighting special attractions. Ensure tourist information staff are regularly invited on familiarisation trips to your attraction.

Make sure you have made contact with the press office at the tourist board; keep them informed of your activities and new exhibitions and encourage them to include your museum or attraction in media visits. They may also be asked by the national tourist boards or the British Tourist Authority to organise familiarisation visits in your region for overseas journalists.

Always arrive well prepared for meetings with tourism professionals, and bear in mind that they are usually looking well ahead – usually one or two years (though this does not apply to tourist information staff). Basic information like hours and admission charges, as well as events and exhibitions, should be provided for the year and years ahead. It is well worthwhile considering beforehand what might be offered in the way of a discount for special exhibitions or groups, or what benefits could be offered to enhance a commercial package. Well-organised information and a professional approach to marketing will give tourism organisations the confidence to go out and market your product for you, knowing that you are doing all you can to make it a successful, quality experience.

Tourist boards hold up-to-date lists of group travel companies, cultural tourism companies and other specialists in the travel market. You need these for direct mail activities. They will be able to tell you of meetings at which you might have an opportunity to provide a speaker about your event. They will also be able to give you information about concierge societies and taxicab organisations.

Without a doubt there will be advertising opportunities which arise from contact with the tourist board or convention bureau. Sometimes the expense of appearing in tourism brochures and handouts is beyond the means of the museum, or it may simply be judged the wrong medium for the museum's message. Museums do have to keep on explaining that they are non-profit-making organisations, and they have to try to achieve a public profile without spending the kind of sums which commercial organisations will spend on marketing.

In some areas of the UK the local authorities now have bigger tourism budgets than the regional tourist boards. Make sure your contacts include the local authority tourism officer and follow the plan above. Check out their overall marketing strategy for the area, how you can fit into specific activities and promotions, and keep them informed of your exhibitions and events. The new regional development agencies have strategic responsibility for tourism. It is not yet clear how they propose to develop these, whether through local authorities or tourist boards or directly.

Hotels

Hotels in the area may be interested in working with you on special promotions for big exhibitions or events or through a specialist operator on special interest breaks. These partnerships take time to

develop, so be patient. Sometimes such marketing initiatives can be negotiated directly with the manager on the spot. As some hotel groups centralise all such activities, it means finding the right contact at head office.

Hotel chains also have special publications or in-room TV channels that may be able to cover your museum or event. They have leaflet stands for brochures, usually managed by independent companies. Their restaurants may be able to accept tent-cards to stand on dining tables and promote your venue. Reception staff should be invited to familiarisation visits at the museum. Presence in hotels is a great way to ensure tourism business.

> In early 1999 out of town visitors to Los Angeles were offered a hotel reservation combined with a much-coveted ticket for the popular Van Gogh exhibition at Los Angeles County Museum of Art. The LA Convention and Visitors Bureau, led by their cultural tourism department, started work on the marketing, in close collaboration with the museum, two years ahead of the event. In their presence at trade shows in New York, Washington, New Orleans, Toronto, Sydney and Hong Kong, they were able to promote the event as a star attraction for the following year. What museum could afford such international outreach? The results were spectacular, with half a million advance tickets sold before opening.
>
> A nearby diner offered a Van Gogh 'special' meal to tempt visitors inside. They certainly appreciated the upturn in business!

Concierges

Head porters, concierges, headwaiters and desk staff are important people in hotels. They have direct contact with customers and make recommendations on what to see and do. But be warned: they sometimes expect some inducement. It is, however, useful to include these people in familiarisation visits and previews of exhibitions.

Some museums in tourism destinations have special previews for people in the tourism industry, and the director gives briefings from time to time on what's going on. But remember: these people are in the hospitality business – you need to provide appropriate refreshments and a sense of welcome. Some towns have concierge associations, which makes it easy for you to send out mailings or talk at meetings.

Tour and coach operators

Tour operators and ground handling agents

'Tour operators' covers a multitude of groups and very different requirements. Do try to keep them separate and identified on your mailing lists. Tour operators put together tour packages and market them directly in the UK and overseas; sometimes these are by coach. In this group fall most of the few heritage or cultural tour operators and also some ground handling agents who specialise in these areas. Ground handling agents are the people who look after travellers on package deals purchased overseas. They do have an input in programmes but the overseas operators will have the final say on the content and how it is marketed in their own country.

Both tour operators and ground handling agents really need to know what's going on in your museum very early on as they make their plans and price their services one or two years in advance. They are interested in group discounts, but they also need to know that you are geared up to look after their customers.

Coach operators and group travel organisers

The coach operator and group travel organiser tend to operate on shorter lead times, planning perhaps six months ahead. Coach operators across the UK put together speculative programmes which they sell on locally. They are known to include museums on certain day trips just because they have excellent toilet facilities! (One can only hope that people get a chance to visit the museum as well.) Coach operators are also known for expecting some inducements to bring groups to particular attractions. This should be resisted; liaise with your tourist board regarding persistent approaches or offenders in this area.

Group travel organisers tend to work for specific organisations – women's institutes or large insurance companies, for example, organising staff outings – often as freelancers but sometimes as staff members. They are more receptive to one-off events and shorter exhibitions than the tour operator who is looking for a long-running tour programme.

They need all the information about admission charges and discounts and, in common with the tour operators, they need lots of practical information such as drop-off arrangements and parking facilities.

In developing any kind of group market, it is vital to be organised and have an agreed system for bookings. Museum desk staff need to be on the ball about expected groups and what arrangements have been made for them. Can you provide an introductory tour as part of

the service? Is there somewhere where a picnic or lunch could be served? Will your cloakroom be able to cope with a sudden influx? If your museum is admission free, can you think of a creative incentive to bring in the tours – such as special tours, access to video tours or discounts in the shop or restaurant? And, last but not least, can you do anything to look after the coach-driver while he/she is waiting? A free or discounted meal or a voucher would be appreciated.

During their special Cézanne exhibition in 1998, the Philadelphia Museum of Art arranged a special deal for group tours, giving them access and a discounted rate at a nearby famous French restaurant. Customers booked a tour that was inclusive of transport, a special tour of the exhibition and a fancy meal in a great restaurant. It was wildly popular. Such arrangements need to be made well ahead of time if the travel trade is to be able to market it to customers.

Registered tourist guides and guiding

This important group of people can be difficult to reach as they are virtually all self-employed and are usually fiercely independent people with strong opinions! However, they are important allies to museums, so do spend time cultivating them through their associations' newsletters and by organising regular familiarisation trips. Not only do they organise group visit programmes themselves, particularly for special interest groups, but they are important communicators with many, many visitors who take introductory guided tours. In a busy attraction you have to decide how to deal with guided tours inside the building. Many museums and galleries do not encourage guides to talk within the exhibition areas as it can interfere with other visitors' enjoyment and result in congestion, particularly at a busy exhibition. A pre-exhibition talk is a useful alternative.

At the American Museum in Bath, where rooms are small, the mornings are set aside for group visits. These are all pre-booked and include talks by staff, some groups being broken down into smaller units. This is useful not just as a marketing device but also in creating a better environment for individual visitors. (This can be a useful way of dealing with school groups if educational facilities are not available.)

Taxi-drivers

Let's face it, cab-drivers are the source of all wisdom on what's going on. Yet how many times do you visit a town and discover that the taxi-drivers do not know where the local museum or gallery is situated? You can reach cab-drivers with literature through their local association, or through the cab companies themselves. Why not include them in your tourism familiarisation events?

> The Financial Times in London recognises that cab-drivers are the fount of all wisdom. Not only do they advertise on taxicabs, but on Budget Day they invite cabbies to a briefing breakfast, where they get all the key information along with quotable quotes about the nation's finances. Later in the day, passengers find that they are not only sitting in a cab that advertises the newspaper, but that their driver can give them the low-down on budget announcements and implications. Great fun, and a good image-building device for the paper!

Tourist magazines and the internet

Tourist magazines should be targeted through your general public relations activities as a matter of course, and specifically when you have something to offer of particular appeal to visitors. You may consider advertising but look carefully at any 'free' distribution publications and circulation figures (see Chapter 5).

The internet is now a major source of information for the travel trade and for international travellers. Make sure your website has the latest information and that you are plugged into gateways such as the 24 Hour Museum and linked to your tourist board and other listings sites (see Chapter 7 and Appendix 2).

Convention and conference markets; incentive travel

An important aspect of the conference and convention business is the social side. Evenings are sometimes difficult to fill. Also, large conventions often have to arrange tours for spouses. A museum which has a good product to offer, and which is tuned into the needs of the business, can make a lot of money from this sector. Evening events can be particularly useful. Marketing officers need to get to know tourist board and convention bureau staff and position their museum to become a regular feature of local convention business.

Some companies like to reward achievers within the company with special privileges, often involving travel and access to special events. Corporations sometimes do this on a huge scale. Credit card companies, air-mile companies and others are constantly seeking incentive awards to offer to members. This is the high end of the travel market, where quality service and attention to detail are paramount. Venturing into this area can be very rewarding financially, because high premiums are paid, but it generates a great deal of work and puts the receiving institution on its metal to deliver a very high quality of service. Local tourist boards and convention and visitors bureaux can usually tell you about incentive travel opportunities, but it is possible to spot them for yourself when you see special schemes and offers being made through your own air-mile and credit card companies. The attention to detail and long-term planning in this sector require very long lead times.

Museums with good hospitality and event facilities can do well from the conference and events market. See Chapter 15 on how to maximise on this business for your own museum.

CASE STUDY 7 Tourism marketing in an overcrowded market place (Bath)

This case study is based on a presentation by Ylva French to the Heritage Management Course at Ironbridge Institute in 1998 and on her work in Bath.

The current situation in Bath

At first glance it may seem a distinct advantage to be a museum or attraction in a destination which already attracts a large number of visitors. Here are some facts and figures (1997):

- The local population for Bath is 78,600, for the new local authority region 158,692 and for the South-West region 4.7 million.
- Bath estimates staying visitors at 1.9 million a year and day visitors at 2.9 million. Staying visitors spend an average 1.7 nights in the town and day visitors 3–5 hours.
- The spend is an average of £50.50 per head for staying visitors and £20 a head for day visitors.

The downside is that there are some 40 competing tourist attractions, 17 of which are museums.

Visitor figures for main attractions	
Roman Baths and Pump Room	930,000
Bath Abbey	320,000
Museum of Costume	146,000
American Museum	61,200
No 1 Royal Crescent	46,000
Victoria Art Gallery	40,000
Royal Photographic Society	17,000
Holburne Museum	16,000
Bath Industrial Heritage	12,000
Building of Bath Exhibition	11,000
Museum of East Asian Art	5,000+

An analysis of the visitor figures immediately reveals the itinerary of the average visit to the town: the Roman Baths, possibly followed by one other attraction, shopping and eating.

The Roman Baths — apart from being a wonderful attraction and a world heritage site — enjoys one further advantage: it is managed by the City of Bath and thus contributes extensively to the local economy (residents enjoy a discount on their council tax bill thanks to the revenue from the Roman Baths and Pump Room). There is free entry to all local residents (the proof of residency to be replaced by a local heritage pass) and it is of course the lead attraction for the city. Schools also enjoy free entry and activities here and at the Museum of Costume.

What does this mean for all the other attractions in the city and for any newcomers? Information providers, guide-book publishers, producers of special supplements and tourist magazines, and other publicists all come to this tourist honeypot, and all are trying to reach the elusive first-time visitors. The city in the meantime tries to manage the visitor flow and concentrates its longer-term marketing activities on attracting more staying visitors (albeit with a limited hotel base).

The result is a very high cost of entry to the market place for all attractions, simply to keep their name before the potential audiences. This is well out of proportion to the returns they can possibly achieve (but keep hoping for in view of the flow of people from the coach station to the Roman Baths) to a point where many are struggling to survive. A new attraction for the millennium, Bath Spa, will add to the competition but will provide a more up-market, pre-booked experience aimed at staying visitors.

A typical small museum or attraction in Bath (or a similar city) will have no professional marketing staff and possibly no professional advice. The function may well be combined with running the office and the shop. The marketing strategy will consist of repeating last year's formula, booking advertising in response to pressures, special offers and what the rest of the market is doing, producing leaflets and spending a great deal of money distributing these — without having identified the audience. The budget might look like this:

- **Advertising** (£2500): minimum spend to cover guides, co-operative leaflets and local newspapers
- **Leaflet distribution** (£4500)
- **Mailings** (absorbed cost)
- **Press activities** (absorbed)
- **Tourism and trade activities** (absorbed).

Future marketing strategy

The marketing strategy for a small attraction or museum in an over-crowded market might be as follows:

Agree on a strong positioning statement defining the unique qualities of the attraction.

Marketing objectives

- Build on quality overall.
- Build on existing collaborations and develop new ones.
- Sustain existing audiences and develop new audiences.

Build on the strengths and weaknesses which can be tackled within existing budgets and which will deliver increased audiences and improved audience perception, by targeting local residents, schools and staying visitors.

Marketing action plan: growing audiences

TACTICS

- Use a professional marketing/public relations person two days a week.
- Withdraw all expenditure on attracting costly day visitors, except for effective signage.
- Cut out all advertising except for special events aimed at local residents.
- Participate in local authority and tourist board co-operative initiatives whenever free of charge.
- Target distribution of leaflets at staying visitors and residents.
- Set up effective mailing lists for the group market, and possibly joint mailings with other small attractions.
- Intensify public relations activities to build stronger local support and thereby increase 'word of mouth'.

ACTIVITIES

Activities would vary according to the group targeted.

LOCAL RESIDENTS

- leaflets
- direct mail
- media
- advertising
- local television/radio/internet
- Friends' networking and welcome days in the museum.

Staying visitors
- leaflet distribution
- public relations programme
- familiarisation visits for tourist information centre, guides and hotel staff
- liaison with and promotion to the travel trade
- promotional activities with others.

Group and travel trade
- promotional material
- collaborative approach to this market
- contact with British Tourist Authority offices in the UK and USA
- intensive targeted programme of mailings with new offers
- use of the internet
- direct mail to Friends' organisations
- direct mail to others (NADFAS – National Association of Decorative & Fine Arts Societies)
- group trade fairs
- mailings and editorials
- familiarisation visits
- liaison with Bath Tourism and West Country Tourist Board
- target local English language schools.

Educational markets
- mailings
- try out a series of workshops for 'free'
- video of events and workshops
- education packs using sponsorship
- adult learning
- evaluate results and report.

People with disabilities
- training
- promotion to local groups
- get funding for trips
- highlight special visits.

Corporate hospitality
- develop offer and information pack
- direct mail.

Chapter 7 MARKETING: NEW TECHNIQUES AND HOW TO USE THEM

This chapter examines some new areas of marketing, including co-operative marketing, direct mail, websites and the new media.

Partnerships and co-operative marketing

Proper long-term planning presents an opportunity to find partners with whom the museum can co-operate to achieve greater public awareness and bring in more visitors. Sometimes this will be a hotel, a restaurant or a tourism provider; sometimes it will be companies or corporations which have some connection with the project in hand; and sometimes it could be a consortium of museums working together. This might be a purely commercial arrangement, whereby participants share costs in order to bring themselves to public attention. Working together with others in creative ways is a future trend for museum marketing. It brings museums into greater contact with new markets and brings added value to everyone concerned.

Research shows (see Appendix 1) that the majority of museum visitors go to museums more than once a year and that they are also likely to visit other similar attractions – historic houses, gardens and heritage sites. There is a lot of scope for museums to market themselves co-operatively on themes and on the basis of location to encourage visits to other museums and heritage sites. This can be done simply by displaying each other's literature, or more actively through joint publications, trails and joint promotions. Embarking on a co-operative marketing programme requires commitment. It is not likely to pay off in the short run. Many of the areas explored in Chapter 6, particularly for tackling the tourism, incentives and conference markets, are well suited to co-operative marketing.

Co-operative marketing may be initiated by local councils, by the tourist boards or by one museum or attraction taking the lead. As a general rule someone has to take the overall responsibility for moving the project forward; marketing by committee does not work well. So decide from the beginning how much time you want your museum to commit to this, whether you are going to take the lead, or whether you are happy that the person in charge will ensure the success of the venture.

In general the effectiveness of the promotion decreases with the number of participants. There are exceptions – for example the very useful co-operative marketing leaflet produced by the association of

Bath attractions, which now includes more than 40 entries. *Museums Alive*, an attractive booklet featuring all the museums in the Yorkshire and Humberside Region and updated annually, is now well established. The key to the success of these projects is the effective distribution and monitoring of the use of the leaflets and booklets.

When considering co-operative promotions aimed at the travel trade a long-term approach is essential. You are building business here for the future, and with long lead times (see Chapter 6) results may not be visible for some time. Joint participation in trade fairs such as the British Travel Trade Fair need careful planning and investment – a themed stand and specially printed literature – to be really effective in an increasingly competitive market.

Consider your partners for travel trade/group travel promotions carefully and get a good match for a day out in your area; two or three museums may not be the best combination for a day visit, whereas a historic house, a cathedral or garden may link well with a visit to your museum. However, you are really combining your products to give the group travel organisers a wider choice and to enable you to reach a larger audience. In the end organisers will put the visit together to suit their programme and their audience.

Evaluate co-operative marketing initiatives just as you would any other. If your contribution to a joint leaflet for your area is not working for you, pull out or get more involved and find out how it could be improved to work better for everyone.

Relationship marketing and direct mail

Building relationships with existing customers and developing loyalty is the basis of relationship marketing. Museums have in some ways pioneered relationship marketing through the establishment of Friends' organisations. Attracting an existing visitor back again and again is in principle more cost effective than constantly building new audiences. Consciously or unconsciously, many museums and heritage attractions have already achieved this, with high repeat visitor rates. Others – because of their location, subject matter or lack of investment in this area – have not been so successful.

By developing relationship marketing as part of the overall marketing strategy, the museum will create a solid base of supporters and visitors. It is easy to leave the Friends out of the marketing equation, particularly if they see fund-raising as their major activity. Friends are not only important regular visitors and supporters of the museum's activities and events; they can also play a part in marketing

the museum. This means that regular communication through the Friends' newsletter or in person is important; you could also give them specific tasks which fit in with your marketing objectives: recruiting younger Friends, bringing other Friends' groups to the museum, assisting in enhancing the welcome or services provided for visitors, or spreading the word about the museum and its activities in their local communities.

Museums with or without Friends must also develop other relationships and sustain these through a variety of means. Funders and other decision makers have been identified as one of the key audiences; local communities around the museum are another. Building a database of existing visitors is an important way of maintaining contact and creating loyalty. But before you start, consider how you are going to use it and whether you have the resources to maintain it.

Capturing the data is another challenge. You may do this through a simple survey in the museum over a period of time: ask visitors a range of questions, including how often they visit the museum, and then ask them if they would like to be on your mailing list. Indicate what they are going to receive from you, for example your newsletter, the events leaflet or invitations to private views.

Your database could become a valuable asset to commercial and other organisations. Make sure you have cleared each entry for 'other mailings/offers, etc.' You should also, in the UK, register any mailing list held electronically under the Data Protection Act.

Direct mail and relationship marketing are inexorably linked. You may decide to use direct mail to build new audiences, perhaps through another museum's mailing list on a swap basis, or by accessing a complementary market segment, for example theatre-goers. Your local theatre or local arts marketing organisation would be a source for this information. You can also buy mailing lists for specific promotional purposes, i.e. targeting group travel organisers, sports clubs or schools – the choice of lists is endless, but of course they come at a price.

Through postcodes it is now possible to target very specific groups that match your target audiences. Again, before embarking on this – it can be relatively costly – think carefully about the offer, and how you are going to continue to communicate with the new visitors you have attracted in this way. The 'offer' needs to be more than a leaflet. Remember that these people will be 'cold prospects', know little of your attraction and need to be made to think of a good reason for

visiting. A covering letter – short and to the point – should provide the invitation and a good reason for visiting as well as a mechanism for the visit to take place, perhaps through an introductory guided tour which visitors have to book, or an open day during Museums Week. You should also build in evaluation so that you can learn from the results in developing new approaches.

Don't start a major direct mail programme based on your own mailing lists unless you have the resources to maintain and 'clean' the list. Once a year you should get people to send in their 'renewal' to stay on the list (don't forget to put a return address on the envelope). You can also get the list 'cleaned' by a database company, who will check it against the electoral roll and other sources – but for a charge.

The internet and new media

What are 'new media'? As we enter the new century, 'new' media include CD-ROM, intranets, the internet and other forms of interactive networks such as touch-screen information and booking points in towns and cities across the country. No doubt by the year 2005 there will be a few more products added to this. Museum researchers and academics have been in the forefront of developing database technology and intranet and internet communications, but it is only now that the marketeers are getting their hands on these very important tools. What relevance do they have to marketing in this sector?

The internet has captured the headlines due to its phenomenal growth. Already one-third of the UK population (as of March 1999) is online. By the year 2001, 700 million people around the world will have access to the internet regularly. Companies, organisations and some museums use intranets for daily communications, and sales of CD-ROMS have finally taken off after years of development. It is essential that marketing techniques are adapted to take these far-reaching changes into account.

Most internet users now have access to the web at home (38%), one-third has access at work and the proportion of school, college and university users is almost as high, at 23% (UK 1999). Most users at this point in time are the so called 'early adopters' and 'affluent families with children', but that picture is changing fast as the internet is taken up by young and old from a variety of backgrounds. People are spending less time watching television and reading newspapers as they get more of their information from the internet.

How can you use the new media and measure its effectiveness?

You can tap into this market through your own website and through promotions and advertising on other websites. How do you make a success of your own website? Start with the website itself. Many current sites were created in the first flush of internet excitement and are already showing signs of age, consisting mainly of brochure style information. Some large companies, such as British Airways, have re-launched their websites every year. Such extravagance will not be possible for the average museum and gallery, but developing a website so that it can be refreshed and updated easily is one of the keys to its success.

The website is a major part of your brand management and should reflect the brand that you are so carefully building through the rest of your communications, your exhibitions and your general service delivery. A home-made look to the website may have been acceptable in the early 1990s, but for the bigger players in the heritage sector the website has become a major investment, reaching thousands of people who may not have any other contact with the museum or gallery – until one day they come and visit as a result of their website introduction. Avoid at all cost a static display full of text. The website is the place for interactivity and, increasingly, moving pictures and sound.

The website should be an integral part of all marketing communications. This means that it should be easy to find the answers to the additional questions which may arise from your promotional activities targeting different markets. The Metropolitan Museum of Art, New York, the London Transport Museum and the Natural History Museum are all good examples. The website should not simply be another brochure, repeating the printed information you have already sent out. The beauty of the web is that your communications can be instantly updated and that you can now, or very soon, organise yourself to take bookings for groups, tours, lectures and other events over the net.

These are some of the areas on which you need to provide information:

- individuals – opening hours, facilities, current exhibitions
- groups – group facilities, including catering, guided tours, lectures, coach parking
- overseas groups – foreign language literature, guided tours
- special exhibitions – pre-booking
- schools – education packs, education room, talks, workshops, lunch-room

- press information
- shop/merchandising information and mail order.

Your website should also be effectively marketed to both non-web-users and web-users. Various programs are available which enable you to keep a check on 'hits', i.e. the number of visitors to the site, and also to do sample surveys so that you can see how long people spend and which routes they take through the site. You can also put a questionnaire on the site at various times to get feedback.

The first opportunity for marketing the site is of course its launch. In the early days of website developments, launches could make a bit of a splash, and even today new websites get write-ups in specialist magazines, internet pages and supplements of the nationals. So make the most of the launch – the challenge is then to maintain the interest and not just sit waiting for people to come upon the site, almost by accident.

How do you rise above the millions of other sites? Some investment will be required to raise the profile of the site on the net. To list some options:

- Make sure your site is effectively 'tagged': every specialism that you offer should be tagged on your home page so that anyone browsing under 'the Romans', for example, will get your museum or heritage attraction as one of the options.
- Linking with portal sites: as from 1999 the *24 Hour Museum* (www.24hourmuseum.org.uk) provides a gateway to UK museums, galleries and heritage sites. All registered museums are automatically listed, but you may want to set up a direct link or take banner advertising on this site to highlight a special exhibition. The *24 Hour Museum* is extensively promoted to non-web-users and web-users alike. This is a free service as long as the site is supported by the Department for Culture, Media and Sport, and it has a direct link to the National Grid for Learning. Other portal sites and search engines will make a substantial charge to push your name to the top of the list (see Appendix 2).
- Listings: a huge number of websites – from the British Tourist Authority's www.visitbritain.org.uk site to regional, town, magazine and newspaper sites – now carry listings. Make sure your museum is listed, that the information is correct and that you are hot-linked from those sites.
- Keyword search campaign: this means that when a specific word is typed (reflecting the subject of your attraction for example), a

banner advertisement for your attraction will automatically come up on the results page.

- Banner advertising on top consumer sites: a list of the top-60 sites is published each month by *New Media Age* (website: www.nma.org); here is another opportunity for reaching those who may not know where or who you are.
- Building loyalty: getting people back to your site is important. Looking forward to next week's update is one way. Special offers is another, including competitions and perhaps discounts on items in your shop.
- Sponsorship: look at opportunities for linking with major events and/or commercial sponsors with major websites. Sporting events, for example, attract huge audiences to dedicated websites where people check scores and form. Museums with any sporting links should look at ways of linking to these.
- Research and evaluation: change and adapt the site as research on how visitors actually use the site becomes available. Set up the site in the museum and get direct feedback from users.

In order to carry out a specific advertising and keyword search campaign on the internet, you may wish to use a specialist company in this field, who can devise and cost a campaign using the appropriate mix of banners, interstitials (the advertisements which come up between pages), sponsorship, e-mail advertising and sponsorship of discussion groups.

Does online advertising work? This is not easy to answer as the medium is so new, but some research and evaluation has already been set up in the USA and the UK. Tests across a random sample of one million web-users in the USA showed that awareness of advertised products increased by 30%. The research also showed that exposure to banner advertisements or interstitials was more effective than 'click-through'. (Click-through is the rate at which web-browsers click on your banner advertisement to get direct access to your site.) Click-through is important where there is a 'call to action' – a direct marketing opportunity you want browsers to take advantage of.

Potentially, advertising on the internet can be very powerful, targeted to exactly the right audience. But there is still a lot of work to be done to develop more effective means of measuring the profile of the internet audience so that you know who you are reaching, something which traditional advertising has developed to a fine art.

Online advertising opportunities in other areas should also be explored, including intranets linking employees in large organisations

as part of a sponsorship arrangement, touch-screen kiosks in tourist centres, and shopping and other specialist channels developing as part of digital television networks. These are new areas and learning from others is useful, as is also testing the waters with a targeted and carefully evaluated campaign before committing large parts of the marketing budget in this area.

CASE STUDY 8 The promotion of Hampshire art galleries

This promotion initiated by Arts Marketing Hampshire used direct mail to generate new audiences for modern art. In the first phase, undertaken in 1995/96, research and evaluation was built in to provide useful ammunition for the second and main phase of the promotion supported with an Arts for Everyone grant from the Arts Council. The second phase will get under way in the year 2000.

Participating galleries

Three galleries – the John Hansard Gallery in Southampton, Southampton City Art Gallery and The Winchester Gallery – participated in the first phase. Each gallery ran two 'taster' evenings. Invitations to attend were sent to individuals on the Arts Marketing Hampshire mailing lists for a variety of different art forms, excluding those who were known to be already interested in the visual arts.

Invitations were well-produced, quality print and were accompanied by a response form, so that recipients were given the opportunity to join a mailing list for similar events if they could not attend the first one. In this way the mailing list grew to a maximum of 1000.

The research

The objectives of the research were to gauge attitudes before recipients accepted an invitation; find out what they hoped to get out of the event; discover whether the experiences measured up to their expectations; and check on practical aspects of the invitation as well as on their continued interest in viewing contemporary visual arts.

Research was carried out through focus groups and also by analysing responses to the events and follow-up interest. The focus groups' research is summarised as follows:

- The attenders who were new to contemporary visual art were mostly over 40 with an existing or previous interest in other forms of art.
- The preconceptions about modern art of the groups were similar to those of the general public, i.e. 'anyone can do that'.
- The invitations sparked off a lot of interest, with some people attending more than one event.
- Experiences at the event were reflected in what happened next.

Some of those who only came once had had the experience ruined by too many people or an unsympathetic guide. Those who had a good first experience and/or came more than once felt that the first visit had been 'stimulating' and 'enjoyable'.

- The invitations made a difference to everyone who attended. Many gained a new interest and would visit in the future. Others said it had made them look at their lives differently, that they were 'enriched' by the experience.

Table 1 Analysis of direct mail marketing

Gallery	Mailed	Responded	Attendance	Response rate
John Hansard 'Nonas'	881	64	47	7%
Southampton City Art Gallery 'Real Art'	903	63	57	7%
Southampton 'Co-operation'	991	174	118	18%
John Hansard 'Desert'	586	112	68	19%

Source: Arts Marketing, Hampshire
Note: A response rate of 10% is considered very good in direct mail marketing.

Summary

A targeted promotion of this kind is an excellent way of bringing in new audiences. Running a pilot first and carefully evaluating the results ensures that snags can be ironed out at an early stage and lessons learnt. A total of 243 names will go forward from phase one to phase two. After one year 43% of newcomers were found to go to new exhibitions at the art galleries concerned (telephone research).

The Hampshire Art Gallery promotion – *Gallery Go* – now includes five galleries and will go live in the year 2000. In addition to those who attended in the first phase, it will include those who indicated interest as well as those on arts related databases. There will also be door-to-door mailings using ACORN/TGI (A Classification of Residential Neighbourhoods/Target Group Index) indicators for the visual arts. Students will be targeted (not through direct mail), and a special website will be used.

Chapter 8 AUDIENCE DEVELOPMENT

The political climate

A great deal has been said about 'audience development'. In fact, it is simply marketing and programming under another name. Most museums have a component of their mission statement which says something about making the collections available to 'the people' or 'a broad public'. Audience development is the term currently in use to describe how that broad audience is achieved. And it is endorsed in the UK and many European countries by government policy:

> Museums are about objects and for people. The UK's museums have some of the finest collections in the world. By preserving, exhibiting and interpreting these collections, museums enrich the lives of today's visitors and ensure that future generations will also be able to enjoy and learn from them. They contribute to four main Government objectives. They:
>
> • Promote education, notably through support for the National Curriculum, through formal and informal education and by providing opportunities for lifelong learning.
> • Provide physical and intellectual access to collections which illustrate and illuminate history, the natural world, the great artistic and scientific achievements of humanity, and contemporary cultures.
> • Help to tackle social exclusion by encouraging participation in museum activity and reach across social and economic barriers.
> • Support economic prosperity by helping to sustain and regenerate communities and by providing information and services for commercial and business users.[1]

It is quite a challenge for museums to try to please all of the people all of the time! The Museums and Galleries Commission publication *Building Bridges* describes audience development as being about 'breaking down the barriers which hinder access to museums and "building bridges" with different groups to ensure their specific needs are met. It is a process by which a museum seeks to create access to, and encourage greater use of, its collections and services by an identified group of people.'[2]

Audience development is very much a political activity (with a small 'p') – something which museums should take on board for the greater good but also as a means of establishing closer links with its local community. For most museums this type of marketing activity will be of critical importance to some of its funding bodies.

> Countering negative perceptions and turning museums into powerful engines of social change are central aims of many museums, especially in our big cities – how could

they be otherwise? The Labour government can be confident that the social priorities it has been elected to pursue find strong resonance in museums, and that the old, exclusive order is being put to the sword.[3]

Audience development is about research, implementation and evaluation. Does this sound familiar? Marketing staff have a key role to play here in helping the whole museum to work through this process by identifying the existing audience, modifying the product to attract new or under-represented audiences, reaching out to them and then evaluating results.

Know the existing audience

It seems almost too obvious to state that until you know who is coming to the museum, it is impossible to work out who is not coming: so everything has to start with an analysis of the present customer base. A great deal of work has been done on how to classify people who use museums.

Some studies break the market down into **traditional visitors** (those who have probably been socialised into visiting during childhood, understand what is going on and enjoy visiting) and **new visitors** (those who want to be able to say they have been, or are cultural pilgrims, or for whom participation is an end in itself). In the UK 36% of the population visit museums at least once a year and the majority make more than one visit (see Appendix 1). A committed 24% of all visitors go to visit museums five times a year or more. Therefore serious or frequent attenders make up a substantial proportion of visitors to a local museum or gallery, as well as to national museums with a changing programme of exhibitions.

However, for an individual museum or gallery most attenders will be **infrequent visitors and, possibly, casual browsers**. This in itself poses a challenge to information, circulation and interpretation throughout the gallery. (Many museums prepare their displays to suit a tiny proportion of their visiting public and forget that not everyone knows how to find the toilets, the café or a gallery in an adjoining building.)

A better understanding of why people visit can shed light on why some people don't. The 1999 research carried out by MORI for the Museums and Galleries Commission will provide some of the answers but needs to be repeated over several years before a national picture emerges. (For an extract from this research, see Appendix 1.)

Research carried out by Molly Hood at the Toledo Museum of Art in Ohio indicated that early introduction to museums is a key factor in

establishing museum visiting, and that there are people who see their needs and interests being met by museums, and some who don't.[4] Such cultural factors – as well as available leisure time – far outweigh entry charges, transport costs, hours of access or distance from home. For many years it has been obvious that if museums wish to build audiences, they need to develop their appeal to children and do their best to make the museum a comfortable experience for the wider (occasional) visitor. We know that the occasional, non-dedicated visitor:

- values comfortable surroundings
- equates leisure with relaxation
- values social interaction more than intense interaction with exhibits
- comes for a special event or exhibition.[5]

Tyne and Wear Museums have led the way in the UK in audience development. The museum service commissioned the Arts Management Centre at Newcastle Polytechnic (now the University of Northumbria) to undertake a policy analysis and audience survey in 1989. Not surprisingly, the picture that emerged confirmed that between 67% and 80% of visitors to the museums and galleries came from the better-off socio-economic groups (ABC1) – 41% of the potential national audience. The museum service has made a long-term commitment to marketing activities targeted at specific groups, including outreach projects based on the Discovery Museum's People's Gallery (Newcastle upon Tyne); the Vaults and People's Choice programme in Newcastle and Sunderland; the art ambassadors scheme to encourage young people into the Laing Art Gallery (Newcastle upon Tyne); and work with NACRO (pressure group for past prisoners), MENCAP, Age Concern, the Chinese, Jewish and Pakistani communities, the Black Youth Movement and hundreds of other organisations. The results include reversing the audience profile at the Discovery Museum, Newcastle, previously the Museum of Science and Engineering, where C2DEs now account for 53% of visitors (previously the figure was 27%).

The available or potential audience

As we have seen, museums and galleries discover that their visitors come from every walk of life, every income level and a wide geographical area – but that the audience is heavily weighted towards the educated and financially better-off. By comparing a museum's visitor profile with that of the surrounding population, differences

The Victoria and Albert Museum did not measure up well in the family market. While other South Kensington museums attracted family groups as a matter of course, the V&A was perceived as an 'adult only' experience. With the help of the V&A Friends, the museum acquired an 'Activity Cart' – a moving display and activity centre, which is easily positioned in a gallery and from which family-led activities can be organised, based on the exhibits in that gallery. These activities take place each Sunday and include arts and crafts and storytelling. A sign at the entrance tells family groups where to go to find the cart.

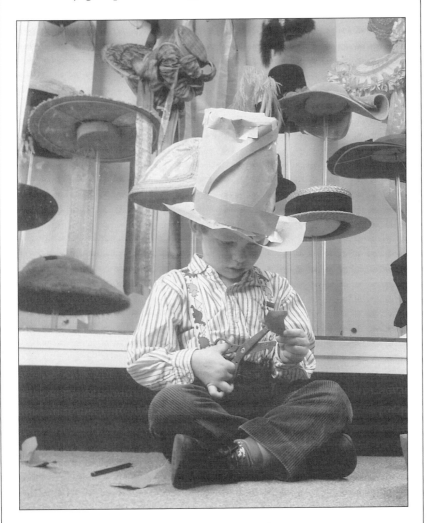

Making an Easter bonnet in the Dress Collection at the V&A. Courtesy of the Victoria and Albert Museum.

begin to appear in the various segments. Comparisons are useful in, for example, the following categories:

- **Educational attainment**: Does the proportion of museum visitors with college degrees contrast dramatically with the number of people with college degrees in the region served by the museum?
- **Available income**: Does the number of people (or households) earning over the local average represent a heavy proportion of the visitor base?
- **Ethnicity**: Does the cultural mix of the museum visitors accurately reflect the mix in the surrounding population?
- **People with disabilities**: Do they appear in the same proportion in the visitor base as they do in the surrounding population?
- **Age groups**: Is the age spread among museum visitors similar to the age spread in the surrounding population?

The results obtained from such a survey provide a good indication of where the museum should be directing its efforts in becoming more inclusive and less exclusive.

Further research

It would be convenient to assume that having identified who is not coming, marketing and publicity outreach can simply be addressed to these groups in order to bring them in. Some temporary changes can be achieved in this way, but they are rarely sustainable. Short-term gains are a waste of precious museum resources. Somehow we have to identify what will provide a satisfying visit to the groups we wish to attract, and see whether we are providing what is required.

Culturally, we are all conditioned to behave in different ways during our leisure time. Some of us like to mooch around informally and solo, with as little interaction as possible. Others see leisure time as an important opportunity for the family to be together in an interactive and sociable group. In some cultures it would be extraordinary for a woman to attend a venue on her own; in others it is quite normal. In many countries there is no tradition of museum visiting, and it may be only the second or third generation of immigrants who develop the museum habit through school visits. Curiosity drives some of us; others seek the familiar.

We can discover a great deal through talking to representatives and agencies of the groups we wish to attract. In fact, it's essential to listen to our target market, and it is dangerously patronising to assume that

we know what will appeal. It is also important to learn from others – area museum councils, regional arts boards, and other agencies have sponsored and funded programmes and a wealth of material should now be available for others to share and gain from. It may mean hunting around for published material, but don't embark on a new initiative without learning from the mistakes and successes of others.

In marketing exhibitions designed specifically for people with visual impairment, the press office at the Natural History Museum, South Kensington, had to learn a lot very quickly. Early assumptions were that all the messages had to be sent directly to the target audience in the form of Braille literature, talking newsletters and radio programmes. In fact the organisations which provided advice were quick to point out that the percentage of visually impaired people who read Braille was fairly low and that it was just as important to reach the carers, clubs and agencies which could actually *enable* a visit as it was to motivate blind and visually impaired people. Many visually impaired people also suffer from mobility problems.

For any group, population or community, there are usually a host of organisations or agencies that have been grappling with the issues for some time. They probably have a lot to say about how their communities like to spend their leisure time and what they value. They will also know how the networks and grapevine work, making it easier to plug into effective communications. In the USA church groups can be extraordinarily helpful in connecting cultural organisations to new audiences. Listening is the best starting point.

Developing the product

Implementing change to the museum and the way it presents and interprets objects is part of audience development. By now it will be evident that the achieving of sustainable change is a long and slow process and requires long-term planning and commitment. Small incremental change should be the objective. Goals should be realistic, and one year's work should build on the next. As long as progress is upward and steady, it doesn't matter that changes are small. Indeed, dramatic changes are rather suspect in this area, because they are probably not sustainable – a temporary exhibition like the one mentioned above, for example, will only be worthwhile if there is a

The 1993 Peopling of London exhibition at the Museum of London was a major initiative designed to show how the museum could reach out to Londoners from a wide variety of backgrounds. It started with an extensive consultation programme capturing hitherto unwritten community history from immigrant groups. Interviewees were encouraged to participate through the Museum on the Move campaign. A mobile trailer toured markets, community centres, supermarket car parks and other venues that the museum would not otherwise reach with a display about the forthcoming exhibition. People were asked to contribute information and many offered personal memorabilia, such as passports and photographs.

The marketing programme included flyers and vouchers in Hindi, Urdu, Bengali, Chinese, Arabic, Greek and Spanish, which were distributed through community centres, mosques, churches, shops and associations. During the exhibition there were focus weeks, when people were invited from particular communities to present their history or culture.

Visitor research carried out before and during the exhibition showed a substantial increase in the proportion of visitors from ethnic communities – from 4.1% before the exhibition to 20.08% during the exhibition. The museum committed itself to continuing the process of collecting oral history from local communities and to incorporating contributions from overseas settlers to London's development in other galleries, such as the new gallery devoted to London since 1945.

continuing programme which will convert these new visitors into regular museum-goers.

The following are areas which may need to be addressed in order to improve universal access:

- **The internal culture**: Is the whole staff on board, or do some still regard the museum as a private and exclusive club? Does the composition of the staff reflect the ethnic balance in your community at all levels?
- **Accessibility**: Is the building physically accessible? Are improvements needed?

- **Customer care**: Do front-of-house staff (and others) need training? Is the welcome right?
- Are the needs of **visually and aurally impaired people** catered for?
- **Intellectual access**: Are the exhibits pitched at the right, inclusive level?
- **Cross-cultural access**: Are there labels and information materials available in the appropriate mix of languages?
- **Facilities**: are there clean lavatories; baby-changing facilities; clean, well-lit galleries; refreshments at a range of prices; cloakrooms for umbrellas, parcels and coats; wheelchairs; strollers; exhibits at children-friendly heights?
- **Stakeholder consultation**: Have representatives of target markets been asked to contribute towards policy in any way?
- **Programming**: Who are the exhibitions and events being designed for?

When these areas have been addressed, fresh marketing efforts have a chance of delivering sustainable new audiences. Keep the dialogue going; keep listening; and keep evaluating in order to see what's working.

Notes

1. Department for Culture, Media and Sport (July 1998). Consultation document – 'The Comprehensive Spending Review: A New Approach to Investment in Culture'.
2. Dodd, Jocelyn and Sandell, Richard. (1998.) Building Bridges. Museums and Galleries Commission, p.6.
3. David Fleming, quoted in Museums Journal (April 1999), p.29.
4. Hood, M.G. (1983). Staying Away: Why people choose not to visit museums. Museums News **61** (4), pp.50–7.
5. Miles, R.S. (1996). The shift to greater self-sufficiency (in Russian only). Unpublished paper.

CASE STUDY 9 Audience development for the Getty Center, Los Angeles

Diane Brigham, head of education, had the task of leading the audience development effort for the J. Paul Getty Museum in its transition from the leafy enclosed site in Malibu (attracting half a million visitors a year) to the new prominent location at the Getty Center, which opened in 1998 and attracted nearly two million visitors in its first year. Los Angeles is a multi-cultural city with about 150 different languages spoken in its schools. Half of its schoolchildren speak Spanish at home. Around 30 million people live within day-trip distance of the museum. Many of the city's residents are first or second generation immigrants. The museum's collections are largely European, from the Middle Ages to the 19th century. Some modest head-way had been made in attracting a multi-cultural audience to the Malibu site, but the intention was to improve upon this. With such massive diversity of ethnicity within the population, it was decided to divide the target market into socio-demographic groups rather than along simple racial or ethnic lines. Brigham writes:

> It was never a question of *if* people would come. It was a matter of *who would* come and *who wouldn't* come – and how we could extend a welcome to a broad audience. Our opening was long-awaited. Locally, commuters on the freeway could see the Getty Center construction progress on a daily basis. Internationally, the opening received wide exposure, and offered numerous opportunities in education and marketing. In terms of audience development, it gave us the chance to define our place within the community of Los Angeles and a chance to shape our audience through programmes and marketing. The earliest part of our planning process involved lots of listening to groups representing those audiences we wished to attract.

Our experience

We chose four priority audiences. We shifted our planning emphasis from specific ethnic groups to socio-demographic categories that we expected to have similar visiting patterns:

- children and their families
- students and their teachers
- young adults, including college students
- potential visitors who are new to art museum-going.

We identified key messages to communicate to each of these audiences. We reviewed programmes already in planning to ensure that the needs of each audience would be met, and we created new programmes with the goal of attracting new audiences within our targeted groups. The tools included:

- family festivals
- teacher open houses
- Friday nights at the Getty
- community partners
- colleagues and community events
- promotional efforts, e.g. banners, new design for printed materials, use of community media.

We tried to minimise obstacles to visiting. The site, located on a hilltop, required a tram journey to the top, and there were strict limitations on parking at the bottom of the hill. This is a city in which nearly everyone relies on a car. Public transport is very limited compared to many other cities. We knew that we would have to have a reservations system for car parking, so, anticipating the public demand, we made special early reservations for the groups we particularly wanted to attract. We also successfully spearheaded the extension of city bus routes. We then communicated all the different ways of visiting the Getty through our public information literature and advertising.

Key principles that guide our audience development work

- Place emphasis on listening to the audience.
- Plan initiatives that are sustainable.
- Focus on specific targets.
- Continually ask: how can we create a positive experience for *all* of our visitors?
- Emphasise in-depth projects, and balance with a few bigger, but lighter, efforts.
- Programme should drive the marketing.
- Analyse and reduce obstacles to a positive museum experience by the groups we are targeting.

Lessons learned

- Be patient; progress is slow.

- In order to measure progress we needed to have a baseline and to make our goals even more specific than originally intended.
- Community organisation partnerships are essential.
- Listening really does pay off.
- Simple efforts can make a big difference (e.g. college coupons).
- Link programmes strategically to maximise impact.

We also learnt to acknowledge that changes in audience profile can make staff anxious. It is advisable to incorporate into your plan a process for staff to gain skill and comfort in working with new audiences. We need to apply our strengths as a staff to the work of attracting and serving new audiences, e.g. by continuing a tradition of warmth and friendliness on site, alongside skilful teaching.

Chapter 9 RESEARCH AND EVALUATION

By now, it must be apparent that research and evaluation are keystones of marketing. Information is marketing power and essential for the marketing strategy. Sometimes understanding mistakes is just as important as enjoying success. It really is essential to monitor effectiveness whenever resources are being used. Some areas are very difficult to monitor. In-built devices have to be considered very early in the planning process. Admission-charging museums have a huge advantage here. Museums that make a transaction with their customers are in a much better position to monitor different marketing techniques than free museums. Crude market segments can be measured by price. The impact of special promotions, including discounting schemes and advance ticketing sales, is easily measured.

Visitor research

It must go without saying that regular consistent visitor research should be undertaken by every serious-minded museum.

Ideally, visitor research is both quantitative and qualitative. Quantitative research will provide useful numerical information as well as visitor profiles to provide basic information. Good quantitative research carried out by trained interviewers can also elicit useful qualitative information, i.e. reactions to the product on offer and statements about future intent. For in-depth information on attitudes and likely reactions to future changes, focus groups are currently the top of the agenda – not just with attractions but with politicians.

Before embarking on a major piece of visitor research, do your homework. Some forms of information about visitors and potential visitors can be gathered without surveys, by using desk research. Published resources can provide information on local demographics or the results of other organisations' surveys (see Appendix 1, for example). Information may be available from the museum shop in the form of customers' postcodes, and also other information about how much each person spends and in what categories of product. The education department probably keeps a comment book of some kind, so that the comments of children and teachers can be accessed. This is useful because the code of practice for market researchers prohibits them from surveying children under 16.

This information will be of help in putting together your own research among visitors. Surveys can be organised as:

- self-completion questionnaires
- interviews by trained volunteers or professional interviewers in the museum.

Both require the same clear thinking; know why you are doing it. Is there a specific problem that needs to be researched, or is it a matter of collecting regular, consistent information to assist all areas of planning?

Visitor research in the galleries of the Natural History Museum. Courtesy of Sue Runyard.

In planning our second in-house survey for the museum service [Hampshire County Museum Service], I decided to take the risk of using self-completion questionnaires. This was because on the previous occasion we had asked museum assistants (attendants) to interview visitors using a brief questionnaire. Two things emerged: firstly, most of the staff felt uncomfortable doing it and were very reluctant to do it again; secondly, there was a huge variation in sample size, with some museums filling in only 20 questionnaires and others 500! Self-completion at least led to a more consistent sample throughout the museums in the service. I have used the results of the second survey extensively in formulating the marketing plan, and feel that I could not have managed without them.[1]

Whenever possible, use a professional research agency. The results will be more accurate, professional and consistent. Questionnaires will be designed to be unambiguous. Interviewers are trained not to be biased in their approach. The analysis will be useful and factual. Sometimes local business colleges will undertake a survey as part of a practical project for their students. These need careful supervision and instruction. The element of consistency may also be lacking.

Many smaller museums are now using self-completion questionnaires. Bedfordshire Museums have developed a market research resource pack to help small museums (see Appendix 2, Resources). This has been developed by professionals, has been carefully researched and should serve as a useful model for museums. Self-completed questionnaires can take a long time to accumulate if no one is driving the project. Some museums staff a desk, engage visitors in conversation, and persuade them to fill out a questionnaire themselves, giving a pencil or postcard as a small 'thank you' gift. This speeds up the process.

Some questions – hypotheticals – should never be asked. The question 'How much would you be prepared to pay for ...' is a complete waste of time. Until a product is offered, people cannot answer honestly how much they would pay. Nevertheless, many museums do wish to ask this question, especially if they are trying to establish a price for admission to a new facility or exhibition. It is much more advisable to ask about a person's other leisure habits. For example, regular cinema attendance indicates that households have sufficient disposable income to spend about £8 per head on two hours of leisure. If this information is put together with other motivational questions about aspirations and interests, the resulting information is a far more accurate guide to spending capacity than can be elicited by a hypothetical question.

We [Bradford's Colour Museum] learnt from the research undertaken in 1992 ... that it is far easier and better to deal with small groups of students (i.e. three to four) than with larger groups (six to seven). The main problem encountered here was ineffective lines of communication between the students, which resulted in staggered arrival times for meetings, or students turning up on the wrong days, or approaching various members of staff and asking what they should be doing next. The cash costs were negligible, but a fair amount of staff time was involved.[2]

Finding the most appropriate way to ask a question in order to obtain accurate results is a fine art. Kenneth Hudson, founder of the European Museum of the Year Award, warns museums to beware of the politeness factor. He reckons that once a person or family group has decided to visit a museum, they have committed money and precious time to the occasion, so there will be a great desire to confirm that decision by taking a positive view of the experience. Also, the educational and intellectual overtones of a museum visit tend to make people feel that they should be enjoying it. One has only to look at the consistently high satisfaction results achieved in some national museum visitor surveys. Can 98% of visitors really have had a great time if the museum was dirty, poorly serviced and had incomprehensible labels?

It is, therefore, quite important to frame questions in a way that leaves the visitor free to take a reasonably objective judgement. Here is a format that encourages thoughtfulness:

> Q: *Thinking about the staff you have met today, how helpful have you found them?*
> A: *Extremely helpful Very helpful Quite helpful Neither helpful nor unhelpful Not very helpful Not at all helpful*

This approach gives graded options and, importantly, provides an even number of options, so that responses have to err towards one side of the scale or the other: there is no middle option.

Qualitative research

An effective, and reasonably cheap, way of buying national qualitative/quantitative research is to take part in an omnibus survey. These national 'polls' by MORI and other organisations are conducted as telephone interviews of a statistically representative cross-section of the British public on a variety of subjects. You buy as many questions as you like, but you may be one of up to 20 different subjects. This can be a good way for a large museum or heritage attraction to measure awareness of its activities or of special promotions. It would not be suitable for a small or medium-sized museum which did not already enjoy national awareness.

Focus groups or in-depth interviews are only valuable if professionally organised. This means an investment in time and money, briefing the researcher and taking part, as a bystander, in the discussion groups. In-depth interviews can be carried out over the phone or in person. Visitors or non-visitors chosen by particular criteria, e.g. new audiences who you want to target, or influencers

and decision-makers, can be asked to discuss and give reactions to certain issues or topics. This can be a great way to gauge popular perceptions, misconceptions and levels of interest. Be prepared to encounter the raw, unvarnished truth if you venture in this direction!

Utilising research

It is sad but true that some museums either underutilise their research results or completely ignore them. Results should be disseminated throughout the museum, because virtually every department in the museum should be aware of public perceptions when they shape policies. For the marketing department research is vital.

Professional market researchers might have reservations about how we [Dean Heritage Museum, Edinburgh] did our research, but we think it provided useful pointers. For example:

- With 30% of visitors sampled proving to be repeat visitors or coming on personal recommendation, we recognised that product and product improvement are very important.
- We realised how important it is to place our literature in tourist information centres.
- We proved the effectiveness of our publicity leaflet, but learned how to improve distribution.
- We discovered that a joint tourist attractions' leaflet was working better than a glossy leaflet devoted to museums.
- Many expensive guide-book entries proved a waste of money, and we began to question the effectiveness of media advertising.
- For the first time we were able to handle 'bargain telephone sales' advertising more sensibly because the information we had collected showed what was fruitful and what was not.[3]

Evaluation of museum performance

Bench-marking

Bench-marking is another buzz word for cultural attractions in today's world! Simplistically, it's a way of measuring performance against bench-marks you have set yourself in a systematic fashion; or against an average performance of other museums and galleries which feed their statistics, information and results to a central organisation. The

Cultural Heritage National Training Organisation, formerly the Museums Training Institute, has produced a bench-mark work-pack, free for museums and cultural attractions.[4] Version 1 pack contains some information which relates to marketing, but unfortunately there is no specific section which could provide useful marketing feedback. By returning the questionnaire in the pack, cultural attractions will receive a report comparing the museum's performance with other similar sites. Responses are treated in confidence.

Bench-marking projects have already been established among independent museums and among leading visitor attractions. The first, initiated by the Association of Independent Museums, provides valuable feedback for smaller independent museums, measuring their performance in terms of revenue and visitors trends against the average of similarly independent and charging museums. The Association of Leading Visitor Attractions (qualification for membership is over one million visitors a year) is also leading a pioneering bench-marking initiative whereby major museums and cathedrals can compare their performance against trends in an exclusive (27 member strong) group which includes the UK's leading commercial attractions.

The most useful aspect of bench-marking is to look at trends rather than actual performance. It can provide important feedback on particular marketing initiatives where your figures are substantially different to the general trend. However, it is important to make sure that your figures are being compared with the average figures of a similar group of attractions or museums.

Evaluating marketing activities

Targets

The marketing strategy or audience development programme should have set clear targets for any particular project or for the year as a whole. Finding time to collect this information and relate it to the original strategy is not always easy, but it is invaluable. Analyse the results by examining the figures critically, particularly if they are exceptionally good or bad.

Were there negative, or overtly positive, factors at work which influenced these results? You may have had to close for part of the year for refurbishment and this would have affected the visitor targets (and may not have been taken into account at the time). Your special exhibition may (quite by chance) have benefited from renewed

interest in Jane Austen or William Morris, due to a current TV series (you may wish to claim this as foresight!).

Did revenue increase or decrease in the shop? Was it staffed right through the opening hours? Was the merchandise appropriate? It should be possible to analyse the most popular items through simple stock control, even if the till is not sophisticated enough to do this automatically.

Did the increase in visitors show a relative increase in café sales? If not, why not? Is it a question of opening times or not having the right products on sale? Perhaps there are not enough seats?

Specific evaluation of activities

Advertising

Large expenditure advertising budgets include in-built measurements, whether through audience research or mechanical means (such as discount vouchers or telephone enquiries). Coded advertisements can be very useful where a response (for booking reservations or purchasing tickets) is required. The response to *ad hoc* general advertising in tourism publications, guide-books and local newspapers is impossible to measure accurately.

Special promotions

Museums and attractions are bombarded with offers to join various promotions – usually offering two for the price of one or other discounts. These may be run by tourist boards, local newspapers, guide-books or events such as Museums Week. Choose your participation carefully and make sure you can measure the results. Usually short-term promotions (which meet your marketing targets in terms of audiences) are more effective and easier to measure. The simpler the offer the better (two for the price of one is good for communications), but make sure the take up can be effectively monitored through your tills even if there is no voucher. The full co-operation and understanding of desk and admissions staff are needed for any scheme that involves discounted entry.

Distribution of printed material

This is becoming increasingly expensive and should be more accurately measured. If using more than one method of distribution, museums would be well advised to compare results in each method. Introducing a coded entry form – quiz or competition – is a good

way of finding out which distribution methods are most successfully reaching the target audience. You should also check on your distribution by visiting a random number of tourist information centres and other distribution centres throughout the main season.

Group travel

This is an easy area to monitor, since the museum will automatically collect information about visiting groups. Try and relate this to specific mailings or promotions at trade fairs so that an analytical report can be produced and informed decisions can be made in the future. Simple records can show trends in age groups, interest groups and geographical zones. It is always useful to talk with tour group leaders and coach drivers, who have valuable insights to offer.

Audience development

Regular, consistent surveys are the most highly recommended way of monitoring performance in this area. It is also worthwhile keeping track of costs. When an upturn in attendances of a particular targeted audience is detected, it is instructive to calculate how much per head it cost to attract each new visitor. It can make for depressing reading; on the other hand there may be a consistent upward trend, showing that progress is being made, even if the early visitors from a new audience prove quite expensive to attract.

Economic impact

Marketing and public relations campaigns which set out to change perceptions or re-position a museum or gallery, or which launch a completely new product, should if possible be accompanied by some sort of economic impact study. Increasingly, it is important to demonstrate the value of museums as economic generators. John Myerscough's work in the 1980s showed that the arts can be formidable generators of income both nationally and at local level.[5] Studies done in the late 1980s showed that, depending upon location, museums can generate spending of between £8.50 and £33.00 per head in the locality of the museum – on petrol, food and other goods and services. These figures are much higher now.

Carrying out economic impact surveys during major exhibitions, or simply during the course of a normal period of opening, may be outside the scope of many museums. If we want people to pay credence to surprising statistics, we need to be sure that those statistics are independently, professionally and dispassionately

gathered. It is, therefore, best to use an outside consultant to do this work and to carry it out in conjunction with the local authority, the tourist board or, in the future, your regional development agency (see Chapter 17).

Notes

1. Jo Bailey, marketing officer, Hampshire County Museum Service. Quoted in Runyard, S. (1994). *Low-cost Visitor Surveys*. Museums and Galleries Commission, p.22.
2. Sarah Burge, curator, Bradford Colour Museum, which worked with students on the MBA course at Bradford University. Quoted in ibid, p.23.
3. Ian Standing, director, Dean Heritage Museum, which carries out regular self-completion visitor surveys. Quoted in ibid, p.25.
4. See Appendix 2, under Museums and charitable organisations.
5. Myerscough, John. (1988). *The Economic Impact of the Arts*. Policy Studies Institute.

CASE STUDY 10 Economic impact – 'Eternal China', California

When museums stage particularly successful exhibitions which bring in extra visitors to the town, it can be useful to commission an economic impact survey to assess the financial effect. The results of such reports provide convincing evidence of the museum's importance to the local community – not just in educational and social terms but also in hard cash.

Santa Barbara is a tourism town in California, but until recently the Santa Barbara Museum of Art was not perceived to be making any major contribution to the tourism industry. This summary sheet from the economic impact survey for the 1998 'Eternal China' exhibition (for the full marketing plan, see Case Study 4) shows that the museum was drawing in an audience specifically to see the exhibition – and that those people were spending significant sums of money in the neighbourhood.

When the specific figures are extrapolated to represent the whole of the exhibition (a very conservative calculation would multiply by three or four times) the study demonstrates that the exhibition generated at least $3 million for the town of Santa Barbara.

Table 2 Summary, Economic Impact Survey

	Resident survey	Non-resident survey	Totals
Average spend ($)			
Food/beverage	12.06	51.62	
Recreation	8.66	10.48	
Transportation	5.52	8.37	
Retail	30.36	47.41	
Accommodation	NA	65.81	
Other	8.06	15.66	
Total	**64.66**	**199.35**	
Average party size	2.85	4.96	
Adjusted total per person ($)	22.96	40.19	
Number of visits to the 'Eternal China' exhibition	33,809	88,606	128,415
Percentage whose primary purpose was to see the exhibition (net impact)	88	83	
Net conversion: number of visitors primarily to see exhibition	35,032	73,543	108,575
Estimated economic impact from net conversion ($)	794,787	2,955,8177	3,750,604

CASE STUDY 11 Visitor research – J. Paul Getty Museum, Los Angeles

The J. Paul Getty Museum has for many years done regular, consistent visitor surveys. Since it moved from Malibu to its new location at the Getty Center in Los Angeles, staff have been looking even harder at who is (and who is not) coming to visit. Dr Diane Manuel, program evaluator at the museum, says this requires 'different strokes for different folks'.

Every museum has different priorities. Research needs to be directed towards specific needs, so museums shouldn't just copy what others have done. The key is to think clearly. Research should spring from the mission, not be free-floating. While the mission may be pretty high-flown, the survey needs to address those goals in a very specific and practical way. Never ask a question unless you know how the answer can be analysed and what eventual purpose it will serve.

Every museum probably wants to know the same core information: who's coming, what they thought about it, who's not coming, etc. After that, research can get into some very interesting areas, such as who goes to other venues, whether there is any overlap, what motivates people to come. It can be interesting to compare people who go to museums with, say, people who go to sports events. Do they have completely different interests, or is it a matter of early conditioning on how to behave and how to enjoy yourself in a museum or a sports stadium? What little research is available indicates that museums' interests will be served by attracting and welcoming children from an early age. Changing people's habits later in life is a challenge.

There are questions that should never be asked – they may seem interesting but they cannot be analysed. Nor should we ask 'what if ...' questions. Responses are unlikely to be truthful or realistic. Likewise, when struggling to discover how to write texts for display purposes, it's no good asking 'what do you want to know about this?' Visitors cannot tell us what they do not know. It is the job of the museum to identify options, and then test visitor reactions.

The difference between surveys and focus groups is that surveys can obtain a great deal of simple, interesting information fairly quickly. Focus groups take a while to set up and carry through, and use far fewer respondents – but the information can be to a much greater depth. Surveys answer the what, when, who questions. Focus groups get into the how and why.

CASE STUDY 12 The Tate at St Ives, Cornwall

St Ives in Cornwall has had a long history of association with artists. Famous artists who made it their home include Barbara Hepworth, Bernard Leach and Ben Nicholson. Two fortunate coincidences – rather than inspired planning – contributed to the transformation of St Ives into a cultural destination and the consequent re-positioning of Cornwall, and to some extent the West Country as a whole, as a cultural destination.

The Tate Gallery, firmly established for 100 years in London, decided that it should spread cultural influence and benefits to other parts of the UK. After the successful opening of the Tate Gallery at Liverpool, St Ives was identified as another possible outpost. The status of Cornwall meant that European funding for part of the project was possible. The county council was reluctantly keen, the local population vaguely hostile – yet the project went ahead in a new dramatic building overlooking the sea.

The Tate at St Ives opened to great acclaim in 1994. At the same, the West Country Tourist Board and its partners had decided that the time had come to respond to the decline of the traditional seaside holiday market and were developing a series of initiatives to identify new products and new markets. It was clear from research for the first museums/tourism strategy for the region in 1992/93 that there had to be a great deal of awareness-raising among the tourism providers themselves before the West Country could even dream of re-branding itself as a cultural destination. The view of tourism officers of museums could be summed up by the comment 'good places when it rains'. Yet the West Country has rich cultural resources in terms of artists and craftspeople and also in art galleries, collections and museums. For the UK market, the West Country was firmly seen as a bucket-and-spade destination – and certainly not somewhere they would go if they had more money and could go to Spain or Greece.

The arrival and opening of the Tate Gallery acted as the essential catalyst which sparked off the process of change. The experienced public relations department of the Tate Gallery worked nationally to build an image for the new gallery and for St Ives and Cornwall as a whole, targeting new visitors whose interest included arts (of course) but also nature and the countryside. The new director used educational programmes aimed at adults and children, to gradually win round the local population.

The striking building for the Tate at St Ives, Cornwall. Courtesy of Ylva French.

The county council contributed by initiating research which illustrated the economic impact of the Tate Gallery at St Ives both locally – in terms of increased bednights, extension of the season, spend in shops, etc. – and in terms of spin-offs for working artists and craftspeople. This ongoing research has been essential, and its public dissemination has been an important tool in changing attitudes, however slowly, among tourism providers.

Early research produced some very encouraging results, with 85% of traders confirming that their trade had improved in the first full summer of the Tate and that the season had continued for longer. The council estimated an overall increase in trade of 5% in the first year.

Supporting information material included a crafts map identifying working craftspeople in Cornwall. Less successful initially were relations with other museums and galleries in other parts of Cornwall, and a planned bus shuttle service never got off the ground.

Thanks to brilliant media coverage and an excellent product, the Tate at St Ives was set for success from the beginning, but the director realised there was work to do in maintaining interest in the media and in building bridges with other cultural institutions. The answer lay in a festival – 'Quality of Light' – planned with input from cultural institutions in Cornwall and led by Falmouth Art College, rather than the Tate at St Ives. This took place in 1997, the objectives being:

- to spread visitors
- to introduce 'cutting edge' art
- to use industrial locations
- to promote international collaboration
- to involve galleries and other venues.

Galleries and derelict industrial sites around Cornwall were chosen as locations for new artwork, and 14 European artists were invited to create installations and experiences. The three-month festival was supported by a leaflet/map which guided visitors from one event to another by car. As an alternative, a free coach from the Tate at St Ives was laid on. Very little advertising was done due to the limited budget, but media activities co-ordinated from Penzance, where the festival office was located, with input from the Tate public relations team, ensured good national coverage. Essential for future planning was the research, which showed the high proportion of visitors who came to St Ives specifically for this festival.

Table 3 'Quality of Light' visitor survey

Visitors to the area (staying away from home)	71%
Visitors from London and the South East	35%
Average length of stay	8.8 nights
Reason for visit	
Quality of Light	18%
Quality of Light as added reason	49%
Decision to visit before leaving home	39%
Publicity	
Leaflet	32%
Press/television	20%
Recommendation	18%
Economic impact	
Associated expenditure	£7.4 million
Additional spend through new visits	£1.4 million
Total number of visits to sites	149,000

Note: Some visitors answered more than one question.

Source: Research (unpublished) undertaken by St Ives International.

These results are very impressive for a first event developed on a budget of £300,000. Lessons learnt from 'Quality of Light' have informed the new exhibition, 'Dark as Night', which got under way in May 1999. As before, a number of venues all over Cornwall will be involved, but the event will be strengthened by the introduction of a series of exhibitions over a longer period, thus providing more opportunities for media coverage as well as prolonging the season.

The Tate at St Ives has now logged over one million visitors. The West Country Tourist Board and South West Arts are continuing the attempt to re-position the region as a cultural destination by developing a series of cultural routes. This ongoing commitment to the re-positioning process is one of the keys to its success; the other is the investment in the cultural heritage as represented by the Tate at St Ives and in other museums, notably the Penzance Art Gallery and the Royal Cornwall Museum, through Heritage Lottery funding. None of this investment would have made any sense without an existing artistic base in the area on which to build.

Those leading the change know that culture cannot replace the dying Cornish tin-mines, nor the decline in the traditional seaside holiday. But it can contribute towards making the West Country a better place for the next generation of local people looking for work.

CASE STUDY 13 The Museum of Science and Industry, Manchester

The Museum of Science and Industry in Manchester (MSIM) is an educational charity based in the buildings of the world's oldest passenger railway station. As one of the most popular attractions in the North West, the museum welcomes one-third of a million visitors each year.

Visitors are attracted to the lively, participative way the museum interprets the past, present and future of the region. The overall theme is the industrial city, and central to the museum's mission is capitalising on Manchester's unique past, contributing towards its future prosperity and fostering pleasure and understanding for a broad public.

Marketing is a fundamental activity within the museum. As an independent charity, the raising of income through admission charges, the operating of commercial services and the attracting of sponsorship and grants are essential activities. Equally, developing products in line with customer needs and attracting new audiences are both core elements of the marketing strategy. The museum has a commitment to provide entertaining and educational exhibitions to the broadest possible audience.

Alison Vincent, MSIM marketing manager, describes the research and evaluation aspects of one major campaign.

In addition to its permanent exhibitions and galleries, The MSIM presents a varied programme of events and changing exhibitions. The extent of the marketing campaign for each element in the programme varies, depending on the resources available. Rather than following similar formats for the changing programme, the MSIM looks at what each element has to offer and how best to use the resources available:

- What will attract most public relations – can we rely on a below-the-line strategy?
- Do we have great expectations of this event?
- Do we need to actively attract visitors or can we use the event to enhance visitor experience on site?
- Is this event about opening a dialogue with an organisation or community or about increasing visitor numbers?
- Have we put substantial resources into this project?
- Do we need to see a return for our investment?

By making our expectations explicit we can immediately see where to concentrate time and money. There is often no point in stretching resources to provide a little marketing support for each activity, because the message becomes so diluted that there is minimal impact on target audiences. All too often, the success and failure of marketing campaigns in museums has depended more on how realistic expectations have been rather than on the creativity of the marketing.

Once we have made the decision where to focus resources, the need to measure the effectiveness of campaigns and understand visitor profiles and trends is evident. Since we have sacrificed other activities to enable this marketing spend, we have to learn from it. It has to provide information which will aid the development of future campaigns and ensure each pound spent in the future provides even more value for money. We want to know with more certainty whether the museum meets expectations, and if not, why not? How long in advance do people decide to visit? Are adults or children the main motivators in a family group? Which newspaper advertisements promote the best response? Information of this type helps us to understand who visitors (and non-visitors) are and contributes to our aims of attracting them and meeting their needs. At the end of the project we should have something concrete to feed into future corporate and marketing plans, some way of improving our performance.

In 1996 the museum opened a blockbuster Star Trek exhibition. The marketing campaign was extensive by museum standards and included a brief (very brief!) television campaign and both press and radio advertising. In addition, public relations activities ran through the whole programme with direct mail and promotional initiatives interspersed at intervals. As the exhibition was very different from the usual programme, and marketing at this level was new to the museum, it was necessary to understand:

- How the visitor profile differed from the core audience.
- If new audiences were being attracted (one of the major reasons for doing the exhibition in the first place), what was their experience at the museum? Could they be converted from Star Trek visitors to MSIM visitors?
- Which elements of the marketing spend worked the best and was this different from the usual experience?

In the past, we have had good results with using incentive vouchers in the press, to track response rates from different publications and

Janine and Andrew Scott in Xperiment!, *the hands-on science centre at the Museum of Science and Industry in Manchester. Photograph by Jean Harsfall, Museum of Science and Industry.*

areas. However, we were positioning this exhibition as a 'must-see' exhibition in Manchester, and didn't want vast amounts of money-off coupons appearing in the press and downgrading this image. Also, due to the nature and variety of information we wanted, we decided that a quantitative visitor survey was the only really good way to get the level of feedback we were looking for.

We employed Arts About Manchester, a local arts marketing and audience development agency, to carry out exit surveys with visitors, and 500 questionnaires were completed over a three-month period for a cost of £2,000. We based the survey on previous questionnaires so that we could compare the results with data we had built up over the years. We also added new questions to probe specifically about the exhibition and our activities relating to it. The results were good:

- 50% of visitors to Star Trek were new to the museum
- 15% of visitors were not aware of the museum before the block-buster exhibition, thus showing clearly how far Star Trek could boldly go in raising awareness!
- 72% of respondents said that they wouldn't have visited the museum if it had not been for the exhibition, indicating that the exhibition was key to attracting repeat visits as well as motivating first-time visitors.

There were also differences with the audience profile. Visitors travelled from further afield, with longer drive times to the museum. They had also made the decision to visit earlier than indicated in any previous research (the number deciding to visit either on the day or the day before was halved from previous surveys, with over one-third planning their visit at least one month or more in advance). This backed up other results: it makes sense that new visitors coming from further away specifically to see an exhibition would plan their visit in advance. This is obviously different from our frequent-visitor profile – people who know what we have to offer and call in for a casual visit, often making the decision at the last minute.

The response to the marketing campaign was good, with awareness of:

- print from 34%* to 58%
- radio publicity and advertising from 7%* to 18%
- press publicity and advertising from 28%* to 40%.

 * 1995 Visitor Survey at the Museum.

We tend to interpret the data for media advertising and public relations together since many people would describe a good article about an exhibition as an advertisement. By so doing, we can still see which media channels were the most successful, without trusting too much on correct definitions of industry terms.

Ratings for television were much the same as usual. This was disappointing in that we had a paid-for campaign in addition to the television public relations we usually rely on. The campaign was so small (only 12 spots) that it obviously did little to increase awareness with most of our visitors. However, with the core Star Trek fan-base the television advertisement was mentioned much more frequently. This showed the effectiveness of television in starting the word-of-mouth publicity and conferring status on the exhibition – 'it must be good if it is advertised on TV'.

In all, 85% of visitors thought Star Trek was very/quite good. Interestingly, 86% rated the museum itself as very/quite good. This was encouraging since we wanted new visitors coming to the museum specifically for Star Trek to find the museum itself interesting and worth another visit. Almost 80% of the sample said they were likely to visit again.

The research was useful as it has provided the blueprint for much of the major exhibition marketing since then. For exhibitions like this, we have an intensive campaign at the launch with a wider geographical spread than usual. This helps to position the exhibition and give it status, and it also gives people the time they need to plan their visit. We want as many visitors as possible to visit immediately following the launch, so that the word-of-mouth publicity can start working for us. (We have even specifically targeted tourist information centre staff, hairdressers and taxi-drivers for public relations events to harness as much word-of-mouth publicity as possible.) Radio works well for us and forms an important strand of our campaigns. Where budgets are tight, we often tend to advertise on radio and rely on public relations for press coverage.

Exhibitions which attract broadly different audiences from usual are good at initiating a dialogue, but if the core product cannot sustain the relationship there is little long-term benefit to the organisation. We know that many of the out-and-out Star Trek fans will not come back to the museum unless we offer a similar product. But the mass marketing campaign was successful in that it attracted many other people who had not heard of us before and who are far more typical of our

usual visitor profile. We know from tracking season ticket purchases that visitors who purchased a season ticket for the first time for Star Trek are still season ticket holders three years later.

The museum is much more experienced now in blockbuster exhibitions, with 1999 visitor figures at an all-time high following a massively successful Dinosaurs exhibition. We are undertaking a research project on this and will duly feed this back into the next major marketing campaign.

By understanding visitor profiles, trends and motivations we can plan for the future, using our knowledge and resources to best advantage. Evaluation can reveal hidden truths. It often just confirms gut feelings. Either way, it is an essential tool for development.

Chapter 10 PRINCIPLES OF PUBLIC RELATIONS

Public relations is about reputation – the result of what you do, what you say and what others say about you. Public relations practice is the discipline which looks after reputation, with the aim of earning understanding and support and influencing opinion and behaviour.[1]

How information became public relations

When public relations first reared its 'ugly' UK head in museums – early pioneers were Corinne Bellow at the Tate Gallery and Sir Roy Strong at the Victoria and Albert Museum – it was promoted as an extension of the public information function. It was developed to interpret and explain what particular museums were doing in a way which would be more digestible to the media than leaflets and promotional material. It did not take long, particularly for showmen like Strong, to appreciate the potential of adding a twist to the presentation, inspired by public relations activities in the commercial world. And as the media's appetite for news, unusual angles, good photographs, exclusive interviews and scandals has grown, so have museums and galleries appreciated that public relations as it relates to the media has to be managed if it is to be to the advantage of the institution in a competitive and potentially hostile environment.

Public relations expands

In the 1960s and 1970s public relations was very much about media relations. And the weight of newspaper cuttings is still a valid and inspiring way of measuring the success of any public relations campaign. It was during the Thatcher years when public funding came under severe and sustained attack – directly from government and indirectly via local authorities – that a number of organisations, including museums and galleries, realised that public relations had another job to do: to keep existing funders informed and happy. At the same time the call went out for commercial sponsors to come on board, and again museums and galleries had to face the demands they were putting on returns for their money, in terms of profile, directly with target audiences and indirectly through the media.

Some basic principles

Public relations has several jobs to do within and outside the organisation. It is the channel as well as the means of communications,

and how it is done is just as important as what it does. There are conflicts within every organisation just as there are between the organisation and those outside. Public relations is the process of maintaining harmonious and understanding relationships between the various internal parts as well as externally with stakeholders and others.[2]

Here are some fundamental principles of public relations which are relevant both to publicly funded organisations and to independent, commercially managed attractions. Public relations should be:

- part of the whole organisation
- true and honest
- consistent
- creative
- well timed
- reflect best practice
- professional.

Public relations is part of the whole organisation

From the information and security staff to the chairman and trustees, everyone is communicating something about the organisation, its principles and its mission. It may seem a simple solution to set up a public relations department, leave it to get on with public relations, and let everyone else get on with their job. But this will not work. Just as the marketing strategy is part of what everybody does, so the public relations strategy is central to the working of the organisation. Everyone in the public eye and everyone with an opportunity to communicate with stakeholders and influencers is part of the team.

The politics of the last few years have given this idea its own terminology – 'on message'. Take this rather frightening term and use it positively. Think about how you would like your staff and trustees to talk about your organisation. And then start to cultivate these principles within the organisation by doing it yourself and by giving your colleagues lots of information and reasons for talking positively about their own organisation (see Chapter 17).

The organisation of public relations within the institution will be a reflection of how it is viewed by its director and trustees. Here are some tell-tale signs of poor internal public relations which will reflect on the organisation's reputation in due course:

- The public relations officer or manager is never allowed into the boardroom.

- The chairman has a direct line to (and his/her own agenda with) the media.
- The marketing or public relations officer has no authority or involvement with consultants retained by the director or chairman.
- Curators or exhibition officers engage in behind the scenes tittle-tattle with friendly journalists
- External agencies report only to marketing or public relations officers and never see the director or chairman.
- The press office consists of voice-mail messages – everyone is always in a meeting.

Truth and honesty in public relations

Public relations activities and messages must be true to the organisation; they must reflect accurately what the organisation stands for and what it is delivering to the public. Public relations is not a substitute for a good product, a good story or the truth.

Public relations practitioners are not infrequently consulted by museums and galleries in crisis and asked to perform magic – create good media stories out of nothing, raise profiles where no profile exists or, worse, turn round a crisis-hit institution without major internal changes.

There are journalists who will buy into a good sell from public relations practitioners and there are public relations people who are known, and in some ways respected, for their media stunts, but anyone who plans to be around to build an ongoing reputation or repair a damaged one needs to be truthful and honest

Good public relations starts internally with a communications audit and a PR strategy (see Chapter 11) and then proceeds to the implementation process. There may be severe shortcomings – in terms of staff, internal communications, trustees and directors, the product itself – which have to be addressed before external communications can play a proactive and positive role.

In practice, truth and honesty remain the basis of good public relations. There may well be situations where the whole truth cannot be told, but that does not mean that lies should be a substitute. It is better to say nothing and ride the storm, if necessary.

Consistency in public relations

Hand in hand with honesty goes consistency. It is only *sustained* public relations activities over a period of time which are going to be successful. There are thousands of messages bombarding the public

every day. In Chapter 13 there is an indication of what each individual journalist may receive in terms of information every day; only a small fraction of this gets through and is then interpreted correctly.

Politicians who appear regularly on television know that they have perhaps 20 seconds to get their message across before our attention wanders to what they are wearing, the colour or lack of hair, the tie, the brooch on the collar. If they change their minds every five minutes, which of course they often do, we lose the plot.

Similarly, organisations with frequent changes at the top suffer from lack of consistency. Suddenly the messages to the media and other stakeholders cease, while the new incumbent takes stock and reviews and adjusts the messages. This is bad news for the organisation. Quite quickly they will be forgotten, dropped from the page, the round-up or the unprompted call to get a quote. Nothing beats the regular drip, drip in public relations and the consistent message that this delivers — nothing that is except the mega-story but that does not happen every day.

Consistency and regular communications with the media and stakeholders is a fundamental principle of public relations.

Creativity in public relations

It is easy to get bogged down in the day-to-day management and implementation of the public relations plan and forget the most important function which the PR officer, manager or consultant can provide — creative and clear thinking.

The public relations consultant to the museum and the internal PR team must have an opportunity to be creative. That's what they were hired for! That means giving them enough time to develop new ideas and new thinking and to be involved in product development, including the planning of new exhibitions, educational initiatives and events and community activities, from an early stage. It also means that they must be allowed to fail every now and then: not every public relations idea is going to work. As long as everyone learns — this, too, is valuable.

The public relations officer should be a valuable resource, someone who is in touch with other institutions and the wider world, and who brings useful ideas and important insights. It is very easy for those who are very close to their subject, their wonderful objects, and their specialism to lose sight of what the public might want and how they might turn against something that is politically incorrect.

When a public relations officer or consultant stops providing that

creative input or is not encouraged to become involved, he/she will lose interest and you will lose a potentially valuable member of the team.

Timing in public relations

Many public relations practitioners would put this at the top of any list. Get your timing right – and the world is your oyster. Get it wrong – and even the best story – an official opening by HM the Queen or a president, or a world exclusive – will go wrong.

You can learn about timing and get it right by incorporating deadlines and target dates for each stage of your launch or public relations masterplan into your strategy. It is never too early to start promoting a new exhibition.

Timing is also about being on the ball and being aware of what's going on in other institutions and attractions, about having a feeling for what's going to make the news by reading, watching and listening to all kinds of media. It's about catching a public mood at the right time, like catching a pendulum as it swings in your direction. Some people are better at this than others, but everyone can learn. Read the newspapers, listen to the radio, watch television on a daily basis and see what it is that is catching the public mood today!

In the end timing can be out of your hands; at the extreme are wars and disasters. The sudden and tragic death of Diana, Princess of Wales in August 1998 wrecked hundreds of public relations strategies around the world, and the pages and news programmes devoted to her life and death knocked every 'soft' story off the news pages for almost a month. In the face of such a situation all you can do is re-cast your plans and learn that all activities which involve the media also involve uncertainties.

Adopting best practice

Don't think you know it all or you will go on repeating past mistakes. Learn from others and adapt successful public relations ideas to your museum, gallery or attraction. It is said that imitation is the sincerest form of flattery, and this certainly seems to be the case in public relations work. But be careful: you can only get away with so much; you have to think of your own creative angle; and, as regards stunts in particular, you have to gauge how much the media is likely to take.

The ghost story is always popular and makes regular appearances. It made great headlines for the Royal Albert Hall when journalists were invited to spend a night with the ghost (which of course never

showed). This has now been overtaken by a couple of ghosts on a video camera in a Leicestershire museum. One museum sending out parcels of dust to announce their redevelopment plans is a good idea; but if two or three others follow suit, they will not get the same media attention.

Networking, public relations seminars and the trade press are all good sources of information for finding out what others are doing. When something unusual makes the headlines for the heritage, ask yourself how was it done – what were the ingredients of that successful story – and then see whether you can apply it in your public relations activities.

Professionalism in public relations

Professionalism should not be difficult to define as public relations has its own institute with a code of conduct[3] to which its members should adhere. This code sets out some basic principles. For example, a public relations practitioner should:

- conduct his/her professional activities with proper regard to the public interest
- have a positive duty at all times to respect the truth
- have a duty to declare conflicting interests
- identify and respect the code of other professions
- respect statutory or regulatory codes
- honour confidences received or given in the course of professional activity
- not improperly influence the media or others
- not discriminate on grounds of age, disability, gender, race, religion.

In the USA, museum public relations are inspired and guided by ICOM (International Council of Museums) and Art Table activities as well as by membership of wider non-specialist groups. Most European countries have their own association for public relations consultants.

However, as in every industry, there are a number of practitioners who describe themselves as professional but do not have the training or accreditation which membership of a professional institute implies. This does not necessarily make them worse at their job; membership cannot guarantee the effective delivery of public relations.

Whether or not you are a member of an institution, professionalism

is important and means observing the principles outlined here in dealings within the organisation as well as without. The public relations director, manager or officer has a difficult and delicate role: he/she represents the external ears and eyes of the organisation as well as being its spokesperson. This person is frequently the only professional in this discipline within the organisation. Membership of professional groups and networking with other public relations professionals is important and will help the PR officer to sustain his/her professionalism.

Organising public relations

Where the public relations function sits within the organisation's framework will depend very much on the individual organisation. In terms of corporate public relations and how it influences everything within the organisation, the function is either part of the director's role or a senior appointment reporting directly to the chief executive and with its own department and staff.

In terms of the public relations role in marketing the museum or heritage attraction, this function may be part of the marketing officer's job or it may be a separate function linked to development and sponsorship. This is likely to be a more junior hands-on post, which does not always sit comfortably with the strategic role of public relations in terms of influencing stakeholders and funders and guiding the organisation as a whole. This is where an independent public relations consultant or agency may come in.

Here are three models for different types of organisations:

Large museum or gallery, national institution

The director of public or corporate relations reports to the director/chief executive. The department may include several divisions:

- press office/media relations
- development/sponsorship
- parliamentary/local authority lobbying
- and possibly public services, including information, publications, corporate hire.

Combining public relations and information reflects the early days of public relations in museums and galleries and also the way the government information service has been organised. In view of the professionalism and dedication now required at senior levels in public

relations, combining these two roles may not always be successful. Public services itself requires many different skills, such as information technology.

Medium-sized museums, attractions
The public relations officer reports directly to the director. This role may be combined with publications, development or marketing. Again, this may not always attract the person with the appropriate public relations skills or seniority to advise the director and the trustees on public relations strategy. Another solution would be a freelance public relations consultant, working inside the museum two to three days a week. Yet another would be to use a public relations agency to get a spread of senior input and junior staff to put public relations strategy into action.

Small museums and galleries
The director or assistant director take on the public relations role, and a freelance PR consultant is used for any major events or exhibitions. (For comments on employing consultants in general, see Chapter 4.)

Notes
1. Institute of Public Relations' definition of public relations.
2. An excellent summary of the growth and development of public sector marketing in general – and a thorough examination of the difference between commercial and public sector objectives which influence the way in which both marketing and public relations have developed in the public sector – is to be found in:
 Chapman, D. and Cowdell, T. (1998). *New Public Sector Marketing*. Financial Times/Pitman Publishing.
3. Available from the Institute of Public Relations. The Public Relations Consultancy Association and the Chartered Institute of Marketing also have codes of conduct. For details of how to contact these organisations, see Appendix 2.

Chapter 11 PUBLIC RELATIONS STRATEGY

A new arrival in the public relations seat at any museum or gallery will be keen to get on with the job in hand. Some time may have elapsed since this position was filled, or this may be a new post, or perhaps the whole area has been badly neglected. Fingers will be itching to get on the phone to media contacts and start putting out news stories. But stop — and consider the longer term. Developing a public relations strategy at this stage and providing a framework for future action will be well worth the time invested. And any organisation without a public relations framework is going to lurch from initiative to initiative without a clear direction or message.

In many ways the process is similar to that for developing a marketing strategy. And the marketing strategy, if it exists, will be a useful starting point. But the public relations strategy will have different objectives, aimed at creating a strong profile for the organisation with all its audiences.

The five-stage process of creating a public relations strategy includes:

- *research and planning*
- *analysis leading to strategy and the setting of overall objectives*
- *developing the public relations plan*
- *implementing*
- *evaluation.*

Research and planning

Research for the public relations strategy starts with internal and external communications audits, which follow the same lines of the marketing audit (see Chapters 2 and 3). Essentially it is a question of looking at what messages are communicated and how they are communicated and interpreted. The importance of the internal communications audit in the public relations strategy cannot be over-stated.

The internal audit should examine the following:

- how staff (in different areas) perceive the organisation
- what the organisation is essentially about
- who is seen as the competition
- how internal messages are received
- how and when these messages are communicated to the public and other users
- where the organisation will be in five years' time
- how change and future opportunities are perceived
- comments by the public.

The most interesting answers will no doubt be those to the first question. It is unlikely that the chief executive, chairperson of the board, curators and public services staff will all come up with the same answer. The challenge of the public relations strategy will be to define in simple terms what the organisation is about and persuade most people to back this definition. There should also be general agreement regarding the organisation's future. Where will it be in five years' time, bearing in mind the external forces to which it will be subject?

The external audit should examine a variety of external audiences. This should include those reviewed in the marketing audit but also those who have an influence on the way the institution is perceived and those whose views influence others.

Start with the media's perception of the museum. This can be done in two ways: formally through a media evaluation exercise and secondly through an informal survey. The formal survey over a period of time, measures the organisation's media coverage and evaluates the contents of articles and broadcasts against agreed messages. There are now a number of agencies which will undertake this on a professional basis (see Chapter 16).

Public relations agencies frequently undertake informal surveys among journalists on behalf of a client or, more frequently, before a pitch to a new client. This kind of survey is ideally done by someone who is not directly involved in the day-to-day contact with the media as this may colour his/her judgement. It is important to set clear objectives for the survey: is it simply going to measure awareness or is it going to deal with how improvements can be made?

Surveying the media

An example of how to carry out a small-scale survey among a particular target group is the media survey carried out by Ylva French Communications for the British Travel Trade Fair (BTTF) in 1998 among journalists who had attended the fair during the previous three years. This survey was useful in developing the public relations strategy for the 1999 event as it measured the attitudes of one important group of visitors – the press – as well as their awareness. It also suggested ways of improving delivery of information.

Out of a total of 200 journalists, 30 were chosen at random and interviewed over the telephone by a graduate placement not directly involved with the agency. A short questionnaire was prepared and the results were analysed in a simple Pinpoint

(research software) programme. Awareness of the British Travel Trade Fair was high,even among those who had not attended for the last two years. Those who had attended in the previous two years had noticed substantial improvements in the way the exhibition was presented and in the information the press had received.

The survey identified two areas for action. One related to travel – the event is held at the National Exhibition Centre in Birmingham – and confirmed the London-centric thinking of the UK press. The other related to the need to provide advance information – in addition to information about press registration – to a wider range of media than had previously been targeted.

The constraints in carrying out this survey related to the difficulties in getting hold of journalists – frequently on the move or otherwise unobtainable – and their reluctance in being involved in more than a brief conversation. Brevity is, therefore, essential.

Results: Both the issues raised by the journalists were addressed for the 1999 British Travel Trade Fair. More, and free, travel opportunities were offered to a wider range of journalists and more advance information was sent to a key list of 250 media. As a result of these activities, press attendance at BTTF 1999 increased by 9.5% (220 attended over two days) while visitor numbers as a whole remained the same. In fact, not many journalists took up the special travel offers. It seems that it was the increased flow of information to a wider range of journalists that made the difference.

An exercise similar to that undertaken for the British Travel Trade Fair could be carried out among all key stakeholders – including trustees and board members, local councillors and other decision makers – and, critically, among other professionals outside the organisation. These people will be difficult to pin down and perhaps reluctant to be interviewed (or may even be quite destructive), but the information gathered overall will be invaluable.

The results of this research will have identified the strengths and weaknesses of the organisation's current communications strategy. It could form the starting point for something more free-wheeling, something which will allow new ideas and new thinking to emerge in identifying future opportunities and threats. Think-tanks or

brainstorming sessions are nothing new, but this does not stop them from being useful when the museum, gallery or attraction is faced with a major change, for example the result of a new funding situation or the threat of increased competition from new attractions in the area. The objectives should be clearly stated: How do we survive with our grant cut in half? How do we build our reputation as a museum of natural history? What will our audiences want in the year 2005 and can we deliver it? Setting up a think-tank requires some outside assistance to ensure that it is productive and stimulating. Here are some practical ideas:

- The facilitator should be well briefed about the organisation.
- He/she should be assisted by a note-taker (although parts of the discussion may be free-wheeling).
- The chief executive or director should only join in the later stages.
- The participants should include a cross-section from all departments (ideally not more than 10).
- The event should be held away from the offices – and somewhere fairly isolated: no phones or mobiles.

The process may go something like this. The facilitator may simply start by asking the participants to work through a traditional SWOT analysis (of strengths, weaknesses, opportunities, threats). This will throw up a number of useful starting points for a free-ranging discussion. This is where a well-briefed facilitator is important in order to keep the session on track and add other pertinent questions (similar to those discussed in the internal audit) to stimulate further discussion.

All ideas should be recorded and, at the end of the day, a summary should be prepared and an action plan drawn up in agreement with the management team. The think-tank session may have provided some ideas which need further exploration and research, perhaps among users, to gauge their relevance and practicality. A working party may be required to take forward ideas and turn them into something more tangible. It may be that further research is required among visitors in general. It may also be that you and your colleagues perceive the natural history collection as the defining element in the museum's collection, whereas visitors come for the musical instruments or simply to enjoy the building and its facilities.

The research phase is a continuous process in the public relations strategy as its implementation and evaluation feeds back more information. In fact, it is easy to become stuck in a rut at this stage and

to continue the search for more information – this is a common phenomenon today as more people succumb to the information overload syndrome.

Setting objectives

Moving on to the next stage – that of setting objectives – should not be delayed in a rapidly changing world. Someone will have to make the commitment and set the objectives for the future, based on the information gathered and on the new thinking generated in the process.

These objectives should form the basis for the mission statement, the rather bland statement which is now standard in corporate plans but which will need to be more detailed for the public relations strategy. This strategy should have some clear objectives and measurable targets related to the museum's or gallery's 'brand', audiences and communications process.

The brand or profile should be clearly identified as it is perceived now (as it really is) and how it must change or be reinforced for the future. For example:

- The Brick Museum – the museum of the building industry for professionals and amateur builders
- The Greater Worth Museum – an outstanding local history museum for the people of Greater Worth and an example to other local museums
- The Holburne Museum of Arts in Bath – for all who are interested in the arts and crafts of the 18th century.

As part of setting the objectives, the key public relations messages need to be clearly defined and built into the communications process. The overall message which lines up with the objectives – i.e. we are the best local history museum in the UK – will need to be segmented and varied for the many different audiences, including the media.

The brand

Public relations plays a central role in safeguarding and building the brand. And the public relations strategy should set out a series of steps for protecting the brand – the value of the museum's name as well as its intellectual property rights. Whether it is possible to register the brand name or not – this depends on the uniqueness of the name as well as other factors – investing in the brand, in terms of strengthening its visual impact, reinforcing its use throughout the

organisation and in all internal and external published material, will add value to the brand and protect it from infringement.

Brands *have* value; accountants can now include them in company accounts and could probably do the same for museums. But what is 'brand'? Brand is a way of differentiating similar products. Take trainers: they are generally the same and all do the same job; manufacturers invest them with 'personalities', and with names which evoke these personalities; buyers choose the trainers with the personality traits they aspire to. Can this apply to museums?

In the UK there are approximately 1800 (1999) registered museums and galleries. They are all different, as we know, with unique collections, buildings, and ways of displaying and interpreting their objects. But they all offer the 'museum experience'. To the visitor, therefore, they may not appear very different. Museums are gradually waking up to the fact that they can 'brand' themselves by investing their names with values that are not directly related to the objects. The Victoria and Albert Museum was the first to do this in a big way with its 'An ace caff with a great museum attached' advertising campaign. The campaign proved controversial and generated a lot of media coverage, but perhaps not in the way the museum had intended as it detracted from the value of the brand, i.e. the museum itself.

The V&A's uncertainty about the value of its brand is reflected in the off-the-cuff remark by the director that it might change its name to reflect the collections more closely! The Tate Gallery, on the other hand, has been successful in its investment of the Tate name – now in three locations in the UK, and, from spring 2000, also to be on Bankside in London. Although the name has no meaning in relation to art and is purely historical, its brand value is indisputable: everyone knows what it stands for, the personality of its audience, and the ambience of its rather stark public facilities. Can other less well-endowed museums and galleries achieve the same recognition factor and develop their brand?

Many museums and galleries with very uninspiring names take the visual route to create an image and a brand, for example the National Gallery, the National Portrait Gallery or the National Museum of Scotland. Others with strong personalities include the Horniman Museum (no longer just because of the tea), the Dulwich Picture Gallery (because of continuing good public relations activities), the Tyne and Wear Museums (through effective marketing), the Museum of Science and Industry in Manchester (through excellence and innovation).

Developing the public relations plan

The public relations strategy is now beginning to take shape; the next stage is the public relations plan. The main headings for this all important document will also apply to the individual public relations plans prepared for exhibitions, launches and special events.

Corporate identity

In order to strengthen the profile of the organisation and build recognition value, the development of corporate identity has grown from a designer's doodle to a major industry involving thousands of pounds. It is true that we are all becoming more visual as a result of television and an overload of visual stimuli in our environment (a child of two can recognise a McDonald's sign at 200 paces!). It follows, therefore, that any museum, gallery or attraction must invest in a corporate identity which will project it to its key audiences through a variety of means. The identity should sit comfortably with a range of subsidiary means of communications relating to exhibitions, education services, the library, the events programme and so on. Corporate identities also need to be reviewed at, perhaps, five-yearly intervals to ensure that they are fresh and relevant.

Identifying key audiences

Key audiences include stakeholders (present and future) as well as visitors and non-visitors (i.e. potential visitors).

It is useful to set communication targets that can be measured and, if a survey has been carried out as part of the public relations audit, to set targets for awareness, for example:

- Local authority – two mailings a year to councillors, three events at the museum per year, monthly meetings or conversations with director of leisure or other chief officer: awareness rating increased by 10%.
- Trustees/board members – four meetings a year, monthly news bulletin, two informal lunches per year: attendance at meetings increased by 50%.
- The profession – one article per year in *Museums Journal* or the *The Art Newspaper*, participation in or organisation of one workshop or session at the Museums Association conference, three lectures at museum training courses: awareness/standing increased by 20%.
- The media – one or more press releases a month, four or five press views per year, depending on exhibitions, at least one informal event at the museum for local and specialist press per year, monthly

conversations with key journalists: awareness rating increased, media coverage increased.

Key messages

The public audience will need to be segmented, not just by standard measurements such as ABC1, but also by using the more sophisticated segmentation techniques pioneered in the 1980s. These included such groups as **innovators** – those who respond to any new product, event or exhibition; **early adopters** – those who follow the new trend quite quickly; **followers** – those who are far behind when it comes to change; and **traditionalists** – those who are the last to convert to a new technological development or fashion.

Museums and galleries may also find it useful to look at research which identifies museum audiences in terms of the other leisure activities they pursue. Museum visitors are likely to go to historic houses or gardens or to the theatre, but not so likely to go to football matches or pop events (see Appendix 1).

Messages need to be fashioned for these audiences but also for the media through which you are communicating. Your research, planning and analysis should have identified those key elements in the museum or gallery experience which already appeal to visitors and which are likely to continue to appeal in the future. It is important that the main message about the museum is clear and distinct; but this does not prevent you from developing subsidiary messages.

Wimborne Museum

The Wimborne Museum in Dorset is a small local history museum in a significant historic building with a walled garden. At the start of the marketing review, undertaken by Ylva French as the marketing consultant, the museum was trying to convey all the identified key elements in the messages it delivered through its public relations, print and publicity, thus producing confusion in the minds of the potential visitors as to what the museum was really about. In addition the museum was linked to a tourist information centre and felt that this should be an additional draw, although little had been done to promote this element.

Without the funds to carry out additional research, discussions took place – mainly internally but also with external agencies such as the tourist board – to try and decide on the museum's strengths and the best way of communicating these.

The recommendation by the marketing consultant was to focus the main message on the museum as a local history museum for the area and to communicate this clearly and decisively through print and publications (partly by dropping the secondary name – The Priest's House).

As time and funds allowed, it was recommended that the museum develop secondary messages to highlight its status as a historic building of considerable interest and to strengthen interest in the garden. However, as neither of these elements were strong enough to warrant a stand-alone leaflet or promotion, it was proposed that joint promotions were developed with other historic buildings – for example Wimborne Cathedral – and that Wimborne Museum joined a historic garden trail.

Public relations strategy should support this essentially marketing-inspired approach by focusing on the museum's 'local museum' role, but also by producing individual messages for the relevant media.

This strategy for developing key messages should also be followed for public relations plans for exhibitions: identify the strongest element of the exhibition as the main public draw, and then look for secondary interests, for example in conservation, in particular objects on displays, or among the personalities involved in putting the exhibition together.

Implementing the public relations plan

Rather than a simple action plan, this is more likely to be a whole set of tactical plans developed for each key audience, including the stakeholders. It will include a plethora of public relations tools including:

- newsletters
- public and private events
- conferences
- exhibitions
- sponsorship
- the media plan
- photography
- stunts and media events.

It is important to get the mix right. It is easy to focus on media relations and ignore the importance of direct communications through presentations or indirect communications through news-letters, your website and the way you deliver your own events. These activities will be examined in greater detail in the following chapters.

Awards

Entering for (and winning) awards should be part of the public relations strategy. The Museum of the Year award, specific interpretation or audience development awards, marketing and public relations awards are all useful in PR terms. They are also excellent for morale within the organisation. Many of the organisations listed in Appendix 2 run award schemes. The Museum of the Year award and the Gulbenkian awards may be combined into a new award scheme for the year 2000. More information can be obtained from the Museums Association.

Annual report

This very essential corporate tool is often neglected in the heritage area, mostly because museums do not have to publish their accounts in this way, but also through lack of funds. However, do not overlook the impact that a well-produced, informative annual report can have on your stakeholders and on potential funders. This is an annual statement of what you have been doing, your achievements and your goals for the future, as well as a report on your financial performance.

Evaluation

The public relations plan ends with a section setting out the evaluation process by audience and in terms of overall impact.

The public relations strategy is not set in concrete and needs to be reviewed regularly. At the same time it is there for a reason: to achieve the agreed objectives and to maximise on limited budgets. It is easy to be thrown off course, sometimes by necessity, when a sudden crisis occurs, but more often through lack of discipline. Someone has a good idea: perhaps the chairperson wants to invest in a flashy annual report or in a stagy event for a dubious charity, which would eat up most of the publication budget; or maybe a creative public relations idea takes up an enormous amount of time and energy and delivers none of the key audiences. Go back to the public relations strategy every time someone says 'Why don't we do that?' and see if the idea fits into the framework.

CASE STUDY 14 Creating and promoting Museums Week

Awareness weeks, days and months have grown from the very first Christian Aid Day in 1951 to a major industry with some 400 listed promotions for 1999. The health and welfare sector, including charities, is the biggest, but the arts and heritage sector is growing fast. Museums, galleries and heritage attractions will be approached to join in a variety of such events from Museums Week and Gallery Week to Heritage Open Days and Science Weeks not to mention Volunteer Week and Adult Learning Week as well as a series of local initiatives. Are they worth it? Only if they are properly planned and implemented both by the museum and by the organisers of the Week.

When at the Museums and Galleries Commission, Sue Runyard assisted Loyd Grossman in setting up Museums Week. Ylva French Communications now administers and promotes Museums Week on behalf of The Campaign for Museums.

Museums Week operates on a budget of only £70,000 (1999) and achieves a considerable impact on such limited resources. It is now considered one of the top ten awareness weeks in terms of media coverage and awareness.

Museums Week has the following objectives:

* to raise the profile of the value of museums with decision makers and influencers
* to encourage visitors to explore a wide range of museums.

Museums Week started in 1974 as a week-long promotion on BBC Radio 2, supported by the *Radio Times*, and has grown into a major campaign supported by the Department for Culture, Media and Sport, commercial sponsors, the Scottish Office and other sponsors and foundations. It is timed to coincide with International Museums Day on 18 May. In 1999 nearly 1000 museums took part, and the themes included travel, food and treasures.

In the year 2000, Museums Week will combine with Gallery Week to celebrate the millennium in a Museums and Galleries Month in May (see Appendix 2 for details).

Loyd Grossman, chairman of The Campaign for Museums, takes a closer look at the priceless 200-year-old ice-cream cooler at the Wallace Collection. Courtesy of The Campaign for Museums.

Museums Week national promotional campaign

Communications with museums
- regular newsletters from October onwards
- workshops at Museums Association conference
- marketing seminars around the country
- telephone helpline.

Communications with the media
From October onwards:

- listings
- specialist press and correspondents
- television and radio programmes.

From January onwards:

- national television and radio
- national newspapers and specialist correspondents
- consumer/lifestyle magazines
- regional newspapers
- regional radio (particularly BBC regional radio).

From April onwards:

- news material for all the above media focusing on events in museums
- national Museums Week linked events – openings, launches, etc.
- museum issues.

Promotional support
- leaflets (350,000) in 1999 distributed through tourist information centres, libraries and museums
- posters (10,000) distributed as above
- Museums Week website with link to the *24 Hour Museum*
- *Radio Times* phone-line.

National activities
- launch and VIP reception
- MPs day – Saturday at the start of Museums Week
- visits to museums around the country by chairman and committee for special events
- photocalls and opportunities

- RSA (Royal Society for the encouragement of Arts, Manufacture and Commerce) Museums Week lecture
- promotional initiatives.

How is Museums Week evaluated?
- number of participating museums (this eventual limit will probably be around 1200)
- number of events organised by museums (as reported by museums)
- raised awareness of individual museums (as reported by museums)
- visitor survey in museums undertaken by Friends groups (evaluated by The Campaign for Museums)
- MORI survey (annual survey undertaken by the Museums and Galleries Commission, to be continued by the Museums, Libraries and Archives Commission)
- media coverage (as measured in press cuttings and broadcasts – reached over 700 in 1998)
- in-depth telephone interviews with a sample of participating museums
- hits on Museums Week website.

Chapter 12 THE MEDIA OVERVIEW

An uneasy relationship

The relationship between public relations practitioners and journalists is traditionally fraught. On the one hand, journalists are dependent on press officers and public relations consultants for leads, news and information; on the other hand, journalists feel that they are being obstructed and are perhaps missing out on a much juicier story direct from the horse's mouth.

Developments both inside major organisations and within the media are contributing to change this into a more businesslike and professional relationship. As organisations grow, it's simply not efficient or safe for everyone to have a direct line to the media. The in-house press officer or public relations consultant can gather information from various sources and make them available to the journalists to meet their deadlines – something to which the non-PR professional is not always very sensitive. At the same time, newspapers, magazines, television and radio news and features are working to tighter deadlines in a more competitive environment and with fewer people. They therefore have no choice but to deal with the person who has the information and who can, when appropriate, organise a direct line for an interview.

However, the tension remains (see also under Categories of crises in Chapter 14) as some parts of the media dig deep to find scoops and make headlines – one of many very good reasons why curators or librarians should not make comments to the media on important issues without briefings from the press officer and clearance from the director. At the same time, the antics of those so called spin-doctors who try to control the flow and presentation of messages, mostly on behalf of politicians, have added new tensions between journalists and the public relations professionals, most of whom would not like to be tarred with that brush.

The message of this introduction is that the distrust between communicators and their counterparts – i.e. journalists – is likely to continue and should always be in the forefront of your mind when dealing with the media. For the public relations professional, however, establishing good relations with the media is the key to success. It does not simply depend on 'contacts' or friendly lunches: being familiar with the publication or programme targeted will win you more respect than free drinks. Visiting journalists in their offices, on their own ground, is a revelation for most public relations people. A

formal tour of television news centres and printing presses will also put a different perspective on the pressures that the media work under.

The London bias

For UK museums and attractions, the influence of the national media and its strong London bias is obvious – and frustrating for those outside the capital. The bias is based on geography: national newspapers and broadcasting stations are concentrated in London and so are their staff. Regional offices are a thing of the past. Most political and cultural sources and influences are also based in and around London.

Two strong trends are emerging which are gradually breaking down this bias: first, the arrival of a Scottish Parliament, a Welsh Assembly and a new political structure in Northern Ireland will create political centres of influence away from Westminster which the national media will need to observe; second, there is the strengthening of the regional structure throughout England. Although the latter does not as yet involve new democratic institutions (except in London), the bringing together of cultural, tourism and economic regional agencies will reinforce the trend. The cultural revival outside London has been fuelled by the Lottery, which has invested over £1 billion in expanding cultural attractions outside London.

Ten years ago the 'unveiling' of the Angel of the North at Gateshead (see Case Study 17) would not have been national news – it would not even have happened in pre-Lottery days. The coverage received was phenomenal and is an encouraging sign for museums and cultural attractions all around the UK. The prerequisite for such success is a professional approach to public relations which can take on and excite national journalists and persuade them that there are news stories north of Watford.

The UK is not alone in its focus on the capital: France is very similar. Regionalised countries such as Germany with strong regional media do not have the same problem. And the USA, with its immensely fragmented media and different time zones, is again a different kettle of fish, with each part of the country needing a separate media strategy.

A plethora of news and attractions

Later in this chapter we explore the phenomenal growth and fragmentation of the media. But first we need to examine the

competitive world in which museums, galleries and attractions operate, producing mainly 'soft' news and features. The explosion in the number of attractions and leisure opportunities in the UK, and the increasingly more professional ways in which they are promoted, means that, for example, the average listings magazine for London, Manchester, Dublin or Boston will have more than trebled its contents in the last ten years. If you translate that to the rest of the media, it becomes clear that the choice of what to cover is enormous.

A national UK newspaper such as the *Daily Express* or *The Times* will receive something like 200 photocall notices a day. Twenty of those will go into the diary, five or six will be covered and perhaps two pictures will be used (see how to increase your chances of success in Chapter 14).

Freelance journalists have to install extra large post-boxes to cope with the influx of mail, including large brochures, CD-ROMs and tapes. The arrival of e-mail does not really help the journalist, who has to sort through up to 100 e-mails a day. The old adage of getting the gist of your story into the first paragraph still applies; most people won't read any further before pressing the delete button.

So where does this leave the average museum or gallery? Well there is a positive side to this story. As the number of leisure opportunities grow, so do the various media opportunities as the media fragments into a thousand pieces.

The fragmentation of the media

Winners and losers

It's not long since there was talk of the whole business of newspapers and magazines being written off due to the expansion of electronic means of communicating. That has certainly not happened in the magazine sector in the UK. There are between 4000 and 5000 titles around at any one time, with about 1000 being launched every year and another 1000 closing down. The 1990s has been an exceptional decade for magazine publishing (according to the Periodical Publishers Association) with circulation up by 13% and revenues up by 113%. Who is winning and who is losing?

Table 4 Top UK consumer magazines and their circulation (July–December 1998)

Ranking order	Sales
AA Magazine	4,084,522
Sky TV Guide	3,403,912
Safeway Magazine	1,997,063
Cable Guide	1,860,622
What's on TV	1,765,369
Radio Times	1,400,331
Reader's Digest	1,302,659
Take a Break	1,273,820
The Somerfield Magazine	1,777,307
Debenhams	1,109,902
Saga Magazine	923,872
O Magazine	915,589
TV Times	850,282
Jazzbooks – Group	799,800
FHM	751,493
TV Quick	740,800
Woman	711,133
Ford Magazine	667,116
Woman's Own	654,473
VM The Vauxhall Magazine	627,197
Bella	610,843
Homebase Living	598,500
Woman's Weekly	594,680
Legion	556,891
That's Life	540,003
You and Yours	510,675
Hello!	510,552
Prima	510,142

'Cultural' publications in the top 100
41. National Geographic
79. BBC Homes and Antiques
99. Heritage Today

Source: ABC (Audit Bureau of Circulation)

Table 4 reveals some of the strong trends which are currently emerging in the magazine sector. The biggest growth is in the men's magazine sector. From a public relations point of view, unless your organisation is into sex, sun and men's fashion it is not going to offer that many opportunities. There is more to gain by focusing on lifestyle magazines – some of which have a definite masculine slant but which also cover leisure and holidays.

Customer magazines are another big growth area, with organisations of all kinds going beyond the traditional company magazine and aiming for a more general readership – all part of relationship marketing. *Safeway Magazine*, for example, is not just about recipes, and the *AA Magazine* is not all about cars; there are lots of opportunities here for leisure-orientated news and features. Customer magazines are generally part of the free magazine sector (although Sainsbury's charge for their magazines and to receive others you usually have to be a member). Giveaway magazines on property and jobs advertising thrive in major city centres and in residential areas. In some areas of London, for example, they are a good way of reaching a younger audience who may not regularly read magazines.

Computers, television and the internet have spawned a plethora of publications. These and other very specialist publications are subject to the largest turnover and need to be checked carefully each time they are targeted.

Magazines on homes and interiors continue their success by transforming themselves, as do magazines for the 50+ age group. *Saga Magazine* has set a trend of excellence here but tends to focus on its own products.

Women's magazines have fragmented and almost all titles are now suffering. New entrants aimed at the 30-year-old working woman are finding the going tough. Relatively, however the big titles still have a large readership, and many are in the market for advertorials, surveys and competitions. They are good partners in a public relations campaign aimed at women – who, after all, make most of the decisions about the family's leisure time.

The list of top-selling magazines in the USA (see Table 5) is interesting for the way it demonstrates shifts which are taking place all over the Western world: an aging population, more leisure time, widespread TV viewing, home focused activities and time to follow sport and fashion.

Table 5 Top thirty US magazines and their circulation January – June 1998

Ranking Order	Circulation
Modern Maturity (retired persons)	20,402,096
NRTA/AARP Bulletin (retired persons)	20,360,798
Reader's Digest	14,675,541
TV Guide	13,085,971
National Geographic	8,783,752
Better Homes and Gardens	7,616,114
Family Circle	5,005,084
Ladies Home Journal	4,521,970
Good Housekeeping	4,517,713
McCall's	4,239,622
Time	4,124,451
Woman's Day	4,079,707
People Weekly	3,719,925
Sports Illustrated	3,269,917
Newsweek	3,227,729
Prevention	3,152,814
Playboy	3,151,495
Home and Away	3,038,968
Redbook	2,854,448
American Legion Magazine	2,691,252
Avenues	2,613,967
Cosmopolitan	2,581,985
Via Magazine	2,489,605
Southern Living	2,470,202
Seventeen	2,437,194
Martha Stewart Living	2,235,723
Glamour	2,208,926
National Enquirer	2,206,747
US News and World Report	2,201,351
YM	2,170,687

Table 6 Top regional titles by circulation 1998 and 1988

Rank	Title (1998)	Circulation (1998)	Title (1988)	Circulation (1988)
1	Daily Record	675,065	Daily Record	773,627
2	Evening Standard (London)	446,899	Evening Standard (London)	496,696
3	Birmingham Evening Mail	195,391	Manchester Evening News	289,528
4	West Midlands Express & Star Group	193,484	Birmingham Daily News	280,961
5	Manchester Evening News	181,480	West Midlands Express & Star Group	245,346
6	Irish Independent	162,064	Birmingham Evening Mail	235,852
7	Liverpool Echo	161,836	Liverpool Echo	188,549
8	Belfast Telegraph	130,756	Irish Independent	154,296
9	Evening Times	117,650	Leicester Mercury	149,010
10	Leicester Mercury	115,724	Evening Chronicle (Newcastle upon Tyne)	147,691

Source: BRAD (January 1999 and January 1989)

Regional and local newspapers

Regional and local newspapers in the UK are steadily losing circulation (see Table 6). The *Daily Record* in Glasgow maintains its leading position, followed by the *Evening Standard* in London. The *Birmingham Evening Mail* is now in third position, pushing the *Manchester Evening News* into fifth place. More and more people get their information from local and regional television and radio, but the regional newspapers remain important as sources of stories for other media as well as for their focus on local and regional issues.

National newspapers continue to thrive against all odds (see Figure 4). Competition between them is cut-throat, and this needs to be borne in mind when choosing a media partner for a major promotion. On the whole they offer plenty of opportunities for creative public relations as they have a great variety of supplements/sections devoted to lifestyle. Health and fitness are now major subjects for the nationals, although there are more pages on travel and leisure. The response rate is good, particularly from the heavy tabloids, such as the *Daily Mail* and the Sundays. The growing

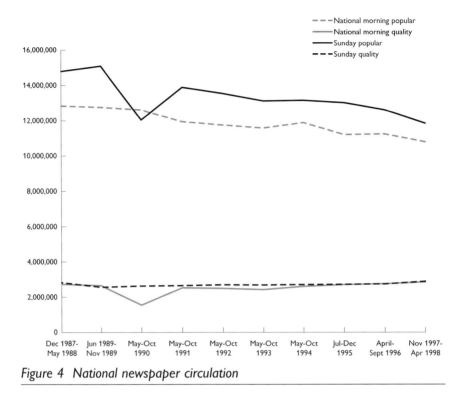

| | Dec 1987- May 1988 | Jun 1989- Nov 1989 | May-Oct 1990 | May-Oct 1991 | May-Oct 1992 | May-Oct 1993 | May-Oct 1994 | Jul-Dec 1995 | April- Sept 1996 | Nov 1997- Apr 1998 |

Figure 4 National newspaper circulation

significance of Saturday newspapers has introduced an even greater variety of editorial and promotional opportunities in their different supplements. Remember that all these sections will have different deadlines, some being planned months in advance.

Broadcasting

Television broadcasting in the UK is on the threshold of change; within a decade we may look back on the 1980s and 1990s as the golden age of broadcasting. The proliferation of television channels and radio stations as part of the digital revolution is likely to spread audiences and advertising too thinly to produce quality programmes in the way that it has in the United States. Already television viewing is in decline in the competition for our leisure time.

But the impact of television is still enormous, and the fragmentation of programmes is producing great public relations opportunities, both in terms of editorial and sponsorship. Frequently it means dealing with production companies which are more flexible than traditional television crews – but also less professional. There are other opportunities in product placements, and on the news side the

reliance on video news release material is likely to grow – despite the protestations of the main newscasters.

Local radio has enjoyed phenomenal growth over the past ten years. There are now (1999) 227 radio stations in the UK, compared with 51 in 1998. Core stations retain a strong following, but others, mainly music stations, have a very narrow and fragmented audience. Budgets are tiny and everything is done on a shoestring. Ways of working with radio are explored further in Chapter 13.

New media

This leads us to the new media and how to use them in public relations. From a media communications point of view the internet is already essential. Your website should have press information on it (and you should be putting your website address on your press releases). This is a useful place for background information, lists, photographs and detailed information.

More and more journalists (particularly freelancers) and most people in broadcasting and specialist information technology publications now work on e-mail. You therefore need to start adjusting your distribution of press releases accordingly.

If you are in the news regularly, you should be thinking of installing an ISDN line for interviews and of training appropriate staff to do impromptu interviews. Your photographers should be able to ISDN photos to newsdesks on your behalf.

The demand for 'cheap' programmes has brought the fly-on-the-wall documentary to the UK in a big way. Should you take part in this and give your staff the chance to become household names? Well, it can work. Maybe it did work for the Britannia Hotel (despite everything that went wrong). But it certainly did not work for the Royal Opera House (which started it all), which was revealed to be an inefficient and unfriendly organisation, badly run and managed – all of which has since been confirmed. Any organisation which goes down this route should make sure they have professional public relations personnel supervising the film crew at all times, as well a firm agreement on what can or cannot be filmed. However, the production company in charge will not usually give up any editorial control.

The internet and the opportunity this provides for individuals to air their views and opinions – even if wrong and libellous – in newsgroups and other forums will become an increasing threat for organisations in the UK, as it has in the USA. Large companies are already monitoring this and stepping in with corrections as appropriate.

Keeping up to date

With so much change going on in the media, it becomes an increasingly vital job to keep up to date and in touch with threats and opportunities. This is another very good reason why public relations professionals inside the museum or gallery, or outside as advisers, are becoming so important. It's impossible for other specialists or managers to keep up to date.

It should be obvious that it is vital to watch television, listen to the radio and read newspapers and magazines. But there are still people, even in public relations, who feel that listening to anything other than BBC Radio 4 or watching a soap on television is beneath them. You must stay in touch with your audiences – with what they are watching and reading.

Reading specialist magazines such as the *UK Press Gazette* or *Media Week* is another good way of keeping in touch with trends, with who is winning and who is losing as well as with personnel changes.

Evaluating the readership or audience of any publication or programme has never been a strength of public relations (see also Chapter 16). The advertising industry has always been hotter on this, as they tend to spend much larger sums of money. Good reference sources such as BRAD are primarily produced for advertisers but should also be familiar to people in public relations (see Appendix 2, Resources).

Chapter 13 WORKING WITH THE MEDIA

There are many helpful publications about handling the media. This book is about taking a strategic approach, so we shall be addressing how you organise yourself, your office and your staff – as well as how you implement your ideas. Start by organising your press office efficiently. The first part of this chapter deals with practical matters for those setting up a press office for the first time or re-organising an existing office; the second part deals with implementing targeted media activities.

Organising your press office

Mailing lists and databases

The press mailing list is the bread and butter of any press office. Great software options allow us to do amazing things these days. Not only can we store thousands of names and addresses, we can sort them by category, name or geographical area, cross-tabulate and avoid duplications. We can choose how to address individuals: 'Dear Mitch' or 'Dear Professor Mitchell'. We can store notes on their children's names, what they like for lunch, what their special interests are and when they last wrote something for the museum. We can plant reminders to notify individual members of the press about particular news and information as it develops. And, of course, we can print out labels of different sizes and formats, envelopes and personalised letters of infinite variety.

If you are starting from scratch, you may be able to choose whether to use a personal computer or a Mac – but increasingly the hardware will be decided by the museum's integrated technology system and is more likely to be based on PCs. Macs are very useful if you are going to do your own design work, newsletters and so on. Mailing list software is available for both. Make sure there is sufficient memory for your databases – these should not generally be networked as you do not want others to update or change your lists. You can set up your own lists from printed sources or buy computerised lists, which can be automatically updated by CD-ROM or online (a fairly expensive option). You can also out-source the mailing of press releases to a specialist service. However, this is only cost-effective for very large mailings, and you would still want to have your own key target lists.

Hot lists

Being able to 'turn on a dime' by responding instantly to events and

opportunities is a key characteristic of a good press officer. Three key lists, kept readily accessible in the office and at home, are:

- **Emergency list**: If there is a major crisis in the museum, you will immediately need the office and home telephone numbers of key members of the museum staff, the press office team, key media people and outside advisers/spokespeople. (Press officers will have a role in the emergency call-out tree for out-of-hours emergencies and will have a call-out tree of their own (see Chapter 14).)
- **Media list**: Out of hundreds or thousands of press names on the mailing list, there will be a dozen or more key journalists who should be immediately notified by the press officer of any major event (fire damage, resignation of a director, winning of a major award, acquisition of an important item, etc.). Never forget the local press if you suddenly find yourself swept up in national news. In time the national press will go away, but the local press are always with you.
- **Photo list**: A list of picture editors' and photo-agency telephone and fax numbers.

These are lists to assemble in quiet times, in preparation for the unexpected. It's a good idea for more than one person to hold the lists, in case the senior press officer happens to be away at the key moment.

New technology

It is essential to have access to the internet. If you don't have it already, an inexpensive modem will allow you to connect. News services such as NEXUS abound, allowing you to check for news cuttings online. You can read the newspapers of the world online each day and monitor radio and television stations. A great deal of the research you will need to do can be done on the web, and in due course we will all be sending an increasing amount of our press releases electronically. Your website should have your press releases on it and also a selection of photographs which can be directly downloaded. In time this will save enormous amounts of postage and print costs. Journalists were among the first professional groups to adopt 'new technology' in their everyday lives, and many can be contacted via their e-mail addresses. (This book is being written in California and London via e-mail.)

Having the facility to scan pictorial material and send it electronically or load it on to your website can be tremendously useful, especially if you are regularly dealing with media based

thousands of miles away. This will require an ISDN line to produce acceptable material at the other end. In the past 25 years the personal computer is the product that has made the most dramatic contribution to efficiency, productivity and creativity.

Printed paper

Headed notepaper should bear the logo of your museum and your postal address, telephone/fax numbers and e-mail address. News or press release stationery should bear the logo and return address and be clearly identified as 'news release' or 'press release'. The press release should reflect the corporate style, and your designer can help establish a standard layout. The name of the press officer and the telephone extension should always appear at the foot of the news release. And of course you will need business cards. (You may wish to consider writing your home telephone number on cards which you hand to key journalists, so that they can reach you out of hours, the traditional time for big stories to break. Alternatively, leave your home telephone number on the answerphone (with direct lines into most offices this is increasingly efficient) or use a pager service.)

Photographs

A stock of photographs is essential for those requests requiring immediate attention which usually happen late on a Friday when the Sunday papers plan their listings or day-out feature. Having a good selection of colour prints or colour transparencies of people and children enjoying themselves in your museum, gallery or attraction is a winner every time. You should, of course, also keep 'arty' shots which illustrate your most important objects, the current exhibition(s) and the building. Up-to-date portraits of key members of the management team should also be part of the photographic library. Most magazines and newspapers will now work from colour prints, and request 'large' transparencies only for good quality reproduction.

It is a good idea to illustrate releases with photographs and have these available on request. You may do this in-house if you have a scanner, or you can use a mailing house that has this facility. Increasingly, the media expects digitised images on disk, downloaded from your website, on a generic CD-ROM, or 'down the line' via ISDN.

Remember that copyright remains with the photographer unless you have negotiated differently.

Press kit folders

Generic press kit folders are a stock item that every press office should have. It is a great time-saver to have a stack of kits filled with general information about the museum. You then just have to add current material before you hand it to a visiting journalist or pop it into the mail. There are many different variations on the press kit folder, and all kinds of innovative designs and materials can be used. General advice is to keep it simple and elegant for long-term use, and save the innovations for special exhibitions and events, when you will want to devise an eye-catching, appropriately themed and styled folder for short-term use. A plastic sleeve is a cost-effective alternative to a folder and a leaflet can brighten up the contents. Journalists like the sleeves because they are light, easy to stuff into a pocket or briefcase and can be re-used. They are particularly useful for trade exhibitions, when the press tend to raid press kits for the information they want and overlook expensive folders and brochures.

For special occasions, folders can be overprinted on every available surface with interesting graphics and useful information. If you are going for elegance and restraint, it may be wise to restrict printed words to the minimum (address, phone/fax numbers and website address on the back or inside cover). Brief mission statements, branch locations, slogans, or press quotes could also be considered. There should be a place for your business card and ample pocket space for the intended contents and for sleeves of photographic material. A durable, attractive press folder may be held on a shelf – or in a teetering pile – in a journalist's office for a long time, so it makes sense to use an eye-catching colour.

Press releases

Much has been published about how to write a press release. There is a tendency among people who work in arts organisations and museums to assume that the public (and press) read far more than they actually do. Most journalists will glance at the heading and first sentence of a press release; if it doesn't grab their attention, they will read no further.

Certainly the vast majority of museum press releases are far too long and make the assumption that the whole thing will be read. Too often they are written to please other museum staff – or at least as a compromise. A press release is supposed to be *news*, not a corporate statement. This means concentrating on what, when, where and who, but not too much on why. Most adjectives are superfluous.

Sue Runyard once asked a columnist from an important daily newspaper to send her the contents of his waste-bin (paper only) for one week, and the results were surprising: 'There were about 700 press releases, but what was really shocking was that some were in unopened envelopes. I asked him about this and he explained that they were in overprinted envelopes, or bore other identifying postmarks, and that each was from an organisation which "pumps out paper and never has anything interesting to say". I asked if he wasn't afraid of missing an important story that way, and he replied that "If the story was that important, the organisation would telephone him, not wait for mail". I suppose the lesson is to be sparing in what you send out, to be tightly focused on individual journalists' needs; and if it's really major – make a phone call.'

A good move is to aim at a single side of paper, maybe two sides if absolutely essential. Press releases should be well-spaced. One-and-half line spacing is standard, making it easy to read and markup. This means choosing the few words that you do allow yourself to use with very great care. Releases can always be accompanied by single-spaced texts headed 'notes for editors' which give essential information about special terms which you are compelled to use along with background to the key information touched upon in the release.

Press kit contents

When planning the contents of a press kit, keep looking at it from the recipient's point of view. What do you see when you first receive it and first open the folder? Does it look too sparse or too wasteful of resources? Does it tell the main story and provide an appropriate amount of supporting information? Here are some possible contents for consideration:

* business card and telephone number
* major press release
* supplementary press releases
* background notes or notes for editors
* photographs
* key to photographs
* information sheet on any new/accompanying publications
* information sheet on any accompanying education programmes
* publicity leaflets
* biographical notes on people involved.

Get help

The amount of sheer drudgery involved in press work is usually underestimated. Anyone who has folded, stuffed and sealed a press mailing of any appreciable size knows exactly what is involved. Anyone who has sat at a telephone ringing around – perhaps hundreds of numbers – to chase up press attendances for events or conferences also knows exactly what is involved. Anyone who has reviewed and re-organised a press list or press filing system knows one thing: you need help. Yet all over the world there are solo press officers sitting in museums, trying to be strategic, creative, responsive, timely and hands-on – all at the same time. Even in large press offices, there is a tendency toward understaffing. The whole museum sector tends to be understaffed, but in press work it is particularly damaging because the deadlines are daily and the stakes are high. You get what you pay for in this business, and a perpetually understaffed press office creates a passive, uncreative mode of working, which means that the museum is less and less in control of its public image. The senior press officers must have time to be strategic, must be able to spend dedicated time cultivating journalists and must receive efficient support.

There is no substitute for intelligent well-trained staff, but one of the problems of press work is the sudden requirement to accomplish bulk mailings or other intensive work. Many museums place such mechanical tasks with a mailing house. It is also possible to mobilise volunteers from time to time – but you need to find a way of making the work a pleasure (as well as a pain) or they will resent being used in this way. Do look into opportunities for student placements from graduate public relations courses. During the summer and autumn keen young graduates are usually available to build up their experience before looking for permanent work. (Contact undergraduates through universities and colleges or through the Institute of Public Relations in the UK – see Appendix 2, under Training and professional development.)

Consultants and public relations agencies can come into their own when the pressure is on a small press office faced with a major exhibition or event. They can provide useful strategic input as well as a team to implement the media activities away from your office (see also Chapter 10).

The press office goes into action

The previous chapter gave an insight into the varied, competitive and

rapidly changing media scene. The days are gone when you could simply set up a mailing list and keep churning out paper; if that was ever a good way to pursue press relations, it certainly is no longer the case. Save the trees and get strategic!

You have everything in place in terms of a fully written-up marketing strategy, and you have a press/media campaign either embedded within it or as part of a separate public relations strategy or plan. The chances are that you feel you have a lot to do with very few staff and small resources. This makes it even more important that your methods of communicating with the press are efficiently organised. Most museum press offices move from one event to another, without having an opportunity to stand back and review the state of contacts and systems. Even if you are well organised, read through the first section of this chapter and see how you can improve your efficiency. Keeping lists up to date is an essential task which must be done as you go along. But if ever time allows, it's a good idea to review the way lists are organised – look for gaps and think about developments. Also, take the time to meet with key journalists whenever the opportunity arises, and take training courses that will keep you abreast of new techniques and bright ideas.

Targeting

Targeting is the buzz word in today's media relations. It is well worth taking great pains to place 'editorial' coverage or 'stories' in the printed and electronic/broadcast media rather than sending out press releases at random. Finding key messages, hooks and angles requires a creative approach to media relations and is much more challenging and rewarding than just producing the standard press release.

Think hard about the messages you have to convey. There should be some unique point which will hold the attention of the journalist during the vital first few minutes (or seconds!) of any communication. The message you choose to use may be quite different to the message that the curatorial staff provide – and there's nothing wrong with this, as long as you remain within the content and spirit of the project, event or exhibition. It may be necessary to explain to the person who planned the exhibition why you are presenting it in a particular way. For example, a museum may decide to hold an exhibition on 18th- and 19th-century Japanese export ceramics because:

- They have never done one before.
- The museum's collection is strong in that area.

- The curator has been writing a catalogue for the past five years and it is about to be published.
- They feel the subject is 'due' for review.

None of these is a compelling reason for a journalist to pay attention; unless you happen to be talking to an art book reviewer (which of course you *should* do as part of your range of actions). It is part of the press officer's job to see connections between the subject matter and popular interest. In initial talks with the curator or exhibition planner, the task will be to identify the key points that the exhibition conveys, and also those features that make it attractive and interesting to a general audience as well as to more specialised audiences.

It is useful to divide the target press into different segments, planning a different 'lead' or angle for each, even to the point of approaching just one or two key publications in each section directly. Take the example of an exhibition on 18th- and 19th-century Japanese export ceramics:

- **General news/events press**: 'A Passion for Blue and White' – a new exhibition explores the enduring passion for blue and white china by displaying early pieces from the Japanese export trade.
- **Arts/antiques magazines**: A new look at a popular area of ceramic art – the Japanese export trade re-assessed in a new book and exhibition.
- **Business press**: Japanese trade roots – the start of a great success story.
- **Children's interest magazines**: The story of a great escape on a plate! The story of the willow pattern displayed in many different ways in a new exhibition.
- **Gardening press**: The everlasting love of flowers – a new exhibition of decorated ceramics is a gardener's delight.
- **Home and lifestyle magazines**: A legacy of domestic style – a new exhibition traces the roots of a trade that inspired three centuries of decorator style.

Each 'angle' needs to be written slightly differently and suggests different accompanying photographs. One story can be spun many different ways.

Timing
At the moment of fixing the date of an opening, it's a good idea to check what is being planned by other organisations that might be

competing for press attention. In London, the Arts Council press office holds a clash chart. In New York and Los Angeles, you can use 'Masterplanner'. Even when you have chosen your date, you don't hold copyright on it, so it's important to notify as many press officers in other organisations as you possibly can.

Timing is everything in press work, which is why you need a well-organised office with efficient systems to handle the complexities of proper scheduling. Lead times (the period needed between placing a story and its publication or broadcast) are different for different sections of the press. It takes about five months to plan, lay out and publish a high-quality glossy magazine, whereas a central city newspaper can turn out a new edition in a few hours. Here is an example of an outline schedule for a major exhibition or event, ready to implement the moment it becomes a certainty:

- **Two years ahead**: Initial short press release and introductory letter to television shows and production companies (features, not current affairs). During the first year, telephone calls, meetings and briefings will follow this up. (The marketing effort at this time will be addressed towards the group travel market.)
- **One year ahead**: Brief press release to wider array of media, including specialist magazines and specialist correspondents.
- **Six months ahead**: Issue press kits, specially prepared for different sectors of the long-term press (mostly magazines and television shows with long deadlines). Make sure your website carries information also. Have a plentiful stock of good quality colour transparencies. (From this time onward, you will be providing special advance briefings to individual journalists.)
- **Six weeks ahead**: Main press release to complete mailing list.
- **Three weeks ahead**: Issue invitation to press view.
- **One week ahead**: Create photo opportunity. Work hard on local radio and local press.
- **Day before**: Issue brief news statement to press associations.
- **On press view day**: Distribute a launch-day release and opening press kit.
- **After opening**: Follow up on all requests, and distribute opening kits to all key press who did not attend.

Postcard campaigns

One tool that lies immediately to hand in a museum is the museum postcard. With cheap overprinting readily available, it is easy to send out messages and reminders to the press – and this is especially

appropriate for such a visual organisation as a museum or gallery. Postcard campaigns can be effectively used to build momentum and anticipation prior to a major event. The Norton Simon Museum in California was planning the unveiling of a complete internal refurbishment, which gave them an opportunity to use monthly mailings of postcards from the permanent collection to remind press of the quality of the collection and build excitement about the new look of the building. Brief and witty messages are more effective than lengthy and learned ones. The 24 Hour Museum website was launched with a range of colourful postcards, all based on the logo. Each of the project team members received a stack of these to send with different messages to their contacts.

Press events

Press views represent a moment in time when the exhibition is finished, the catalogues available, and those who have been involved in preparing the exhibition are on duty to meet the press and answer questions. Weekends, Mondays and Fridays should be avoided if you hope to have a good attendance. Clearly labelled photographs should be available. Press officers need to 'work the room', meet the press and introduce them to key figures. It is not just a kindness to invite press officers from other museums and galleries, as well as representatives of the tourist board or convention bureau: this is a good networking opportunity, which you can benefit from too.

Press conferences require meticulous planning, and serious consideration should be given to the appropriateness of the occasion. It is essential to have newsworthy information to share. (If the news you want to announce is too specialised in interest, or too low key, it may be better to host a press luncheon for a more informal briefing.) One of the museum's senior staff or board will need to give a well-prepared statement, with quotable phrases and sentences. Attending press will be grateful if the conference is brief, if there is adequate opportunity for questions and if light refreshments are available. It's also a good idea to have a quiet room available nearby for radio interviews. Much of the preparatory work will be done over the telephone, which means that invited press will know what the subject of the conference will be.

If your story is really important, you may decide to use an embargo to prevent the story from being used in advance of the conference. It may also be released as part of a speech at a specific event. The embargo is a request printed on the front of the release or invitation,

or emphasised in any telephone conversation, asking journalists not to publish or broadcast the information before a fixed time on a fixed day. Such a request is usually honoured and should only be used where circumstances make it essential.

Photo opportunities

Photo opportunities or photocalls are an essential tool in museum press relations. Sometimes it is possible to tell a long time in advance what is going to make a good press photograph. You may know that a huge object is going to be moved, or that something amusing or particularly precious is about to be put on display. Often the opportunity presents itself without much warning. Every press list should have a section for picture editors from regional and national newspapers, photo agencies and individual press photographers. A photocall can be made in the form of a brief printed invitation or a telephone call. Describe what's happening and give a time, place and person to contact. Examples of photocall subjects are:

- notable objects (size, value, curiosity value) being moved
- final touches to major conservation or restoration projects
- children using a popular exhibit or workshop
- human interest and personality events
- visually curious or amusing occurrences and predicaments.

So-called 'soft' stories, those of human interest value, do well as a tailpiece to television news, and also in newspapers during the 'silly' season in July and August when news is slack.

Awareness weeks

As we have seen there is a proliferation of awareness weeks in which museums and galleries are invited to participate (see Case Study 14). And there is no doubt that the media like awareness weeks – although they are getting more cynical about such promotions, particularly if they have a commercial aim. The packaging and concentration of news and feature material does inspire the media to focus on issues and activities in that sector.

Based on the fact that most of these umbrella promotions provide a free publicity vehicle, they are worth supporting from an attraction's point of view. However, there is a cost for those who want to get involved in terms of the resources it takes to organise a special event, or modify one that is already planned. Use this checklist to see whether your museum or gallery should be actively involved:

- Can you plan early enough – ideally 4–6 months ahead?
- Can one member of staff spearhead the events initiative and drive through public relations?
- Are you a member of a network, or could you set one up to work on this?
- Could your Friends help to get some of the events off the ground?
- Can you create some newsworthy activities, events and photo opportunities for local and regional media?
- Can you produce some special print – using the appropriate logo for flyers and leaflets?

If the answer is yes to most of these questions – go for it!

Media appearances

We definitely live in an age of 'sound bites'. Journalists have the task of engaging the attention of their readers, so during interviews they will be looking for quotable quotes, pithy sayings, controversial or challenging statements. Press officers can help museum staff to prepare for interviews by giving them a dry run. Question and answer sheets are one way to do this, but this method can succeed in worrying the interviewee into memorising official answers. It is much better to work on a personal basis by trying to anticipate questions, and by identifying key phrases which the interviewee uses naturally and work well in the context. There really is no substitute for preparation. Some interviewees may brush off the offer of assistance, saying they are experienced and well able to handle the situation. Challenge this by asking about the three key points they wish to make. Unless the person can answer this immediately, in brief and with vivacity, they do need help.

It is always a mistake to go into any live or recorded interview without a clear idea of why you are doing it and what you need to deliver. Recorded interviews are particularly risky for the unprepared interviewee, who may be tempted to talk at length, scattering or diluting their key points. Once the interview is edited and broadcast, those key points may be edited out. It is sometimes difficult to persuade others of this fact, but live interviews give the interviewee much more control of the situation. The well-organised, confident interviewee can make his/her points almost regardless of what is asked. The conventions of live broadcasting work in favour of the interviewee, and the interviewer has less opportunity to shape the interview or keep pressing a difficult point.

Most of us feel pretty battered after a media appearance because it

seems as though there is a lot at stake but, in fact, museum and arts people are rarely given a rough ride. It is unprofessional to ask for a list of questions beforehand, but perfectly acceptable to ask what ground will be covered and what sort of questions will be asked. The press officer might even venture to make suggestions about the sort of questions that will elicit interesting information – if they feel such suggestions would be welcome. Nervous interviewees may insist on a list of questions. This makes them look ill-prepared and amateur, or as though they have something to hide. Preparation and training are preferable. Even if journalists agree to submit a list of questions, they will rarely stick to it, so the aggravation has been pointless.

Occasionally stories will arise which are potentially of great embarrassment to the organisation, for example questions of provenance or professional malpractice (see also Chapter 14). It can be useful to give an 'off the record' briefing in some circumstances. This applies when it is in the interests of the organisation to have certain facts made known but inadvisable for it to be quoted as the source of the information. It is very important to be as truthful as possible, both on and off the record. Untruths are not worth the risk and have a way of finding you out – and the trust of the journalist is most important. Interviewees should also be reminded that anything said to a journalist – whether over coffee or immediately before or after the camera starts rolling – is counted as being 'on the record' and likely to be quoted and attributed. It's best to encourage interviewees to imagine that the microphone is live the whole time and to get comfortable with the concept. Say nothing which you wouldn't wish to see in the headlines the next day!

The way an interviewee sits, stands, talks or twitches can affect the way an interview comes across on camera. The lenses of thick spectacles, stripy shirts, swivel chairs and inappropriate smiles can all be pitfalls for the unwary. Media training with an experienced trainer is the best possible preparation – and an education in itself. When you stop to consider how important television appearances are within the array of publicity tools, it is crazy not to spend some time and money to do it well.

Why media relations is so important

Research shows that consumers give more credibility and pay more attention to coverage of this kind than they accord to advertising space on the same topic. An industry standard for calculating the cash value of editorial space is to multiply the cost of advertising in the same

space by three times. Thus, ten column inches of editorial are worth three times the cost of ten column inches of advertising on the same page or the equivalent in airtime. (This is a conservative estimate, because some research shows editorial can be ten times more effective than the equivalent advertising space.) If ever there was a justification for a suitably staffed and resourced press office in a museum – this is it!

CASE STUDY 15 Press campaign for the George Washington exhibition, Huntington Library, San Marino

George Washington is one of America's most familiar and, in many ways, least well-known public figures. 'The Great Experiment: George Washington and the American Republic', shown first at the Huntington Library in San Marino, California, was intended to shed more light on the significance of the first president. A media campaign was needed to capture public attention.

The exhibition, which ran from 6 October 1998 to 30 May 1999, was the best attended in the history of the museum, and included the highest attendance day ever achieved.

The exhibition and its publicity potential

As the exhibition ran for a long period of time, it needed publicity 'boosts' along the way. It was a major exhibition on an important theme, and brought new scholarship to the field. It was, however, largely an exhibition of documents, which are traditionally less appealing to a broad public. The plan was to overcome the boredom factor by creative press relations. Outlined here is a plan of action which, although labour-intensive, was designed to provide both quality coverage and more general media interest.

It was recognised from the start that the subject matter and the documentary display material would be considered 'dry' by many people, including the press. George Washington must be one of the best-known names in the world – not just in the USA. Most people know he was important, but not why. The museum hoped to stimulate people's curiosity to find out more about a man who is so famous and so little known. His appearance on the dollar bill must be one of the most familiar images seen by millions of Americans each day. The press were reminded of this image, linked with a famous portrait to be shown in the exhibition, and then the story was pursued with each branch of the media. This provided a layered approach, with different depths of coverage in different parts of the media – from basic listings to reviews and re-examinations of Washington's great vision, resulting in the legacy of today's political, constitutional and financial America.

A key to success was in presenting the exhibition within the context of an enjoyable visit to the whole of the Huntington Library, Art

Gallery and Gardens. In this way, educational benefit became an added bonus to a pleasurable experience.

Key features of the campaign

- Capitalise on the pre-existing media contacts of the museum; use feature story ideas with appropriate media; set targets and pursue.
- Widen the appeal of the exhibition by preparing specially written releases and letters for particular segments of the press; squeeze value from every potentially useful aspect of the exhibition.
- Contact identified media people by letter and telephone, following up with energy and persuasion.
- Meet the prime contacts face-to-face as much as possible, in order to explore potential angles and find the right story for each.
- Take a layered approach – different ways with different media: in-depth coverage and reviews to focus on the academic achievement of the exhibition, and a lighter touch with general-interest press.
- Extend the coverage through the run of the exhibition: opening period; pre-Christmas; Presidents' Day; opening of supplementary Mount Vernon exhibition; other programmed events.

Market segmentation

Primary markets
- people with an established interest in history and culture (higher than the average educational attainment)
- people who wish to be informed (readers of quality newspapers and news magazines)
- members, their families and friends
- schoolchildren
- residents of Los Angeles area (particular emphasis on west LA for audience-building purposes, because fewer visitors came from that part of town).

Secondary markets
- people with special interests in particular aspects of the exhibition (military history, political and constitutional affairs)
- those with no special knowledge of history, but whose attention can be engaged by some easily grasped aspect
- families seeking beneficial leisure-time pursuits
- visitors to the area who want the whole Huntington experience, with the exhibition as a bonus.

Media work

A wide variety of media was considered to form a worthwhile target list for press contact work, and the net was cast very wide over the categories listed below. These lists serve to illustrate how much effort and contact work has to be made in order to get a modest but sufficient return. The media coverage – which was sustained over six months – was considerably helped by an ambitious advertising campaign.

The use of a single press release for all was rejected. The task was to approach different segments of the press with slightly different angles on the story in order to gain their attention and the interest of their readership. Different releases or letters were crafted for each segment of the press; sometimes this involved a variety of tailor-made approaches within each category.

Television documentary

As there was insufficient time to secure the creation of a documentary devoted specifically to the exhibition, the Arts and Entertainment Channel and the History Channel were approached to determine whether pre-existing programmes could be broadcast either at the beginning of the exhibition or around Presidents' Day and Washington's birthday (15 and 22 February). This did not materialise, but later – too late for the exhibition – a new film was commissioned.

Scholarly and history publications

Based on the feature-story ideas already identified in planning documents, contact was made with the following magazines, with a 50% success rate:

American Heritage Magazine	Constitution Magazine
American Journal	Historic Preservation
American Legion Magazine	Pennsylvania Heritage
Chronicles of Culture	Smithsonian Magazine

Art publications

The fine art content was small, making it difficult to get arts reviews, but the portraiture provided some material. The decorative arts offered extra scope. Only a tiny proportion of the following were persuaded to cover the exhibition:

American Artist	Art Issues
Art & Antiques	Art NEWS
Art and Auction	Art Newspaper

Art of California
Ceramic Arts & Crafts
Ceramics Magazine
Ceramics Monthly
culturefront
Drawing Society
Early American Life

Fine Arts Collector
Glass Magazine
Journal of the Print World
Maine Antiques Digest
Print Collector's Newsletter
Sculpture Magazine
Silver Magazine

Collectibles and antiques press

There was seen to be universal appeal in the subject matter, as well as specialist appeal in, for example, plates, buttons and silver. Releases were angled for collectors of different objects. Most of these magazines carried a small item about the exhibition.

American Art
Antiques Magazine
Art & Antiques
Art & Auction
Ceramics Arts and Crafts
Ceramics Magazine

Decorative Arts Newsletter
Fine Arts Collector
Glass Magazine
Maine Antiques Digest
Mid-Atlantic Antiques
Silver Magazine

Business press

There was thought to be a strong story here, showing Washington's role in founding the banking and financial services we know today. The breadth of his vision in investment, trade and commerce was presented as being of great contemporary interest. This proved a hard sell, and none of the following magazines gave serious coverage, despite substantial efforts.

Art Business Journal
Barron's
Business Week
Forbes
Fortune

Los Angeles Business Journal
Money
Wall Street Journal
Your Money

Education press

Two strong threads were pursued: the educational opportunity presented by the exhibition, both formally through schools and informally in the context of family visits; and the story of the museum as educator – training and assisting teachers, and training and involving junior docents. About 30% of the following gave some level of coverage:

About Books

Academe

American Scholar
American School Board Journal
American Teacher
Children's Television Workshop
Chronicle of Higher Education
College and University Magazine
College Teaching Magazine
Department of Education Reports
Education Daily
Education Reporter

Education Today
Education Update
Education USA
Education Week
FOX on Education
Scholastic Scope
School Board News
School Library Journal
Sesame Street Parents
Teacher Magazine

Travel and tourism press

Three tiers were pursued: national, international and western states. The approach was to promote the exhibition within the whole experience of the Huntington Library, Art Gallery and Gardens. Some magazines gave only tiny mentions but reached large audiences.

AAA members magazine, Westways
Avis Traveler
Car & Travel Monthly
Condé Nast Traveler
Departures
Gourmet
In-flight publications
Museum Traveler

National Geographic Traveler
Selection of overseas travel magazines
Travel & Leisure
Travel & Tour News
Travel Holiday
Travel Weekly
Travel Trade
Travellers' guides to museums

Home and lifestyle magazines and women's interest

The material offered centred on the objects, the period lifestyle and Martha Washington. This effort was supported by a plentiful array of photographs, extra contextual material and help from museum experts. Short listings and mentions were achieved.

American Woman
Architectural Digest
Better Homes and Gardens
Colonial Homes
Country Homes
Country Living
Elle
Elle Décor
Good Housekeeping
Home Magazine

House Beautiful
House and Garden
Ladies Home Journal
Mirabella
Southern Accents
Traditional Home
Women's Day
Women's Own
Working Woman

Members of the Huntingdon's Society of Fellows at the opening of 'The Great Experiment: George Washington and the American Republic'. Courtesy of the Huntingdon Museum.

Society pages

The Gala Opening and other events presented opportunities for coverage by the following magazines. Most of these sent their own photographers and published pictures of the guests having a good time, adding brief descriptions of the exhibition.

Celebrity Society
Los Angeles Times
Pasadena Herald Tribune

Pasadena Magazine
Pasadena Star News
Town & Country

Gardening magazines

Contacting this sector of the market tied in with the policy of presenting the exhibition within the context of the whole visit. Gardening is such a rapidly growing interest, there was thought to be much potential here, although nothing major was secured.

American Homestyle and Gardening
Better Homes & Gardens
Country Home Country Gardens
Country Journal
Garden Design Magazine

Gardening Today
Horticulture Magazine
House & Garden
Martha Stewart Living
Organic Gardening

News and current affairs magazines

Using various ideas for feature stories, the exhibition was presented as a major contribution to our understanding of Washington and the foundations of American society. Even if it was not a complete re-evaluation, it did present a fresh interpretation and appreciation of the man and his times. The involvement of John Rhodehamel – the curator responsible for the exhibition and author of the catalogue – and his preparedness to be interviewed was essential. Only three of these publications responded, but their national and international readerships are so large that it was regarded as successful.

American Spectator
Buzz
Christian Science Monitor
George
L.A. Magazine
Life Magazine
Los Angeles Times
Nation

New Republic
New Yorker
Newsweek
People
The Weekly Standard
The World and I
Time
US News & World Report

Book reviews

The press team worked closely with the museum publications department and with the publishers of the catalogue to obtain reviews (and mentions of the exhibition) in appropriate publications. This was one of the more successful aspects of the press coverage.

American Scholar
History: The Review of Books
Los Angeles Times
New York Review of Books
New York Times
New Yorker

San Diego Union Tribune
San Francisco Chronicle
San Francisco Examiner
Time
Wall Street Journal

Events and listings press

Press material was issued continuously to obtain short articles and listings for the exhibition and accompanying programmes in local and West Coast media. This was an area of continuous coverage through photo stories and editorials.

L.A. Magazine
L.A. Weekly
Los Angeles Times
New Times

Pasadena Herald Tribune
Pasadena Magazine
Pasadena Star News
Town & Country

Press agencies

Using hard copy and electronic media, information about the opening was issued to the following; also for Presidents' Day (15 February), the actual birthday (22 February) and the opening of the supplementary exhibition. This achieved substantial coverage in scattered out-of-town magazines and newspapers and helped to interest television stations which monitor news services.

Associated Press (AP)
City News Service
Copley News Service
Fairchild News Service
Hollywood News Calendar

PR Newswire
Radio Central News
Reuters
United Press International (UPI)
Western News Service

Family magazines

Three themes were used as the basis of a special release for children's magazines and pages: truth and fiction (see the exhibition and find out), map-making (Washington started as a surveyor) and Washington's false teeth (a gruesome but amazingly attractive item). The lead times for some of these magazines were too long, and opportunities were missed for the opening of the exhibition; but articles did appear later, which was useful for this long-running exhibition. The false teeth proved most newsworthy.

American Family
Family
Family Circle Magazine
Family Magazine
L.A.Kids
L.A. Parent

Parenting Today
Parents
Sesame Street Magazine
Time for Kids
Weekly Reader

Political, government and public service magazines
There was limited but still useful interest.

Almanac of American Politics
America This Week
American Journal
American Political Report
American Spectator

Cook Political Report
Congress Monthly
Public Citizen
The American Scholar
The Public Interest

Local
Television: Specific targets were identified to avoid a scattershot effort. (Target list: *Life & Times*, KCET; *Eye on LA*, KTLA; *Good Day* on KTLA; KMEX and other foreign language stations.) On press day no less than six television crews turned up.

Radio: Particular programmes were identified for different approaches. KPCC, local Pasadena radio – 'Washington's relevance today', KCRW, a large national public radio station in Los Angeles – 'How much of a radical was Washington?'; KPFK, local station with strong political awareness – 'What was Washington's real contribution – how would America be a different place without him?'

Latino press: A Spanish language press release was produced; there were no other language translations. Various ethnic group newspapers and television stations were approached with small success.

Photo opportunities
The press team created and publicised photo opportunities prior to the opening of the exhibition and during the run. These included: historical re-enactments of a famous battle, children meeting period dress facilitators and a George Washington look-a-like competition.

CASE STUDY 16 Saving the Moran painting for the Bolton Museum and Art Gallery

The successful campaign to save the Thomas Moran painting Nearing Camp, Evening on the Upper Colorado River *(1882) has not only brought an increase in the number of visitors from all over the country to the Bolton Museum and Art Gallery in Lancashire but it has also raised awareness of the museum among the local population and the town's decision makers.*

The campaign which ran from March to October 1998 is described by Adrian Jenkins, curator of Bolton Museum and Art Gallery.

The campaign to save Moran's *Nearing Camp* has been described as a 'remarkable case' and a 'notable achievement for a regional museum'; 'save' in this context meant making sure that the painting was not exported to the USA for auction. The success of the campaign is even more remarkable when one considers that before it started most people had never heard of Moran, or seen any of his paintings.

Thomas Moran was born in Bolton in 1837 and emigrated with his family to Philadelphia in 1844. Moran was one of the greatest American landscape painters of the late 19th century and became famous for his monumental depictions of the American Far West. Along with another Bolton-born artist, Thomas Cole, he is one of the most important British-born painters in the history of American art and largely responsible for bringing the lessons of Turner to bear on American landscape painting. He returned to Britain in 1862, when he studied Turner at the National Gallery, and in 1882, when he exhibited both in Bolton and London. In Britain only one public collection houses any of his works, and that is the small collection at Bolton Museum and Art Gallery.

In March 1998 *Nearing Camp* was put in the hands of Sotheby's and the request for an export licence was opposed by the National Gallery. The government issued a temporary export ban to see whether £1.5 million could be raised to save the masterpiece. The Bolton Museum and Art Gallery decided to pursue the acquisition and an application for £1 million was made to the Heritage Lottery Fund. Following the award the campaign began in earnest. The museum not only had to educate the media and the public about Thomas Moran but also convince them that the painting was worth

'saving' as part of Britain's heritage. The huge national media interest generated by the museum became the most important feature of the campaign. It was this that helped to convince local politicians, the public and funding bodies of the importance of the painting.

The media picked up on the dramatic, emotive side of the campaign. It was perceived as a moral crusade – a small regional museum fighting global, profit-making Sotheby's to save the nation's heritage – and this was set against the heightened drama provided by the ticking clock of the export deferral period. As the six-month deadline loomed the museum was still short of the asking price. By this time the *Daily Telegraph* was reporting the valuation by a New York dealer of $10 million (or £7 million) if the painting was sold in the USA.

At this point – coinciding with the government's highly unusual decision to extend the deferral period by one month – Bolton Museum and Art Gallery invited Loyd Grossman, chairman of The Campaign for Museums, to help promote the campaign. This helped to boost the media campaign and on the last day of the final month the National Art Collection Fund and Bolton Council made up the shortfall. The national media descended on Bolton to see the painting's arrival. The campaign was a museum's marketing dream.

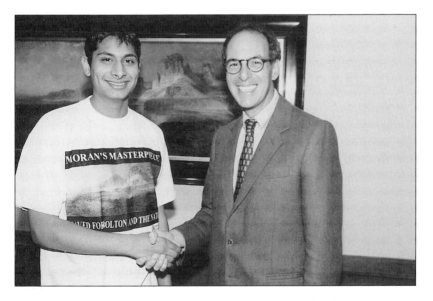

Bolton's masterpiece was promoted through T-shirts and with the support of Loyd Grossman, TV personality and chairman of The Campaign for Museums. Courtesy of Bolton Museum and Art Gallery.

CASE STUDY 17　How the Angel of the North took the media by storm

The Angel of the North *by Antony Gormley is not only Britain's largest public sculpture but also its best known. Its unorthodox appearance makes it instantly recognisable and its location next to the A1 at the gateway to Tyneside guarantees an annual audience of 33 million viewers every year.*

The Gateshead Angel appears to have been designed to bring overnight, international attention to the town. Having seen its success, others now want to mark themselves out by building their own equivalent of the Angel.

Robert Schopen, public relations manager of Gateshead Council describes the controversy leading up to its 'launch' in February 1998.

Gateshead did not set out to build something bigger and better just for quick publicity. We did feed the media's insatiable appetite for superlatives, but the Angel was the culmination of 15 years' work using public art to change the image of the area, to bring art into people's lives and to regenerate derelict industrial sites.

There were more than 30 pieces of public art in Gateshead before the Angel, many by leading contemporary artists like Richard Deacon and Andy Goldsworthy. It is doubtful whether Antony Gormley would ever have created the Angel for Gateshead without that track record – as he said at the first meeting in 1995 to discuss the project he did not do 'roundabout art'.

The controversy

The project only attracted media attention after the artist was chosen and once the first image of his plans was released. The local media seized on the artist's sketch, and in the absence of accurate images the media generated their own. They literally pasted them on to photographs of the site to create the crudest photomontages, and a controversy was born.

The arguments against the Angel broke down into three basic classes: it was big and ugly, a waste of public money and it did not look like an angel. Tagged on to that were the more inventive claims dreamed up by protesters: that it would cause traffic accidents on the A1, interfere with television signals and even that it would be stolen by scrap dealers.

The situation reached an all-time low in 1995 when one local paper carried the front page headline 'Nazi but Nice?' over a story compar-

ing the Angel to a Second World War statue of Icarus that was dedicated to the Luftwaffe.

Regaining the initiative

Our communications objectives soon became clear. Our aim was not to make everyone instantly love the Angel – an impossible short-term task as art is subjective and should stir strong emotions. But we wanted people to understand why we were building it, namely:

- to establish a positive new landmark symbol
- to create an attraction bringing in 140,000 new visitors a year – a condition of European tourism funding for the sculpture
- to raise the profile of Gateshead nationally and internationally
- to enhance Gateshead's reputation in the visual arts and to ensure funding for future projects.

Angel of the North – the final construction. Courtesy of Gateshead Council.

In order to regain the initiative Gateshead Council took action to explain each of its arguments for going ahead with the project. A series of realistic photomontages were created and distributed widely to the media and to photo libraries, on CD-ROM as well as via the Internet.

Reports on possible television interference and traffic congestion were commissioned and publicised and a pledge was made that no local council tax payers' money would be used to build it – all the £800,000 funding would be found from outside sources such as the Arts Council Lottery Fund. Advocates of the Angel explained that successful art has to stir strong emotions and be noticed – otherwise it has failed. A series of public exhibitions were mounted using a scale model and inviting people to give their views in a comment book. The then Arts Minister Virginia Bottomley even posed with it at a televised press launch.

Because of the council's existing work with the arts in schools and community groups, new programmes were focused on the Angel. Children learned how the Angel was created by body casting. The artist was involved in workshops with the youngsters, and the media were invited to see youngsters proudly showing off their own creations.

All ages were involved – the annual Sculpture Day when families create their own sculptures in a local park was themed on angels, and the Prime Time group of retired people wrote poetry about what angels meant to them. The results were displayed on a series of posters on Tyneside's Metro underground system.

The media's demand for new stories was voracious. We used this appetite to publicise a display in a derelict engine shed of another Gormley work – *Field for the British Isles*, a terracotta army of thousands of tiny clay figures. Not only did 26,000 people see it; research showed that 49% of the region's population recognised the work from the media coverage. None of these events were stunts, they were all serious attempts to get people to understand the process of how art is created.

Research showed that by the start of 1996 more than six out of ten people in the region could recognise the Angel, and by the end of the year this had risen to more than eight out of ten – two years before it even existed! What started as a purely local controversy had slowly spread to encompass a national and international audience – and each time we were prepared with the same responses as the old stories were re-cycled and rebutted.

By the time we started to build the Angel we noticed a sea change in public opinion. In letter pages, comment books, telephone phone-ins, vox pops and letters to the council, a balance emerged between admirers and detractors. Our major problem also shifted from

explaining the project to controlling media access to a busy steel fabricator who simply wanted to go ahead and build it.

Photo opportunities were arranged at key stages, and along with commissioned photography this helped to break the information logjam. A local television production company followed the scheme from the start, and video news releases were commissioned and distributed in advance in two stages —one to extend domestic television coverage, the other to secure additional foreign coverage.

The launch and the aftermath

Invitations for the launch were sent out in advance but, because of possible weather and technical complications, it was agreed the date would be confirmed via UNS wire 48 hours beforehand. Coverage stretched over two days: news staff were invited for the day it was erected and art critics and VIP visitors for the following day. A mobile press office and catering facilities were to be set up on the windswept site to deal with 93 journalists, including 15 film crews, five radio reporting teams and 20 photographers. A total of 36 live television and radio interviews were arranged at eight outside broadcast vehicles with 10 interviewees.

This secured coverage on every UK television and radio news bulletin, front page pictures in almost every major daily newspaper, and cartoons, arts reviews and feature coverage on following days and in the Sundays. International coverage stretched as far as the *Buenos Aires Herald* and the *Jakarta Post*. There were documentaries on two regional channels, three national stations and one international station, as well as two series of shorts, three arts documentaries and a book deal.

Since the launch the job has changed again to one of managing the constant demand to use the Angel for filming, advertising, media launches, publicity stunts and merchandising.

As well as picking up a spate of awards for everything from engineering to arts, it has featured in a Lighthouse Family pop video, on the Eurovision Song Contest, in a BBC 'World Balloon' corporate film and on every quiz show from *Mastermind*, *University Challenge* and *Brain of Britain* through to *Wheel of Fortune*.

Visitor numbers were almost double the predicted figure, and the Angel is now built into the tourism fabric of the region, on postcards and posters, T-shirts and souvenirs and in countless websites.

The final irony is that those who opposed it now happily pose in

front of it for media opportunities promoting their causes. But the real legacy is the fact that it helped Gateshead open the door to funding for even more ambitious arts schemes – for the £45 million Baltic Centre for Contemporary Art, the largest gallery of its kind outside London, and, possibly, funding for a £60 million concert hall complex.

Chapter 14 COMMUNICATING IN A CRISIS

Sue Runyard and Ylva French have handled fire, flood, earthquake, bombing, accidents, personal attack and theft. These are all-consuming and very sudden events for which there should be a plan known to everyone who needs to know. They have also handled threat of closure, withdrawal of funding, political demonstrations; scandal and controversy, for which there can be no standing plan.

What is a real crisis?

A crisis can be defined as something unexpected which interrupts the day-to-day management of the organisation. Many small crises occur all the time and are dealt with competently by staff without necessarily involving senior management: an object goes missing; a visitor complains about the toilets; an exhibition runs behind schedule; a staff member with a crucial job to complete is ill. These are not likely to impact on the outside world. Nevertheless, senior management should be aware of a build up of problems in any one area – it could be a major crisis in the making.

A crisis which needs senior management attention is:

- out of the ordinary – an unexpected and possibly unanticipated situation
- potentially of interest to the outside world or involves the public directly
- any situation where the public interest demands a response and the reputation of the organisation is put at stake.

Why has crisis communication become so important?

A quick look through the national broadsheets and tabloids any day of the week provides the answer to this question. Every day public and commercial organisations as well as individuals are in the dock – 'prosecuted' by the media whether they are actually in court or not. Finding someone to blame for every accident or incident is now a media obsession. Acts of God no longer exist!

It is in the interest of every organisation that they stand up to scrutiny in normal times, and at a time of crisis it matters more than ever. No stone will be left unturned by the media once they start 'investigating'. What may begin as a minor incident reported only in the local newspaper could quickly become a major scandal which ruins the organisation's reputation for years to come.

The speed at which the media now work means not only that they demand a quick response in every situation with a potential news value but also that levels of accuracy are not always maintained – and this applies to all media. When an official response is not available, an uninformed member of the public will do, and there are always so-called experts and other commentators who are ready to provide an analysis of *your* problem.

Members of the emergency services, like everyone else, are keen to maintain and improve their image. Fire crews carry video cameras and happily release dramatic footage to regional and national television stations, perhaps making the situation appear worse than it really is. Police or fire department spokespersons will be instantly available to put their side of the story – again not always in the organisation's best interest.

At the same time as the media (and supposedly) the public demand more information, the increasingly litigious environment in the UK and to an even greater extent the USA – has forced organisations into a tight corner. They are anxious to show appropriate sympathy for those involved in an accident but advised by their lawyers to say as little as possible.

All of these factors need to be taken on board in the preparation and implementation of the crisis plan. It is unlikely that any museums, galleries or heritage attraction will ever face the scale of crises that an airline or a ferry operator has to be prepared for. But stop for a moment and imagine what would have happened if the fires at Windsor Castle or Hampton Court Palace had started during public opening hours.

Museums in California have certainly experienced both brushfire and earthquake during hours when the public were visiting. No lives have been lost. Museums in the UK are quite familiar with bomb threats, with explosive devices which have been defused without damage, and even with armed robberies.

Luck and preparedness have both played a part in past incidents, but the wise organisation does not trust to luck alone. Complacency is the first sin of crisis communications; being prepared is essential.

Crisis planning

As part of registration in the UK, museums and galleries are asked to develop a disaster plan. In the USA, museums are expected to have plans as part of their public responsibilities. Such plans will be mainly concerned with the building and objects and, together with the

public health and safety regulations imposed by local authorities, should make a good starting point from which to prepare a communications plan.

Start with a brainstorming session involving senior management and those front-line staff who would be the first to discover or bear the brunt of an accident or major problem involving the public.

Go through as many different scenarios as possible – and impossible (by definition, a crisis is going to be something quite unexpected and out of the ordinary). Categorise them into groups and consider the impact each will have on the outside world and on your reputation. Detailed plans for dealing with each of the different types of crises can then be developed in smaller working parties or by individuals.

Categories of crises

Crises which affect museums and galleries and other institutions in the heritage sector and which could have an impact on reputation fall into a number of categories:

- **Funding and staff**: Cuts in funding; staff disputes; crime or other misdemeanour by staff or trustees; issues relating to admission charges; performance failure.
- **Injury and damage to people/buildings/objects**: Accidents to individuals; overcrowding; fire/flood with or without injuries to people; bomb threats.
- **Injury and damage caused by others**: Damage/accidents involving contractors, e.g. food poisoning; illegal acts committed by third parties on the premises.
- **Media attacks**: Unwarranted negative public comments which spread to or originate in the media; investigations initiated by the media; continuous sniping from one area or one part of the media.

Funding and staff crises

Funding crises can often be predicted, and plans can be developed to deal with them at a much earlier stage than usually happens. Do not be complacent in this area: no organisation receiving public funding is 'safe'. Consider all possible scenarios, present and future, and develop a skeleton plan to meet them head-on. More important: do everything to avoid this particular crisis by developing a proactive public relations strategy aimed at funders, stakeholders and decision makers (see Chapter 17).

When funders and sponsors drop out at the last moment, it is good

to know who your friends are, and to whom you can appeal for immediate assistance. But you also need to handle any media fallout which occurs. When something nasty is discovered about one of your sponsors – for example that they deal in arms or tobacco – and demonstrators appear at the entrance, media coverage is bound to follow.

In most museums in the UK the introduction of admission charges have been handled on a fire-fighting rather than a pre-planned basis. Whatever the economic reasons are for charging, what the public wants to know is that in some way they are going to get a better deal at the museum in question. In 1999 and 2000 some national museums will be able to remove their admission charges again. This will present a challenge for the communicators: they cannot assume that the elusive non-museum visitor is going to queue up at the door just because it's free again (see also Chapter 4).

Staff situations are delicate and may involve any number of legal issues. As little as possible should be said publicly; statements should aim at damping down damage caused by individuals who are made redundant or dismissed. Good internal communications and staff relations are essential and will hopefully prevent a crisis becoming a public issue.

Injury and damage to people/buildings/objects

The disaster plan will have identified problems in the building or with services which are cumulative and which, if not dealt with, may lead to a major problem – subsidence, for example. The prevention of this becoming a 'public' crisis should be part of the disaster plan.

Public safety is paramount in any organisation, and museums and attractions which fail in this area – whether or not through a direct fault of their own – are immediately in trouble. This includes everything from a fall on a slippery floor to a major fire.

Museums and galleries will have emergency procedures for evacuating the public and for other minor accidents in public areas. The communications crisis plan should interlock with the emergency procedure. Security staff should be well-briefed on the crisis plan and on arrangements for the communications centre. The key messages of care and concern (see below) must be built into the way that staff deal with every type of emergency involving the public, from a simple fall on the floor to a major evacuation. Efficient communication on every such event between security, the director and the press office is essential. The communications crisis plan will spell out who is in

charge, who deals with what, and where and how communications take place.

> The J. Paul Getty Museum in Los Angeles, the home of fire, flood and earthquake, not only has detailed plans for coping with disasters – plans in which every member of staff has a designated role to play – but occasionally has a full dress rehearsal with 'wounded' and 'dying' visitors at which observers from the fire department are present to advise.

Injury and damage caused by others

In the case of criminal activities on museum premises, a decision has to be made at the very start as to how far the museum or attraction can disassociate itself from the incident. The police will take charge and the fewer mentions of where the incident took place the better. Disputes with contractors over damage or ill-fitting or leaking show cases and tanks, or late running contracts, are not likely to show the institution in a good light, even if it is not to blame. The rule in such cases is: the less said the better. Food poisoning incidents are likely to be perceived as the museum's fault, even if outside caterers were used. It is best not to cast blame in public; better to accept responsibility outwardly.

Media attacks

These may come out of the blue and appear totally unwarranted; starting perhaps with a dissatisfied employee or member of the public which is taken up by the media. See below how to deal with such incidents. Some attacks may be brought on by the institution itself, for example by agreeing to take part in a fly-on-the-wall documentary. In most cases, this style of programme is not a good way of building a public image. The production company will be looking for an angle, mostly derogatory, which will make enjoyable and fun television. They will not agree to any editorial controls during the shooting or afterwards. There are now plenty of examples of famous institutions becoming unstuck in these areas – notably the Royal Opera House. Sometimes the gamble pays off – it certainly has for BAA and *Airport*. But it is definitely not for the faint-hearted; nor those with skeletons in the cupboard!

Implementing the crisis communications plan

Who is in charge?

In most organisations, the director will automatically be the person 'in charge'. The crisis plan should spell out the alternatives: (a) who stands in when the director is absent or cannot get there quickly enough; (b) in a major crisis, the role of managing the situation is divided, i.e. who deals with the emergency services and who is responsible for communications. A senior press officer or head of public relations with experience of dealing with the media will be well qualified to handle the communications part; the director (who may be managing the emergency) should be available for interviews at specific times.

> Many organisations have a 'call-out tree' which starts with one telephone call, and fans out to create a network of staff who ensure everyone on their 'branch' is contacted. This system worked well at Uppark House in the UK, where fire took hold of the upper floors, and staff had suffient time to attempt to save some of the objects. What 'went wrong' at Uppark in the final minutes was the staff's attachment to the objects. They found they were unable to fling precious items out of the windows, so some things went up in smoke rather than landing broken on the lawn.

The communications centre

The press office or the director's office could be the designated communications centre. It should be close to the emergency centre but not necessarily in the same room – and especially not in the case of a major crisis. The basic requirements for a communications centre are one or more telephones. In addition, it should have one or more fax machines and access to the internet so that journalists can be contacted by e-mail as well as by fax (see also Chapter 13).

It may not be possible to get access to the building to activate the communications centre, either because of the emergency itself (a bomb threat, for example) or because the building is alarmed, locked or otherwise inaccessible at night or weekends. Therefore, an alternative system for dealing with this sort of event has to be planned. This may involve a third party. Museums and galleries who retain a public relations company could use their offices; that would

also provide extra hands to deal with incoming and outgoing phone calls. Alternatively, it could be in someone's home (provided all the necessary equipment is available). As the communications centre may have to be set up in the dark (during a major disaster), it is essential to have mobile telephones, torches, a radio, batteries and powerpacks available. Distinctive vests or sashes for staff are also helpful in this situation.

If the emergency situation is likely to extend beyond one or two days and a temporary office has been set up, extra phone lines should be installed (telephone companies can act quickly in an emergency). Additional staff may have to be taken on or seconded to deal with incoming calls from the public, and a separate line must be kept clear for the media. Call centres are an alternative for providing information to the public and can be contracted at very short notice.

The first statement – care, concern and control

The task of the director or designated media spokesperson will be to convey the forethought and planning which has prepared them for this moment. The organisation needs to look prepared and effective – no matter what is going on behind the scenes. Media training for crises is invaluable for senior management. The Institute of Public Relations has details of organisations who provide this training (see Appendix 2, under Training and professional development).

The first statement by the organisation under crisis sets the tone for the media and could well be the one by which the organisation is judged for ever more, so you can't afford to get it wrong. Remember people come before objects – always. Denials, 'no comments', blaming others – none of this works. The organisation should accept responsibility for the situation and for the action which needs to be taken without at this stage accepting blame or culpability.

The statement must start by showing that the organisation *cares* about the victim(s) of the incident, that they are *concerned* and doing something about it (i.e. carrying out an investigation) and that they are in *control* (even if it is the fire department that is establishing the source of the fire, they are working closely with them).

In a funding crisis, blaming the government, the local authority, individual politicians, Lottery funds, the National Endowment for the Arts or some other distributing body *may* get some instant coverage. But it will not win friends among the people who matter for the future, and it will certainly not restore your funding. In any case, should you not have seen this crisis coming? In this situation a

statement should be more reflective: accept some of your own shortcomings and indicate the steps you plan to take for the future. The rest of the campaign should be like an iceberg – the media and the public should only see the peaks.

The speed of the statement

From the start of this chapter, the speed at which the media works was stressed. So get the statement out quickly, the same day, the same night. Don't wait for trustees and lawyers to clear it and thus miss all the relevant deadlines.

Showing care and concern for what has happened is not an admission of guilt, whatever your lawyers may say. It will win you lots of brownie points with the media in a major crisis, and in a small incident it will ensure that instead of a legal bill you have a grateful visitor who will return again and again (because you sent her home in a taxi and sent flowers to her home after she fell down the stairs).

Using e-mail enables you to send your statement simultaneously to a wide range of addresses across the globe. This means that your crisis communications plan should include an up-to-date media contacts list. It is important that everyone who matters gets the information at the same time. In a crisis situation it does not pay to do anyone favours with an exclusive interview or insight into the problem. Do that later when you start the programme to rebuild your reputation.

The use of websites is equally important – make sure your press releases are on your website as a matter of course. After a major incident you may also want to set up a question and answer forum for people with specific enquiries – if only to forestall someone else doing it independently and not necessarily in your interest. You may also wish to provide an option on your telephone line for callers who want an update on the situation.

Staying in control

Staying in control means continuing to manage the news situation until the media has run out of steam and/or something else has taken their attention. Issuing regular bulletins will keep people informed; making sure press office phones are manned seven days a week is important; and the availability of senior management to make statements, be interviewed and take people on tours, if appropriate, will be helpful in maintaining your reputation in a difficult situation.

When it is all over

When the immediate crisis is over, the real work of rebuilding the reputation starts. The timing of this is crucial, and no hard and fast rules apply. In some cases, an immediate image rebuilding campaign can start: target journalists who are not involved in the day-to-day news story and create positive features on how the emergency has been tackled. In other cases, the damage may be so severe or beyond your control that you have to wait until the emergency subsides; you may have to lie low in proactive public relations terms for quite a long time if there is real public hostility or fear. Test the waters and develop a public relations plan which will rebuild your damaged reputation, restore your funds and lead to the return of visitors. In the case of loss of funding, the situation may be beyond saving if the decision was politically inspired and part of a wholesale cut in funding. A public relations strategy must then be developed to support a new funding strategy.

Every situation is different

Remember that every situation is different and, by their very nature, no crisis will exactly follow the scenario which your communications crisis plan spelt out. So make sure that the plan is flexible; that your staff are flexible and prepared to take control if no one else is available; that everyone realises the need for speed; that everyone knows that first reactions will count – and count against you if they are badly handled.

So you haven't got a plan

The museum and gallery which is faced with a crisis and is without a communications plan should do the following:

- One senior person should take charge of communications.
- The situation should be assessed and a rapid statement issued to the media.
- Staff/trustees should be kept informed and 'on message'.
- If a key media list does not exist, call a friendly public relations person or company and be prepared to pay for this essential item.
- Deal in the same way with all media – do not give any exclusives or favours.
- Maintain communications – don't clam up after the first statement, but don't say more than you know or can appropriately disclose.
- Do not blame third parties or quote third parties.

- Start to rebuild your reputation with a proper public relations programme and put together a crisis communications plan.

How and when to complain to the media

The media coverage of a crisis may in itself generate further problems. The crisis may in fact have started with a spiteful and erroneous article in a magazine or newspaper. What do you do?

It is important to remember that you cannot really win against the media. They will always have the upper hand – even if the media lose a libel case, the public has enjoyed column inches of negative coverage against the complainant before the judgement is passed. And it will have cost a lot of money.

Therefore, the first decision to make is what there is to gain by complaining. These are situations in which you should complain:

- **Mistakes and errors of fact**: Fax a polite letter to the relevant editor immediately and ask for the mistake to be rectified. Mistakes in listings and magazines usually require follow-up phone calls to get telephone numbers and opening hours amended.
- **Strong opinions by journalists or in editorials with which you do not agree**: Send a letter to the editor; make a positive point; make the letter interesting and humorous, if possible, it will have a much better chance of being used. If appropriate, start cultivating the journalist in question.
- **Vicious and potentially libellous attacks on individuals or the institution**: Take legal advice and then fax and send a recorded letter to the editor in person (marked not for publication); file a complaint with the Press Complaints Commission if no apology in the newspaper is offered. As regards television and radio – file your complaint with the Broadcasting Complaints Commission. When you are forewarned of a potentially disastrous item on television or a damaging article, take legal advice, and if you have sufficient grounds (and it really matters) go for an injunction – but consider the cost.

CASE STUDY 18 Accidents and incidents – some examples

Fire

As brushfires are quite common in dry Southern California, the J. Paul Getty Museum has a plan and well-rehearsed evacuation procedure ready to be implemented at a moment's notice. In 1992 a major and very frightening fire swept across the hillside towards the museum. 'Immediate evacuation was called for', said Andrea Leonard, head of the visitor services department.

We certainly did not call 'fire!' because we did not want to cause panic. There was a prepared announcement made by the security staff which told people that because of traffic congestion in the vicinity it had been decided to close the museum, and people were asked to leave. They did so in an orderly way, and we were then able to concentrate on moving the art from laboratories, where there was flammable material, to the more bunker-like main building.

Reporters were trying to get onto the premises to see what was going on. Securing the perimeter is always important. What took us by surprise was the number of telephone calls from concerned residents in the area, who wanted to know if they should come with their cars and pick-up trucks to rescue the art! Of course, we didn't need that kind of help, but we had to turn it down politely and with gratitude, even in the midst of everything that was going on.

- Have a well-considered plan.
- Rehearse evacuation procedures; learn and modify.
- Tell the person answering the telephones what to say.

Flood

When workmen left a tarpaulin inadequately secured on a roof of the Victoria and Albert Museum, a rainstorm washed into a storeroom for paintings and drawings. 'We were lucky because the store was deep inside the building', said Sue Runyard, former head of public relations.

Security officers were able to secure the area easily, so that staff could work on the rescue without the thousands of visitors present in the building being aware of what was going on. We lost a painting by Stubbs and some other more minor works. We thought we had complete control of the information flow, but a member of staff talked to

the press and the story broke. We made sure that the press knew how the leak had occurred, and that it was not caused by negligence on the part of the museum. In fact it helped our long-term goal of untying us from central government building work, and putting more control in the hands of the museum.

- Secure the perimeter.
- Give staff clear instructions about not talking to the press.
- Use the situation to make a point, if appropriate.

Major incidents and earthquakes

Museums can become targets for attacks. There have been two fire-bomb attacks on UK museums with military collections, and various unsuccessful attempts on other museums. Damage has been caused, but there were no injuries and no loss of life. Peter Osborne, from the Bureau of Cultural Protection, and former National Museums Security Adviser, says:

> It is absolutely essential to have an established plan that takes into account all foreseeable situations. Journalists must not be allowed to enter beyond a certain point, and that point should be controlled by official museum personnel, preferably security staff. No information should be given out until those responsible for public relations and security have discussed and agreed the line to take. One spokesperson should be nominated and made known to all other staff. There should be instructions to staff not to respond to media inquiries themselves, but to refer members of the press to the appointed spokesperson. A standard official comment is that police or fire services or security staff are dealing with the situation and that information will be made available in due course. It is also quite usual to say that security at the institution is in good shape, but as a matter of routine it will be reviewed in the light of the incident. Specific details about security should never be given out — such as how many people were on duty or where. It is acceptable to say that the museum is protected by physical, electronic and human resources (if this is true).
>
> Most major incidents do seem to happen after closing hours. While this may be good news in one way, because fewer members of staff or the public are around and at risk, on the other hand, there needs to be immediate response. I have learned from experience that the key to handling the media under bad circumstances is to have an established plan of action that includes the appointment of one

person to be spokesperson. This issue of a 'holding' statement can win time for colleagues and emergency services to confer.

'After the big earthquake in 1994 we discovered that there were so many major stories going on that museums were something of an afterthought for the press', said Andrea Leonard of the J. Paul Getty Museum.

We had plenty of time to get damage reports and decide what to say before the inquiries came. However, it's not just the media who want to know about the situation. Calls can come in from dozens or hundreds of concerned individuals. We have a pre-recorded tape ready which says that the museum is closed 'because of the recent circumstances' to cover several eventualities. The tape also says when the message will be updated. We also give a script to people working the telephones.

- Have a plan for communications.
- Don't give more information than is necessary.

Thefts
Peter Osborne of the Bureau of Cultural Protection says:

Never give out details about security arrangements. You may say that a variety of security arrangements were in place, but that you are not allowed to disclose them for obvious reasons. I have found in the past that by concentrating on the objects that have been stolen, attention has been diverted away from any embarrassing security issues. There is no standard formula laid down regarding thefts, as each incident is different and will need handling according to the situation.

Recent incidents, during closing hours, in Italy and Germany demonstrated how guards can easily be overcome and electronic systems disabled. However, from the total number of annual thefts, over 50% occur during open hours and tend to be opportunist in nature. This tends to show that methods of display and invigilation are at fault, rather than the physical defences of the premises. Weakness in these two areas should not be conveyed to the press. It's more advisable to say that the perpetrator managed to overcome the established defences, and that, of course, systems will be reviewed in the light of this incident. You should always stress (as long as it is true) that members of the public were not at any time at risk or involved in the incident.

A heritage attraction in an inner city area in the UK suffered a gun-point robbery late one Saturday afternoon. Not surprisingly, the thieves found very little cash in the till, but visitors and staff were shocked and upset. 'We made sure that the local newspapers knew exactly how little had been taken (less than £20) so that the word would get around in the area that we did not carry any cash', said Ylva French, who was assisting with public relations at the time. 'We did not have any more incidents of that kind.'

- Never give details of security arrangements.
- Give full information and pictures of the object/s.
- Stress positive aspects and provide information that suits your purpose.

Personal accidents

'When the Lady Mayor slipped on the polished floor and broke her hip my first action was to get help, but my second instinct was to pour out sympathy. It was hard to do so without implicating the museum, or appearing to apologise on its behalf. I wished that I had a form of words ready to hand', says Sue Runyard.

'At the J. Paul Getty Museum we have a very specific procedure to follow, and everyone who deals with the public is trained to follow it', says Andrea Leonard:

Most accidents involve falling. Our staff know that they must immediately ask for a trained first-aider, who can usually get there really fast, because so many of our staff are trained in first aid. The museum employees who find themselves involved in an injury accident should give comfort. Sometimes listening to what happened is a form of comfort. It's OK to say 'I'm sorry that you are hurt' rather than 'I am sorry that you fell'. There is a difference. Tell the person to hang on and that help is on its way really fast. An unexpected aspect of the aftermath of accidents is that sometimes the staff who have been dealing with it feel upset or queasy. I think it's important to look after them too.

- Get trained help straight away.
- Be of comfort without accepting liability.
- Don't forget the needs of the staff involved.

CASE STUDY 19 Dealing with the threat of funding cuts

Faced with the threat of an almost immediate funding cut disguised as a 'review' by its major funding body, a regionally important museum had to take some instant advice and implement an immediate crisis public relations plan. At this stage it was agreed that everything should happen behind the scenes. The second stage of the plan (if cuts went ahead) would require a new strategy which put the case for the museum into the public arena and generate public and media support.

The strategy

- To use available means to highlight the strengths of the organisation and to address indirectly some of its weaknesses.
- To use any available opportunities already underway to subtly put the case for the museum in the overall regional cultural and educational strategy, for example the opening of a new gallery or speaking engagements.
- To be adaptable but to stick to the strategy; the threat could be delayed for other reasons.
- To identify and target key influencers.

Analysis of strengths and weaknesses
Through a detailed SWOT analysis (of strengths, weaknesses, opportunities and threats) the key arguments based on the museum's strengths were identified; key weaknesses were admitted and ways of dealing with these were built into subsidiary messages.

Strengths included:

- safeguarding local heritage
- stimulating inward investment and tourism
- running efficiently – progressive in areas such as digitisation and documentation
- taking the lead in regional partnerships
- providing education to the county – lifelong learning
- providing community focal point and facilities.

Weaknesses included:

- trustees not very representative of local community
- lack of support from district councils

- appears to have been favourably treated by county council in the past
- limited opening hours (closed Sundays and bank holidays)
- interpretation (intellectual access) not meeting the needs of a wider audience.

Immediate action plan

- Analyse council timetable.
- Prepare response to council review (time to influence others?).
- Arrange meeting with council to respond to review.
- Identify key players.
- Initiate public relations campaign.

Public relations vehicles

Newsletter: A special newsletter was commissioned to coincide with the opening of the new gallery – to be the forerunner of a new updated newsletter. The newsletter content was closely aligned with the key messages as identified in Strengths (above) and addressing weaknesses, and included endorsements of the museum from identified influencers.

News stories: A local freelance journalist was briefed on topics for articles to be placed with the local media.

Press releases: It was agreed that the museum would keep up a regular flow of press releases.

Events: The opening of the new gallery was upgraded to a major event through the presence of a celebrity VIP. The newsletter was distributed to all present; the speeches were congratulatory and upbeat.

Follow-up

- The newsletter was sent to a special list of influential organisations in addition to normal mailing list.
- Profile of subsequent special events, including exhibition openings, was raised.
- Press releases announced plans to meet identified shortcomings.
- Meetings were arranged with the county council

Results

The council took on board the direct and indirect messages, postponed the final decision to the following year and confirmed the grant for the year in hand. This 'stay of execution' to be used positively to generate more grass-roots support by tackling some of the weaknesses identified above and by maintaining a positive public relations programme which highlights the strengths of the museum.

Chapter 15 EVENTS AS PART OF PUBLIC RELATIONS

Events present a valuable public relations opportunity. We know that direct communications with target groups make a greater impact than any other form of communications. And yet, so often, the events we professionals go to are disappointing – when, for example, from the moment of arrival to the point of departure no one seems to have thought through the objectives of the event and the messages which the guest or audience should be taking away.

Clear objectives, good organisation and quality in delivery should be the goal for every type of event at your museum, gallery or attraction, as well as for other events which you or your colleagues take part in outside the organisation. From trustees' meetings to Friends' events, press views to workshops or seminars, the same planning and evaluation process should be applied.

Objectives

The objectives for a special event may fall into one or more of the following categories:

- To ensure continuing and secure funding; to attract new funding from sponsors or Lottery funders by bringing influencers to the museum or attraction.
- To create media coverage: to raise the profile of the museum for funding purposes; to attract visitors to a new gallery or exhibition through press views or briefings in relation to a new development or in general; or to highlight special events (e.g. for Museums Week).
- To generate funding or more interest in educational activities and educational programmes through INSET days (training days for teachers) and other activities.
- To raise the academic standing of the institution through seminars, workshops, lectures or by other means.
- To create goodwill and interest among tourist information staff, hotels and guest houses, guides, tour operators and others who influence this market. (This is particularly relevant for museums in good tourist locations, ideally at the start of the season each year.)

Setting clear objectives for one-off events is a more obvious process than, say, examining existing events which take place regularly at your institution. But they should all be scrutinised from time to time. Your trustees probably meet at your museum, if there is room, but how often does the appropriate local authority committee have the opportunity to

meet at your premises? Funders and influencers need to see first hand what you do, and holding their meetings on the premises is one good way of ensuring that they appreciate the good work being done by you and your colleagues. It also offers an opportunity to make them aware of any particular problems, such as physical deterioration or a leaking roof. Fellow professionals may come to your museum regularly for group meetings – what sort of impression do they take away with them?

The target audience

The objectives for the event define the target audience and, from that, the format and organisation of the event. Think carefully about the mix of different groups. The launch of a new exhibition is an excellent opportunity for creating interest and profile; and the traditional approach is to have a press view and separate private views. This certainly works well for major museums and galleries, who can attract a good press audience for the press view and can separate their key audiences for the private views. This means that influencers and other VIPs can enjoy a more exclusive event, while Friends and others may pay for their own refreshments.

Museums and galleries outside London, or those with smaller events and exhibitions to launch, may decide to have one only view to ensure a good attendance and save on costs. When audiences are mixed in this way, the careful briefing of staff becomes even more important so that any 'special' guests who need nurturing are identified and looked after. The opportunity should also be provided for journalists to come at other times, with someone on hand to answer questions. Evening events are not particularly attractive to the media.

At least once a year all those on whom the museum or gallery depends for its existing and future funding should be invited to a special briefing, with breakfast or lunch, as a group or individually.

Organisation

Start planning the organisation of the event as early as possible. It may be led by a small group or formal committee, but it is essential that one person is in charge of co-ordinating and implementing all the details. It is very easy for something quite obvious to be forgotten (the microphone, for example) if there is too much delegation or too many people involved.

Prepare a critical path or simple checklist, with key dates when the various elements have to be completed, and circulate this to everyone

involved. Staff who need to be on duty (as opposed to coming as guests) should be informed as early as possible and briefed about the nature of the event.

Guests and the mailing list

The **guest-celebrity** will need to be contacted a long time in advance to ensure that he/she is available (or to enable you to find an alternative).

Key guests will include your own director, trustees and council members; make sure they have the date in their diaries before invitations are printed.

The **guest list** is usually the greatest nightmare for large events. But with efficient database systems it should be possible for most institutions to create a series of key lists which can easily be updated and then brought together as appropriate for different events. (Make sure the names are correctly spelt and in a similar format (for sorting) and that the postcode is included.)

Banish the mailing list nightmare

Mailing lists are a headache in every organisation but the worst scenario is the big list that has been compiled over a long period of time. There may no longer be any clear idea of who the people are, why they are there or why they were on the list in the first place (or whether they are still alive!). It's the sort of list no one wants to tackle – and sending all the people on the list a letter asking them if they want to receive invitations from you is likely to have a very poor response!

For many years Ylva French Communications handled the public relations for the Soho Restaurateurs Association (SRA) which has some 40 member restaurants. Once a year there was a party for more than 800 people at the Café Royal. The first year was a nightmare as we were handed the historic mailing list. By year two we had refined it, built on our own databases and divided it into a series of mailing lists – some of them were regularly updated and others we could easily update for the big event. The headings were:

- members of the SRA (who received an additional four invitations for staff and could also nominate key clients, but these names were not added to the annual invitation list)
- London MPs
- Westminster City councillors

- local Chambers of Commerce (selected members)
- Westminster City Council officers (relevant to this sector); also local police, street cleansing company directors and similar
- restaurant industry (chairman, director, etc. of the relevant trade associations; Restaurant Switchboard)
- foodie celebrities including Soho celebrities
- tourist board directors and relevant staff, both London and national, a separate list for tourist information centre managers and representatives of the Guild of Guides; others who give information, e.g. sightseeing bus companies
- hotel concierges from West End hotels
- incoming tour operators (selected from the BITOA – British Incoming Tour Operators – list)
- conference and incentive organisers (who might bring business to restaurants)
- theatre managers, agencies and the Society of London Theatres
- public relations/marketing people working the restaurant and theatre sector
- the media: food writers and restaurant critics on national media; London news media; tourist and events magazines, listings, etc; travel and freelance writers (selected); picture desks, photographic agencies.

Compile a similar list of headings relevant to your organisation and suddenly the mailing list nightmare will be a thing of the past! (But be sure to do effective cross-checking as some people may appear on several lists.)

Budgeting
An overall limit may already have been set for the event. Before committing expenditure, allocate this to the various areas, including:

- printing and mailing
- catering and decorations
- extra staff
- photography
- guest celebrity
- entertainment and music
- follow-up print.

The guest celebrity

There are a lot of celebrities around, or at least a lot of people who think they are important, but somehow this does not make it any easier to find the right person to add that touch of glamour or gravitas, excitement or media coverage to your event.

Start at the top with the royal family. Is this the right occasion for that once-in-a-lifetime royal visit to your museum, gallery or heritage attraction? It may well be if it has been substantially redeveloped with public funding or if it is completely new and represents millions of pounds of Lottery money. If so, you need to think a year ahead, and it helps to have support from, for example, your local MP, the Lord Lieutenant, the local council and anyone of influence on your board. Make your approach in a straightforward way with a letter from your chairperson to the private secretary (by name) of your chosen royal. Follow this up with a telephone call to make sure that the invitation has been received and to get some idea of when your invitation will be considered; the royal diaries are usually made up in batches of six months, but sometimes there is the odd blank day when late invitations can be slotted in.

Your invitation should highlight what is special and different about your event; why a royal visit would be a bonus to the local community, museum visitors and schoolchildren who use the museum. Mention all those who support the visit, but make it clear that the member of the royal family would meet some 'real' people and not just a line-up of councillors or trustees. If it is a small museum, there may be something in the area to link up with to create a full-day visit. Give a range of alternative dates.

Remember that it is bad form to invite royalty in the wrong order, so work your way down rather than up if you are turned down by one. Invitations are not passed on.

If you are successful, your programme for the day will be compiled in conjunction with the private secretary's office and may involve quite a lot of formality and security, although the climate of the new millennium is very much for more relaxed royal visits. Build in school workshops and 'behind the scenes' tours, for example to see conservation in action.

If inviting a member of the royal family is not appropriate, there may well be an obvious list of people depending on the nature of the exhibition – from Sir David Attenborough for ethnographic and wildlife themes to Zandra Rhodes or a supermodel for fashion or costume exhibitions. Remember your objectives at this point. What is

the celebrity for? Will he/she add credibility to the event or is the invitation simply to provide media coverage? The latter can never be guaranteed and paying large sums for someone in the news – Trevor McDonald or Ulrika Johnson – may not be the answer, particularly as openings of this kind tend to take place in the evening when the media are simply not going to turn up.

If you decide to pay for a celebrity, make sure that it is clearly stated what they are going to do for you, including photocalls and, possibly, interviews (make sure they are well briefed).

One way of getting celebrities 'on the cheap' is to link up with a charity. This could work for a Friends' summer fete or a music festival in the museum garden or lecture theatre, with the proceeds being shared with the charity. If your aim is to get media coverage, go for a morning or lunchtime photo opportunity with a celebrity who has some relevance to the subject – or, if all else fails, children or look-alikes!

The invitation

You could spend more time on this than on the guest list! For a traditional function, use a white, gilt-edged invitation card; for a private view, use an image from the exhibition and a format in the style of the exhibition; for an off-the-cuff event, ask your design company to come up with something which conveys the excitement of the occasion. For a small lunch or press briefing the invitation can simply be in the form of a letter. The main thing is to get the invitation printed in good time – four to six weeks before the event is the ideal. Press invitations need much less notice, two weeks, or even a day, for a news event is quite enough.

For a formal event consult *Debretts* for wording, order of precedence, forms of address, etc.

The RSVP element of the invitation is important, particularly for cultivation events. Make sure that the RSVP telephone number is regularly staffed; if you use a reply card give an alternative fax or telephone number or e-mail address. A good response list (alphabetical by surname or organisation) will allow badges to be made up in advance, if appropriate.

Setting the scene

Make sure that your guests will feel warm and welcome from the moment they arrive – particularly on a cold and wet evening in the middle of winter.

If it is important to know *who* has attended (rather than numbers), check guests in as they arrive. (Asking people to sign in is not a good idea as it takes longer and the signatures may be illegible.) If you are badging guests, it will be obvious who has attended (just make a note of extra badges issued). Arrange for the cloakroom to be located before the badging area if at all possible.

Flowers inside the galleries may not always be popular with curators, but they can do wonders with dingy corners and for masking areas closed off to visitors. This is not a task for members of the flower arranging society unless you want a traditional look. Find someone who takes a more adventurous or sculptural approach to this growing area of decoration. Your exhibition department should be able to come up with signs, hangings, posters and other decorations which will make drabber areas more attractive. Clear up odd posters, staff notices and reception areas by getting someone not directly involved to go on an inspection visit with you. (You will be surprised how you don't know notice things you see every day.)

For in-house events, most museums, galleries and attractions will use their in-house or regular caterer. Every now and then think differently and ring the changes. If you are opening an Indian exhibition, is your usual caterer up to creating the flavour for this? Add style to a private lunch in the director's office for potential funders by using a more up-market caterer. Whoever you decide to use, agree on the brief well in advance. Many curators are not happy about food and drink being served in the galleries, and it may not even be possible in the case of certain types of exhibitions. However, people will congregate where food and drink is served, so it's a question of finding a balance – possibly serving drinks (white wine and mineral water) inside the gallery and food in a café or other area.

Music or other entertainment may be appropriate as background. For a special performance – a re-enactment, short playlet or special musical performance – guests should be provided with seats; otherwise, they will either not be able to see or they will start chatting and upset the performers.

A musical interlude

For the opening of the Horniman Museum's Musical Instrument Gallery in 1994, a new piece of music was commissioned from a London composer, Eleanor Alberga, through the London Mozart Players and financed with a London Arts Board grant.

A photocall was arranged with the composer and musicians during rehearsals and also with schoolchildren in a hands-on session in the new gallery. (The second photograph was the one most publications used.)

On the evening, the then Emslie Horniman Lecture Theatre was turned into a small concert hall and guests were ushered there as they arrived. They were welcomed by the chairman of the trustees, who introduced the new piece of music, *A Horniman Serenade*, played by the London Mozart Players wind ensemble and conducted by the composer. At the end the then Secretary of State for Heritage Peter Brooke made a short speech and declared the exhibition open.

The chairman and the director then escorted Peter Brooke to the new Music Room. Food and drink was served in the café and wine was served in the Musical Instrument Gallery. (Note: *The Horniman Serenade* proved so difficult to play that it has not been heard since – one of the problems with modern classical music! But it worked as a public relations tool at the time.)

The format

A private view which includes the official opening of an exhibition may run as follows:

6.30 pm	Guests arrive; glass of wine served; opportunity to view the exhibition
7.15 pm	Speech; official opening ceremony
7.30 pm	Photo opportunity; more drinks and nibbles
8.30 pm	End of event

For the **opening of a new gallery or museum** by a member of the royal family, the mayor or other VIP the timetable may be:

11.00 am	Guests arrive; coffee or fruit juice in conference room or lobby
11.30 am	VIP guest arrives, meets relevant people; speeches; cuts ribbon or similar; photo opportunity
12.00 noon	VIP guest tours the new gallery followed by invited

	guests (at a respectful distance – if royal VIP); visit behind the scenes or workshop
01.00 pm	Buffet or sit-down lunch with separate table/room for VIP guest(s)

The timing for a **lunch for trustees, local authority members** or other influencers may be:

11.30 am	Guests arrive; coffee
12.00 noon	Tour of the museum, including behind the scenes; meet staff
01.00 pm	Lunch in the director's office or conference room

The schedule for a press briefing or press view may be:

11.00 am	Guests arrive; state time of special briefing
11.30 am	Director or curator of the exhibition introduces the exhibition
From 12.00	Refreshments in the conference room or café

The question of speeches is always difficult. If people are standing, try to keep speeches to a maximum of 15 minutes and restrict the number of speakers. Make sure the microphone works, that it is adjusted for the speaker (women have softer voices than men), that everyone can hear (test in advance) and that you or someone else knows how the system works. If guests are sitting down, 30 minutes of speeches should be sufficient as part of a more general event (rather than a seminar or workshop). VIP guests will need to be briefed on what is expected of them in their opening remarks.

Briefing your colleagues

For a major event everyone has to be involved and committed from the beginning. Make sure that you have the right number of staff members on hand for the occasion.

Firstly, there will be those on duty, who need to be clearly briefed as to the kind of guests expected and what messages to convey. It is important that they know when the event is due to finish (but agree in advance that they will not start turning off lights or locking doors if guests linger beyond this time – as has happened on occasions). Catering staff can stop serving 15 minutes or more before the official end; serving staff can politely and discreetly start to remove glasses; museum staff can gently move people towards the exit (rather than gather in corners chatting to colleagues from other museums).

Secondly, for a large event, you need a good representation of staff members among the guests. At a cultivation event, they are there to work (therefore no partners). They should be well briefed, clearly badged and given specific targets to find among the guests and introduce to the chairman or director or escort round the museum. They should be discouraged from talking to each other or starting to relax while the event is in progress. (Some organisations will not allow staff to touch alcohol until the guests have left.)

For a private view, you may decide on a different approach: some 'working' staff (those directly involved in the exhibition) and some as 'guests' (bringing a partner to the event). However, all staff must be ready to look after guests and guide them in the right direction.

On departure

It's a good idea not to give people a stack of information as they arrive but to have it available as they leave. Have a selection of literature on a table near the exit and hand people the one piece you want them to have. This could be the newsletter which details your latest fund-raising targets or a more general leaflet about the exhibition. It's very nice to be 'seen out' after an event, so have a rota of staff members on hand for this part of the evening. They can also help to get taxis, or explain the way to the bus or train for those who are unfamiliar with the area. VIP guests, mayors, ambassadors and similar should be escorted to their cars by the director or other senior member of staff. (Royal programmes will have unique arrangements, possibly involving a contingent of people and the presentation of flowers.)

Evaluation

Not later than two weeks after the event arrange a follow-up meeting with those directly involved and review the event from beginning to end:

- Planning and organisation: Did you have enough time? Did it all go well?
- Guest list and invitations: Were there any problems here? Have all amendments been fed back into the mailing lists?
- Celebrities, VIPs and other media opportunities: Did these work? What was the coverage like? If not good, were there reasons for this?
- Reception, catering, staff welcome and interaction: Did this run smoothly?
- Have any comments been received from the guests?
- The next step: Follow up for funding purposes, for example?

- Budgeting: Was there any overspend? If so, why and how could you avoid it in the future?
- Overall: Did the event meet the objectives?

Staging or attending an event away from the museum

When you go outside the museum to attend conferences or run workshops, do you make the most of the opportunity? Organisers of events at the Museums Association conference, for example, frequently forget to highlight their own institution and its activities. This does not have to be blatant; it can be conveyed simply by producing good quality slides with the logo (or even better computerised Powerpoint presentations); by providing handouts which carry the museum's name and address; by placing leaflets on tables at the back of the room. You may also have a sign on lightweight board. Keep the lists of names which are produced for these events, and check whether you should send follow-up information to some or all on the list. Any business cards received should be checked – what did you promise to send that person you spoke to for five minutes over lunch?

Make sure that you know – and approve – of professional events attended by your staff. Discuss any issues which may come up and how they can best convey messages to target audiences at these events. If you get negative feedback from or about staff attending conferences or events, deal with it immediately.

Hiring out your own facilities

This is a completely different subject (and perhaps a book in itself), but it is important to cover it here as more and more museums and galleries have already entered this arena, or are considering it as a way of increasing their income.

There are two completely different scenarios here. The first is where the museum has limited public facilities but makes them available at a nominal rate – which just about covers staff overtime – to local community groups, associations and others. Nothing extra is provided, and at this level of operation expectations will be low. However, it is still an opportunity to convey a positive message about the museum to people who may not come as visitors. So all the rules about cleanliness, a friendly welcome and a favourable appearance apply – as well as making publicity material available in all places the groups may use.

The second scenario is where museums and galleries go down the commercial route and apply charges which compare with conference centres and hotels. They must raise their performance accordingly and will be subject to a variety of local authority and health and safety rules and regulations. Newcomers in this field who believe that their facilities are suitable should take professional advice from a consultant, or initially from one of the big caterers. They will know what the museum or gallery will require to enter this competitive market and deliver satisfaction.

From the marketing of the venue to the training of the staff, there is more to hiring out your facilities than just collecting the fee. There are the basic facilities required by caterers, toilets and cloakrooms for visitors, and your own restrictions relating to the objects, security, environmental control and so on. Consider also your neighbours, parking and staffing and what else you might not be able to do if you hire out galleries (your own events, for example, might be affected).

There are some very successful museums in this field, including the Natural History Museum and the National Portrait Gallery in London and the Thackray Medical Museum in Leeds. Have an informal conversation with another museum or gallery who have gone down this route before you decide whether you are really committed to hiring out your facilities as a revenue stream.

The Thackray Medical Museum
The Thackray Medical Museum in Leeds was in the fortunate position (and far-sighted enough) to be able to build conference facilities into the new museum in an old hospital building in Leeds. Professionally planned, these facilities can operate separately from the museum, have a 120-seater fully equipped auditorium, three separate meeting rooms (one large enough to cater for 120 people) and parking space as well as the opportunity to use the museum café area for receptions. With its own conference officer, the conference facilities are now making a substantial contribution to the museum's revenue without interfering with museum activities.

CASE STUDY 20 A pre-Christmas event at the Natural History Museum, London

The lowest attendance period in many museums is the couple of weeks before Christmas, and this is immediately followed by a really busy period just after Christmas. In 1984, The Natural History Museum in South Kensington decided to address this dip in attendance through special programming. It was quite a challenge. This account is by Sue Runyard, former head of public relations, Natural History Museum.

Situational analysis

Traditionally, the available market for the museum is focused on other priorities during the days leading up to the Christmas holidays. Mothers are often the people who suggest and organise a family visit to a museum, and during this period they are usually preoccupied with shopping and preparations for the holidays. The Natural History Museum is located in central London, within easy access of popular shopping areas, and women with children could be observed in large numbers – but not in the museum. Ironically, the museum had a great shop full of merchandise, but few customers came during this period. We figured that there was no point in trying to win a brand new audience just for two weeks. It would be too much like swimming against the tide. Another factor was the lack of all but a small sum of money to assist programming. However, we had plenty of time, because we had started to plan in the spring. This project was going to have to run on enthusiasm and inventiveness.

Target market

We considered that the most available market, completely consistent with the museum's usual audience and with its mission, was the mothers and children who were scurrying past the front door but not coming in. Brainstorming the factors involved, we reckoned that one of the greatest needs of family groups in this situation was to take a break towards the end of the afternoon, the time when children begin to complain about constant crowds and shopping and nerves are getting frayed. It stood to reason, therefore, that if we could provide something in the late afternoon that would provide amusement to children and give mothers a chance to relax for a while, we could be on to a winner. But what?

Developing the product

There is a lot of street theatre in London, and we began to think of some kind of performance. We opened discussion with a small experimental theatre company who seemed sympathetic to the concepts that the museum exhibitions were trying to communicate. Even though we felt we could make a modest charge for performances, projections showed that we still did not have enough money to cover all the associated costs.

Through pantomimes people are already familiar with the idea of children's performances at this time of the year, but they certainly did not expect to find them in a natural history museum. We knew that we had two major problems to solve in order to make the project fly: find more funding and sell the concept to the available market. We could see other challenges approaching, not least of which was working with a wildly inventive group of youngsters who were unfamiliar with the ways of the museum. But we also had to ensure that the content of the performance would be acceptable to the museum's serious-minded scientists. We could see some hair-tearing practical and philosophical difficulties and lots of unpaid extra hours on the horizon, so, of course, we rushed enthusiastically towards it!

Partnership

Families from all over the country come into London to shop, so we knew that our target market was scattered. We needed a publicity campaign that would achieve national outreach, but we also knew that this would be hard to achieve. Also, there was the danger of using a sledgehammer to crack a nut! As there would be a limited number of performances, did it make financial sense to embark on the kind of publicity we would usually reserve for a prolonged major exhibition? *Good Housekeeping*, a major women's interest magazine, had recently approached us about holding a staff Christmas party for the whole publishing group in the museum, and we explained what we were trying to do. It seemed to us that the performances we planned were tailor-made for the *Good Housekeeping* readership. Could the magazine offer us publicity, with perhaps a special offer of tickets for readers?

Our contacts responded warmly. Having the opportunity to be involved right from an early stage gave them the chance to help shape the project and feel a real sense of commitment to the creative element, and they would provide help for the funding gap. We also gave permission for their Christmas party, in exchange for a market-rate

rental fee. The project was underway and a real sense of excitement began to build.

Posters for the Natural History Museum Christmas event. Courtesy of the Natural History Museum.

Implementation

The performance was developed through what was now a partnership between museum, magazine and theatre group. The magazine was a perfect partner. The staff could see that the museum was keeping the project on track, and would take a strong view of any material that was inappropriate, so they let us get on with it. The theatre group was thrilled to have a national venue for one of its projects and was determined to make a success of it. It took a theme from one of the exhibitions on the evolution of man and called the play *Fossil Face*. The cast romped through a performance that was designed to engage and secure participation from its young audience. The museum education staff, who could not have produced this kind of programming themselves, were delighted with the collaboration. Museum scientists were shown the 'script' and made no objections – some made plans to bring their own children.

The November issue of *Good Housekeeping* hit the streets in mid-October. It offered readers a priority booking deal, which included a

cup of tea and a mince pie with the ticket – just what was needed after a hectic day. In addition, a small poster was sent around to public libraries in the locality, and the museum made the usual releases to the local and national press. There was a good response. There were healthy pre-bookings, some seats were left for last-minute visitors during early performances and there was a complete sell-out for the days just before Christmas. There was even a theatrical review in one of the London listing magazines.

Results and aftermath

The project was accomplished without any major cost to the museum, and a great friendship was formed with the magazine and publishing company. During the period of the performances the atmosphere in the museum was lively and bustling, rather than empty and echoing. The shop did well, and the publicity coverage was good. The theatrical group was ecstatic with the success, and thrilled when the performance was chosen for production on the Fringe at the Edinburgh Festival. The magazine took great pride in the achievement. Was there a downside? As usual, it had taken much more staff time than anticipated, but everyone felt the success justified the input. A fresh performance was put on the following year.

Chapter 16 EVALUATING AND MEASURING PUBLIC RELATIONS

While self-respecting advertising agencies would never put together an advertising campaign for a client without building in research (see Chapter 7), public relations agencies and in-house departments frequently do. The excuse is usually the limited budgets and resources (in comparison with advertising campaigns) and a belief in the 'intangible' benefits of public relations.

The truth is, of course, that advertising is just as intangible – the old saying 'I know that 50% of my advertising budget is wasted but I don't know which 50%' is still valid today. But that has not stopped advertising agencies from carrying out research and proving to their clients that their money is well spent. And it should not stop public relations agencies or departments from doing the same, particularly at a time when accountability is everything.

The obstacles to proper evaluation lie not just in the limited budgets but often in the ignorance of the importance of evaluation by management and by the public relations practitioners themselves. In a busy PR department, setting aside time and resources for evaluation may take time away from running the campaign or starting the next project. Management may consider that public relations is effectively evaluated by a pile of cuttings or simply as part of the marketing programme – if that is more effectively measured and includes visitor research – and are therefore reluctant to invest in evaluation of public relations programmes.

In the drive for effective evaluation of public relations it is therefore important to retain a sense of proportion while introducing more effective measurements of evaluation to meet the need for accountability and also to learn for the future. A £15,000 public relations campaign budget cannot realistically finance a qualitative research programme, so other means must be found to measure its effectiveness.

A variety of methods have been developed to measure the effectiveness of public relations and in 1999 the UK industry bodies agreed on a common Toolkit (available from IPR, see Appendix 2). The next step is to look at developing international standards for global campaigns. In the United States, the Public Relations Society of America (see Appendix 2) is launching measurement and evaluation programme software later in 1999. Museums and heritage organisations entering this field for the first time may feel intimidated

by these sophisticated and probably costly approaches to evaluation. However, they all break down to simple steps which every organisation can implement at a level appropriate to their budgets, resources and expectations:

- building evaluation into the public relations plan
- research
- media evaluation.

Building evaluation into the public relations plan

Building evaluation into the public relations strategy and into individual PR plans for specific projects is the simplest and least costly way of creating a relatively effective evaluation process.

How to set objectives against which the strategy can be evaluated was outlined in Chapter 11. This process can be adapted to individual public relations plans by setting objectives which include specific measurements as appropriate. For a specific exhibition these could be:

- **Visitor numbers**: Supporting the marketing plan and the visitor targets set for this, to attract an additional 10% of visitors over a six-week period; or, if the entry to the special exhibition is separate, to attract 35,000 (or 350,000) visitors in a six-week period.
- **Segmented visitor numbers**: These can be analysed simply by type of admission charge, i.e. groups, students, children, etc., and linked to media activities; if more sophisticated research of visitors to the exhibitions is being undertaken, specific targets can be set for different market segments and then linked to media targeted during the campaign. For example, numbers of family or ethnic groups, Italian visitors, etc.
- **Key messages**: Some informal analysis of this may be possible from visitors' comments on cards or in a visitors' book, but whether key messages have been effectively communicated can really only be measured by qualitative research.
- **Spend in shop and café**: The public relations campaign may have played a specific part in highlighting merchandise related to the exhibition and special offers in the café. Spend here can be measured.
- **Media coverage**: Specific targets can be set in the public relations plan for groups of media and types of coverage, which will make a relatively simple analysis possible at the end of the campaign. More sophisticated media analysis is covered later in this chapter.
- **Overall success**: A subjective judgement based on opinions of

critics, visitors and other influencers, collected at the end of the exhibition/campaign, is valuable as a final summing up of the project when related back to the original objectives.

- **Recommendations for the future**: The final analysis should make recommendations for the future based on what worked well and what did not work.

Research

Research is an integral part of a more sophisticated evaluation process. It can be built into regular visitor research if carefully planned and thought out. It can then give indications of how awareness has been raised or perceptions changed, and which media had the greatest influence on decisions to visit. However, to be truly effective in evaluating public relations programmes, research has to be specifically designed for that purpose and carried out in three stages.

Bench-mark research

Any major new launch or change and any development of a new PR strategy should be accompanied by a public relations audit – the first research stage of developing the strategy. As outlined in Chapter 9, this can be done informally, or formally with professional researchers, using quantitative as well as qualitative research, for example telephone polls and focus groups. This is a vital part of any campaign or strategy which sets out to transform the image or perception of an institution or attraction. You need to know how it is seen now before you can start changing it, and then you need to measure against this bench-mark whether you have in fact achieved what you set out to do.

This type of bench-mark research can be continued over a period of time as the campaign continues and become part of the tracking research. It is a valuable way of measuring recognition, awareness and perception. It should of course take into account other factors which may influence the public's perception but which were not part of the museum's activities or campaign.

Tracking research and monitoring

Once a campaign is underway it's easy to forget the importance of research and how to use it effectively to monitor that the campaign is on course. Governments of today have taken to focus groups with a vengeance, using these not just to test out new policies but also to check the public acceptance of new ideas and programmes. This may be going beyond what most museums can reasonably be expected to

undertake, but a simple media monitoring programme will be an important part of the tracking research. Informal and more formal reactions from visitors will also be vital in making sure the public relations campaign is not creating more problems than it is solving. If alienation is building up or certain key messages are not getting through, adjustments can be made in the strategy while the campaign is still underway.

End research

At the end of the campaign which sets out to change awareness and perception, the bench-mark research should be repeated and measured against the targets set at the beginning. (It is tempting to omit the initial bench-mark study, but the end research will not have the same relevance if the starting point is not clear.)

Charities carry out unprompted awareness surveys at annual, if not more frequent, intervals to measure not just their status against other charities but also whether their latest campaigns have been effective. Nothing equivalent exists for museums, but the Museums and Galleries Commission introduced a research programme in 1999 (see Appendix 1), which will hopefully be repeated annually by the new Museums Libraries and Archives Commission. This was designed to measure the awareness and perception of museums and will over time become a useful programme against which individual museums can measure their results.

The end research will form the main basis for the final analysis of the degree of success of the campaign, and will provide a clear indication as to how public relations activities have been able to change attitudes, behaviour and perceptions according to the objectives set at the beginning.

Media evaluation

As public relations is traditionally perceived as consisting largely of programmes of media activities, the evaluation of media coverage has become the way to measure public relations as a whole. While this ignores the overall impact of the PR strategy and its wider objectives, plethora of targets and activities, it is a visible and useful way of measuring a large proportion of public relations campaigns which have a solid media plan as their main thrust.

In the last few years UK media support companies have developed some useful tools and services to assist public relations companies in measuring media coverage in a more meaningful way. Depending on

budgets, resources and the time available, media evaluation is therefore a movable feast from the simple count of the number of cuttings and broadcasts to an in-depth analysis of contents, key messages, position and impact, accompanied by colour graphs and pie charts.

Monitoring the media

The starting point for this process is the rather laborious and expensive collection of cuttings and the monitoring of the broadcast media. If you decide to monitor your press coverage in-house, it will inevitable be *ad hoc* and patchy. The result will depend on how many newspapers and magazines you can effectively browse through, or on others supplying you with cuttings as and when they see them. The same applies to broadcasting.

This type of in-house media monitoring can be effective if your media targets are limited and if, from the enquiries and contacts made, you can easily follow up and collect cuttings. A small museum or gallery mainly concerned with achieving local media coverage can easily set up an in-house monitoring system which ensures that all local newspapers and the radio are well covered. Any additional coverage in a national magazine or newspaper will probably come as a result of press visits, through the local tourist board for example, and, again, it should be possible to keep track of these. Specialist campaigns – aimed at archaeological publications, art or garden magazines, for example – can also be monitored in-house. But allow for the longer lead time of these publications, i.e. items can take a long time to appear.

Any larger museum or institution initiating a major public relations campaign or appointing a PR agency should invest in a press cutting service, and possibly in broadcast monitoring. Some of these services are listed in Appendix 2. They all offer slightly different services. Some have a higher initial reading charge and a lower per cuttings charge. This is useful if you expect a lot of cuttings, from listings for example. Others have a lower initial charge and a higher per cuttings charge (useful when you expect a limited number of features).

Broadcast monitoring varies from headlines only, to summaries and full printouts. This can be very expensive and broadcast monitoring is best used over a short period – for example at the launch of a new exhibition or the opening of a new museum – if you expect a lot of coverage.

Media monitoring serves several purposes. While it is essential for

the end research of the campaign (see above), it also forms part of the tracking research. Therefore, read the cuttings, see if the messages are 'on line' and pick up any negative comments and misinformation. Get straight back with corrections where appropriate (see Chapter 14 on how to handle hostile media campaigns). The monitoring will indicate your 'softer' targets, who may take further stories and continue their coverage. It will also show where you have to work harder to meet your media objectives.

In view of the growth of the cuttings services, the newspaper industry has introduced a copyright charge on the photocopying of cuttings in the UK. Whether or not you decide to subscribe to this – an inclusive fee covers all your photocopying of cuttings – you need to be aware that technically you are in breach of this agreement if you photocopy and distribute copies of press cuttings round your own office or outside (IPR or PRCA can provide details, see Appendix 2).

The cuttings industry is now extremely well developed and several agencies – and some specialist companies – will offer the mounting and analysis of cuttings as part of their services. You can also buy a simple computer program to produce quite sophisticated analyses yourself.

Media analysis

The do-it-yourself version of a media analysis may include the following:

- target media and others, broken down by type
- initial targets in terms of coverage set for each type, including photographs
- actual coverage achieved against each group
- a simple evaluation of the tone or key messages achieved
- advertising value equivalent (AVE).

The last part of the analysis is controversial and has been dismissed as meaningless by many public relations practitioners as it does not allow (a) for the tone of the coverage, (b) for the circulation or size of audience or (c) for the superior impact of editorial vis-à-vis advertising. Most AVE analyses use simple column measurements of editorial and advertising rate card costs as the basis for their analysis. Of course, this does not allow for any special rates that advertising agencies may negotiate and is a difficult system to apply when you are measuring broadcasting coverage (for example, where 30 seconds of

advertising can cost a fortune but you may have achieved a 30 minute programme). Can these really be equated?

However, writing from a public relations consultant's point of view, there is no doubt that clients love advertising equivalent (when it is good). It's simple to understand, it's impressive, it equates public relations with advertising in a way that make public relations easier to grasp for those who have only a vague notion of what it entails. It can make what is only five cuttings (but all large features with photographs in quality media) take on the significance and impact which they no doubt have.

Compiling advertising equivalent values can be hard work, and assembling the rate card information is in itself a major task. You can out-source this part of the analysis and build more sophisticated analysis into the final report, or you can acquire software which will do the analysis for you.

Leading companies in the UK (see Appendix 2) and the USA have developed media analysis to an art form. They will take on the whole process from cuttings and broadcast coverage, and provide detailed analysis by type of media, by product and by region. They will measure the penetration of key messages and will monitor ongoing campaigns for negative or harmful statements or comments. However, this comes at a substantial price and you may prefer to invest in – or suggest that your public relations agency invests – software that will enable you or them to do this.

Depending on the level to which you subscribe you will get a program which has a directory of 9000 media titles (specialist media can be added) with their advertising costs and circulation figures. As part of your subscription you receive regular cost and circulation updates on CD-ROM.

You will have to collect the cuttings and broadcast coverage, measure the size of it, and also attach some sort of value to its tone and to the key messages you were aiming to convey. Results can be pulled off at intervals, and at the end of the campaign an impressive series of graphs can be produced.

Whether you invest in technology, hire an outside agency or use simple internal means of analysing your press coverage, some sort of analysis of this important area of public relations is essential to ensure that you are fulfilling your objectives, learning important lessons for the future and showing others how successful your public relations activities really are.

Summary

The media analysis should feed into the final report, which may also include opinion polls, visitor research and a more subjective evaluation of the success of the campaign. It is one part of the very important process of the three-stage evaluation of public relations programmes:

- bench-mark research and setting objectives
- tracking research, monitoring and adjustments
- end research, evaluation, analysis and report with recommendations.

Chapter 17 COMMUNICATING WITH STAFF AND STAKEHOLDERS

Internal communications are often given a low order of priority. It seems obvious that external communications are more important, as they affect income, attendance and general perceptions. Yet the best intentions can be sabotaged from the inside – often quite unintentionally – if all of the staff are not clear about what's going on and about the current organisational objectives.

The task of communicating effectively with your stakeholders inside and outside the organisation is largely one of mechanics. If you have the right systems in place, management can keep on top of the situation without creating burdens. There is a temptation to think: 'Well, I'm doing a good job; why can't people trust me to get on with it? It's extra work to keep having to tell people about it.'

Winning people's trust so that you can do your job well with excellent support is exactly what you want to achieve and you don't get that by keeping people in the dark. It may sound slightly machiavellian, but if you are seen to be communicating clearly, regularly and with the appropriate degree of openness, people tend to feel in safe hands. The content of what you communicate is important, but the fact that you are communicating is equally important and creates trust. It means that when there is a problem, there is a level of public confidence to shore up the management.

Clear, regular, and open communications convey the following:

- *Management is being active.*
- *Issues are being addressed.*
- *Recipients (staff and stakeholders) are valued/respected.*
- *There is nothing to hide.*
- *There is pride in the organisation.*

Communicating with the board of trustees or governing body

There are several useful guidance manuals on board development, but the nature of effective communications is rarely addressed. A large measure of transparency is required in dealing with the board, and this usually results in the museum passing reams of paperwork to board members.

Energetic photocopying does not constitute communication. As board members are usually busy people, they will read documents shortly before or *en route* to meetings, and unless you flag up issues clearly, they may hijack valuable meeting time by pursuing topics which are not central to the main concerns of management. It will aid

the flow of business if all topic areas are prefaced by a dispassionate synopsis of the situation. This may lead to the repetition of brief written information, but there is no harm in this; repetition can help to crystallise understanding.

As the chairperson has a crucial role in deciding how much information to provide, there should be a free exchange of information, concerns and possibilities between the chairperson and the chief executive. In the best relationships, they should be able to identify and agree mutual objectives and work together on how to present information to gain the support of the board. Important news, new publications (from books to leaflets) and major achievements should be communicated to the board as quickly as possible. A quick telephone call to each board member from the chief executive when something good happens is an inclusive gesture which helps everyone to participate in the success. It also paves the way for when a telephone call has to be made over a problem on which advice is needed.

One of the most common mistakes is to fail to brief new board members properly. A personal tour and conversations with the chairperson, chief executive and senior management will help to initiate the new members on the board. During this time, you need to re-confirm the role you hope the new members will play. Tell them which skills and insights you value and give some hints as to how they can best make a contribution. Many board members walk into their first full board meeting with little idea of why they have been appointed and what is expected of them.

Some organisations find it useful to have occasional retreats for their board and senior management, possibly involving an overnight stay, in a location where no one will be distracted by day-to-day commitments. This gives everyone a chance to focus on complex issues and can be helpful when a major re-appraisal of policy is needed. Such meetings need careful planning and management, and an outside facilitator may help to provide a degree of detachment.

Effective communications with the board can be achieved by:

- fostering an excellent personal relationship between the chairperson and the chief executive
- telling new board members why they were invited and what their role will be
- prefacing bulky written material with pithy summaries (and not sending bulky documents unless absolutely essential)

- providing copies of printed materials as they appear or in regular mailings (i.e. press releases, significant press cuttings, new publications, new leaflets, newsletters, letters of praise or achievement)
- spreading good news fast by telephone or fax
- asking for informal views person-to-person before important meetings
- remembering each board member is a valued individual.

Finally, don't forget to make sure that your staff know who the board members are; they may contact staff at the museum or call in on an informal visit.

Staff

The world of arts and museums is adept at Chinese whispers, partly because of the way staff may be distributed in nooks and crannies of huge buildings. As poorly informed staff resort to rumour (many a museum is a hotbed of gossip) it is wise to set up systems of communication which make it easy for management to distribute information about what is going on. It is important to have someone responsible for co-ordinating internal communications on behalf of the director (for example the press or public relations department).

The staff are the museum's ambassadors at work as well as at leisure. Without information they can sometimes be the greatest critics of the public relations or marketing effort simply because they don't know what's going on. Make sure you keep staff up to date on advertising and public relations campaigns as they are implemented so that they can respond appropriately to public enquiries and also share in the museum's successes. Press cuttings should be on display or available in the staffroom and library, and news of success – record visitor figures for a new exhibition, increased revenue in café and shop – should be shared with the staff.

Face-to-face communication in formal or informal meetings is the core of good communications. In a large organisation it may not be easy for all staff to get together at the same time due to shift work or lack of space, but the attempt should be made at least once a year, and especially for important announcements. Otherwise information will be disseminated through management meetings to individual departmental meetings. But bear in mind that information may be repeated to the public or the presss and be circumspect about sensitive matters.

Electronic mail is a new and efficient method of achieving good communications, but copying e-mails to all and sundry can become a lazy way of communicating, and it is time-consuming for those who have to read through copies of documents to find out if anything applies to them. Some major organisations put controls on e-mail mania. Think carefully about how this way of communicating is used inside the museum or institution and develop rules for all to follow. Other systems of communications will remain just as important.

A short report on a meeting is preferable to distributing minutes to all and sundry (which could hamper the free exchange of views within meetings). Such reports need not contain sensitive details, but they do need to clearly express what took place. This could be as simple as: 'The Finance Committee met on 11 November 1998 to assess progress on fund-raising for the new building. The development officer presented an update on achievements and prospects. An announcement on Stage One funding will be made in due course. Anyone who has not seen the most recent drawings or read the strategic plan can see them in the library during normal staff hours.'

Nearly all staff should be aware of, and ideally involved in, the preparation of the forward plan. The human resources of a museum or arts organisation are its most important assets, in terms of financial cost and the value of their contributions and it would be foolish not to draw upon those human resources when compiling a long-term plan. In addition, as it is the staff who will turn plans into reality, they need to feel true involvement in the planning process (see Chapter 2).

Some organisations have staff suggestion boxes. While it is a good idea to encourage and reward ingenuity, it is a sad reflection on internal systems and relationships if this is the only way in which people can get their ideas and grievances aired. The staff who deal day in, day out with the public are often not very senior in the organisation and therefore not usually involved in meetings that plan for future relations with the public. The solution may be to set up cross-departmental teams for specific purposes (to advise on the redesign of the café, for example). (Such groups need to be effectively chaired, especially when people are not used to working in this co-operative way with people from different levels within the organisation.)

Devising a flow of information between each area of activity within the museum is a challenge for management. Effective line managers can help enormously, but sometimes this is not enough.

As head of public relations at the Victoria and Albert Museum, Sue Runyard negotiated a deal with curatorial departments whereby information desk staff would be released on a regular basis to help with junior-level work in these departments. (This provided useful extra help in those departments and was greatly appreciated by the information desk staff, who in those days were all would-be curators.)

In return, the curatorial departments provided occasional curators to sit on the information desk for short stints. Only the most junior curators volunteered for such duty; senior people considered themselves far too grand – and may have exposed their ignorance on the basics of public information.

The information desk work was a salutary experience for the curators. Radical shifts in perception took place, and there was a new awareness of why information desk staff need the support and understanding of curatorial colleagues. It is very easy for scholarly folk to lose touch with the great mix of public visitors to museums, so they need the advice of their front-of-house colleagues when plans are being made which involve moving, serving and informing the public. (Architects designing public information desks need similar advice. If they accepted it, there would be fewer circular desks in public foyers; 360-degree exposure to the public is 100% more taxing than having a wall behind your back, but aesthetics seem to rule in these matters.)

Do internal newsletters help the flow of information? They can, but it is quite a challenge to produce something which is both readable and politically acceptable. A large organisation with a good team spirit and a sense of both fun and mutual respect will probably succeed in producing an informal staff newsletter which (normally) skates along the thin line between sharing a joke and causing offence. If you are considering producing a newsletter as an organ of official information, you will need a lot of skill in putting it together in a readable way, issue after issue. There is a surprising amount of work involved and if you can afford it, outside contractors may be the best way to go. However, it is unlikely that a newsletter produced for staff will be appropriated for external use.

In summary, good staff communications depend on:

• commitment by senior management

- efficient organisation of the flow of information
- selection of relevant information to be communicated
- using appropriate ways of communicating
- involvement of staff in new projects and developments.

Volunteers

The moment a volunteer becomes of most value to us – when they assume full responsibility for their duties and turn up like clockwork – is when we are most likely to take them for granted. Every museum and art gallery seems to have a core of unpaid people who make valuable contributions to success and public service. It does not take a lot to show appreciation to such well-motivated people, but it is all too easy to forget to share information with them.

Volunteers usually have a great deal of contact with the public, so it is vital that they should be 'in the picture' on plans, objectives and major events affecting the museum. Written information and newsletters have an important role to play, but in-person briefings are very much appreciated. Choose your words with care because you may find them being quoted to the public. Keep complex issues as clear and simple as possible. As the phrases you use will be adopted by volunteers who answer questions from the public, make sure that they are phrases which serve the institutional aims. Volunteers do not have a right to know everything about the organisation, but they should be kept bang up to date on issues in which the public have an interest. As the 'front line' of the museum, they need to be in a position to give accurate information with confidence.

Ways to communicate with volunteers

- Arrange regular training programmes and briefing meetings.
- Encourage production of a newsletter, co-edited by a volunteer and a member of staff.
- Be clear and brief in all communications.
- Give real-life examples wherever possible to illustrate your points.
- Have a dedicated bulletin board where volunteers meet.
- Encourage curators to have a positive and helpful attitude towards volunteers.

The management of volunteers is a time-consuming and increasingly professional task. Consider an appropriate training course for those staff members involved in volunteer management (see Appendix 2, under Training and professional development).

The Huntington Library in San Marino, California, presents quite learned exhibitions on major historical themes, authors and events. They rely on their volunteers to facilitate visits, by greeting visitors, engaging them in conversation, if that is what they want, and answering questions. In order to prepare the volunteers for this challenging task, many months ahead the library starts a series of briefings for the volunteers body, usually in the form of a talk by the curator most closely involved followed by a question and answer session.

Regular monthly – and sometimes weekly – briefing meetings take place, allowing the library to pass on to the volunteers a whole range of information about forthcoming events, special arrangements, building plans, closures and topical news. There is also an opportunity for volunteers to ask general and specific questions, or to raise issues which have concerned them. This represents a substantial time commitment on the part of the Library management, as well as making them publicly accountable to the volunteers, but they know it is worthwhile because of the invaluable service given by these hard-working people; and they know it is important to provide them with accurate and interesting information.

Patrons, sponsors and donors

We spend a lot of time persuading people and organisations to help us and there is more about fund-raising in Chapter 18. Once we have them on board, we need to keep them informed of events and achievements, in order to ensure their continued support (and, possibly, further injections of funds in the future).

A friend once made, if nurtured, can become a friend for life. As well as keeping patrons informed during the run of a project, continue to tell them about your activities and achievements after the project is over. If you produce a newsletter, keep sending it. Invite past patrons to previews and receptions, and let them know about new developments which are relevant to their area of interest. Corporate giving, in particular, is becoming a highly strategic activity. You need to know the trend of corporate thinking, and to position your patrons so that they can fully appreciate the potential of any given situation. Exchange of information – formally and informally – helps to pave the way.

Too much information will overload the recipient, but short updates and topical news will help to consolidate your position. We tend to

forget the human factors involved in this area. A $60-million gift for a West Coast US museum was 'clinched' by the donors seeing a group of schoolchildren engaged in an activity relevant to their own area of interest. Museum staff may have witnessed amusing or revealing episodes that illustrate the ways visitors interrelate with exhibits and services. Do pass on the best stories to your patrons. They see the balance sheets and reports, but they don't get the exposure to public use and appreciation day by day. It's good to be reminded of the human values involved.

Ways to communicate with patrons

- Send regular updates (such as newsletters).
- Tell them the human stories as well as the facts and figures.
- Keep them 'in the family' after particular projects end.
- Continue to invite them to events.
- Take an interest in their activities.

Lobbying and parliamentary affairs

Museums need to keep an eye on the wider world of local and central government affairs. In the UK, this means being in contact with your local councillors and keeping up to date with changes at election time, as well as with new appointments among relevant officers. You should also know the name of your local Member of Parliament, member of the European Parliament, and, as appropriate, member of the Scottish Parliament, member of the Welsh Assembly, and, from the spring of 2000, member of the London assembly. In addition, it is also useful to be aware of other MPs or members of the House of Lords who take an interest in a specific subject. In the United States, it means identifying local council representatives, state governors and congress and senate members.

Museums funded directly by government departments also need to make sure that they are in contact with the officers who look after museum affairs. Other government departments which you may want to keep in touch with include those for education and employment.

It would be impossible for a small museum or gallery to implement a full programme of public affairs activities, nor would it be relevant, but it pays to commit yourself to a certain level of activity:

- Make sure you know who your key elected representatives are.
- Include key officers at local authority level.
- Include them in your newsletter mailings.
- Invite them to special events.

It pays to become familiar with the process by which decisions are made on key local issues. Museums in Northern Ireland, for example, find that they can offer a central meeting ground for some forms of social and educational activities stemming from politics. They were active in the initiative 'Education for Mutual Understanding'.

If you are taking up a problem which relates to your museum alone, and you have gone as far as you think you can with the local authority, you may find that a letter or invitation to your MP breaks the deadlock. If the problem is shared with others, get together through your area museums council or local tourist board to take your issue forward. The Museums Association can offer advice to members, and it also lobbies Parliament on behalf of museums as a whole.

Museums, galleries and heritage organisations involved in major projects or issues may find the professional services of a lobbyist or parliamentary adviser useful. They offer continuous monitoring of political activities, feedback, and the opportunity of input in reports and bills at the right time.

The newly established regional development agencies in the UK will have indirect responsibility for culture in as much as it relates to economic regeneration. You need to know who and where they are situated. Also, as of 1999, the Regional Cultural Consortia – developed from the more informal regional cultural committees – bring together bodies in each region representing museums, arts and tourism.

CASE STUDY 21 Stakeholders: an example from St Albans, Hertfordshire

One of the key roles of museums is to improve the quality of life within the areas they serve. To do this they have to be engaged with everyday life outside their walls. If we hope to educate and entertain people, we must be responsive to the changes in the society which we both record and reflect. If we expect society to support us, we must be prepared to promote our value to it. In short, we need to make friends and influence people.

The important question is 'which people?' We need to be aware of who is out there, who we can help and who can help us. Who has a stake in our museum and its activities? Who are our stakeholders?

Analysing these answers is an important part of the forward planning process. It gives the museum a sense of perspective and helps it position itself within local, regional and national frameworks. It also identifies institutions, groups and individuals who may be approached for advice, market research or fund-raising.

Mark Suggitt, director, St Albans Museums, Hertfordshire, describes how this process is carried out.

Stakeholders

St Albans Museums identified four groups of stakeholders: corporate local, regional and national. I intend to examine these groups in more detail and consider why they are important to us.

> *Corporate*
> St Albans District Council (includes elected members and colleagues)
>
> *Local*
> Visitors and users (past, present and future)
> Donors
> Local businesses
> Media
> Friends of St Albans Museums
> St Albans Civic Society
> St Albans & Herts, Architectural & Archaeological Society
> St Albans tour guides
> St Albans council tax payers
> Verulamium Museum Trust

Regional
East of England Tourist Board
Eastern Arts
Hertfordshire museums
Schools and colleges
South Eastern Museums Service
Regional businesses
University of Hertfordshire

National
Business in the Community
Department for Culture, Media and Sport
English Heritage
Museums Association
Museums and Galleries Commission

Corporate

For any local authority museum the relationship with colleagues and elected members is crucial. The same is true for trustees within the independent sector. St Albans Museums plays a corporate role, engaging in a wide range of cross-council activities such as economic development, tourism, information technology, planning, arts development and city centre management. Although time-consuming, there are considerable benefits. We know what is going on and colleagues are able to shape corporate decisions. Many of us in museums are multi-skilled and capable of creative lateral thinking, so why not use it! This presence is also appreciated by members, who see that museum staff are corporate players rather than ivory tower aesthetes. We also work hard to ensure a high local profile, working closely with the media and providing a wealth of good news stories for the council.

It may seem obvious, but it is important to remember where your base support comes from, especially when you need to develop new initiatives. All new elected members are offered induction days when they can visit the museums and find out more about what we do. Living in Lottery times, many of us are now engaged in the running of large projects and spend much of our time on them. While doing this it is essential to have a transparent reporting process for members. It is always better that they know if your project is heading over budget at the earliest possible stage rather than finding out at the last minute!

No one likes nasty surprises, and they are more likely to have a sympathetic understanding of the problem.

Local

Local people pay for the museums service and elect the local politicians. They also visit and bring friends and relations. Again, they have a considerable stake in what we do. Good news stories in the local papers help vindicate our activities. St Albans also has a number of very active societies who work with museum staff, and they are important stakeholders. Our Friends' organisation is a later, looser organisation, but equally important as a form of income and support.

The museums service often actively engages with a diverse range of local people who donate material or assist in the research of exhibitions. This community involvement is very important in making the service relevant to those who pay for it.

We have also invested in customer care training for staff as we are committed to ensuring that the museums are friendly, welcoming places. This helps reduce complaints and assists vital 'word-of-mouth' marketing. Our front-of-house staff regularly receive fan mail praising them for their helpfulness.

Regional

It is equally important to be a regional player and get actively involved in the work of regional organisations. St Albans Museums works closely with museum bodies like Hertfordshire Museums, South Eastern Museums and the South Midlands Federation. Our staff are encouraged to take an active role as it gives us a voice and contributes to their own personal development. If problems arise within your authority, it is a body such as an AMC (Area Museums Council) which can offer help and advice. As regional cultural fora develop it is essential that medium-sized museums such as ours are involved. Local and regional businesses are also important, especially if you plan to move into corporate entertainment or fund-raising. It is also important to remember that you are a part of the local economy, and by working with the tourist boards you can quantify the economic impact that culture and tourism have in your area, which can also help impress other stakeholders.

Occasionally it pays to be opportunistic. When the University of Hertfordshire was advertising for a gallery manager I rang them up and offered to help with the interviewing. They agreed and we have since developed an excellent partnership.

National

Nationally, St Albans Museums has developed contacts with the Museums Association, which is the main advocate for museums. We also have good links with the Department for Culture, Media and Sport and the Museums and Galleries Commission (MGC). Staff act as curatorial advisers for the MGC registration scheme. Involving yourself in the work of these bodies not only provides useful information but also raises your profile with other stakeholders.

Conclusion

I began this case study by stating that analysing stakeholders is a part of the forward planning process. Like much of that process, it is applied common sense and needs to be reviewed as the world changes around us. The documents which arise out of this process – the plan, the policy statements, the annual review, etc. – are all useful advocacy tools, professional calling cards for a range of stakeholders.

Queen Victoria once asked Disraeli who Britain's friends were. Disraeli replied that 'we have no friends, only interests'. Museums are in a happier position; we do have real friends, and we must keep them, but we should never forget our interests.

Chapter 18 THE RELATIONSHIP BETWEEN MARKETING, PUBLIC RELATIONS AND FUND-RAISING

This book is about marketing and public relations. There are numerous publications, training courses and consultants who specialise in fund-raising. However, the authors recognise that securing existing and future funding and raising money for specific projects is a major preoccupation for the cultural sector. We would, therefore, like to set out clearly the links and relationship between fund-raising on the one hand and marketing/public relations on the other.

There is a strong relationship between the two areas of activities: museums need a profile in the local and wider community and a good baseline of publicity work in order to attract sponsors, and sponsors will expect a return in the form of publicity. Marketing and public relations certainly set the scene for fund-raising activities. However, fund-raising, or development work, should ideally not be done by the marketing or public relations officer. It does sometimes happen, but it could indicate a half-hearted commitment to both areas.

Brand recognition is a strong motivational force in both marketing and fund-raising. The better known your museum becomes, the easier it becomes to get sponsors and donors to listen to your needs. Success really does breed success in this instance. Most newly appointed fund-raisers comment on the need to raise or establish a higher profile for the museums before embarking upon their work.

Alignment is the key to fund-raising of any kind. Whether selling memberships, asking for donations or bidding for sponsorship, we need to find partners with the same goals or a similar agenda to our own. For example, if a museum has a strong reputation for serving children, it will need to seek funding partners who wish to be aligned with that cause. It makes sense for the marketing/public relations and fund-raising activities to be swimming in the same direction.

Sometimes, the fund-raising needs will put demands on marketing; sometimes the marketing effort will actually create unexpected opportunities for fund-raising. Every contact made, and every parent company of every contact, should be noted and treated as shared information. A good experience with a modest project, well-marketed, will pay dividends for the future, paving a way for the marketing effort.

The synergy between the two areas needs to be fed by the mission of the museum. These are two dynamic disciplines, and they need to flow from the museum's agreed purpose and not lead the whole show. The teamwork also needs to involve the commercial manager, so that each area is supporting the other and realising the potential offered by these different creative efforts.

The main thrust of fund-raising activity may be towards gaining support from trusts and foundations, charitable donations, membership income, and sponsorship in cash and goods or services; but the most important funding source should never be forgotten. If the museum receives core support from a city council, local or national government, that source should always be the number one priority for the public relations and marketing effort. It is much easier – and more important – to secure or raise a regular grant than it is to constantly shop around for fresh sources of income.

Camilla Boodle, experienced fund-raiser and strategist for museums in the UK and abroad, offers the following thoughts on this issue.

Fund-raising for museums and galleries in the UK is entering a new phase. In the era before the National Lottery (and specifically the Heritage Lottery Fund) we saw an occasional campaign for a refurbishment or an acquisition which was managed as an 'appeal' much like cathedral appeals: a gathering of 'the great and the good', a target to reach, a brochure describing the need and a rallying of donors and well-wishers. In between times of appeal, the Friends of museums gave regular, mostly modest, sums of money and legacies of works of art and museum objects. (In the newer independent museums they also gave considerable amounts of time, practical expertise and guidance.) This same period was characterised by limited interest in, or knowledge of, public relations and marketing.

Writing in her book *The Marketing Mix: Promoting Museums, Galleries and Exhibitions* (1995) Dr Sharron Dickman wrote: 'Not so long ago, museums and galleries felt that marketing wasn't really an important part of their operations. There was a belief that if the exhibition was good, people would come and if they didn't, well it was their loss.' By 1995, she observed that there had been a shift in perception and a recognition that 'marketing is the bridge between what we do and the visitors who come to see, to learn and to experience our vision'. 'Why the big change in attitudes? Because museums, galleries and other cultural attractions have learned to use marketing in a way which meets both their philosophical objectives and also brings visitors through the doors.'[1]

There has now been a shift in attitudes to fund-raising in museums. Though there will always be a number of museums and galleries able to run their fund-raising in the old-fashioned 'appeal' way that others may envy (backed by strong boards of trustees with their own excellent connections, the directors of these institutions find funds seemingly without having to be very public about it), this is

becoming the exception. Dulwich Picture Gallery has a board which knows where the money is and the best way of asking for it; the Museum of London is planning to mobilise its connections in the City of London in support of a five-year capital campaign; the National Gallery of Scotland has always seemed to attract 'the great and the good' and, until very recently, had no formal established development office, though the whole gallery had been refurbished under an energetic director.

With the advent of the National Lottery in the UK in the mid-1990s, many museums and galleries embarked on fund-raising for the first time, devoting staff resources not only to securing Lottery funding, but also to negotiating partnership funding from a variety of sources. These fund-raising drives have created an intense competition for funds, especially in London. Strategies have been devised to harness the traditional 'volunteer' leadership (through board members and committees) to the day-to-day workings of a professionally staffed office to raise the money needed – often very large sums – within specific time-frames. At the time of writing (spring 1999) many of these Lottery appeals are still going on.

The National Museums and Galleries on Merseyside is running NMGM 2001, and the Tate Gallery and the British Museum are in the final stages of their campaigns. The size of the sums required has justified an exceptional concentration of resources on fund-raising – the principle of 'speculate to accumulate' surely applying here.

The change to the museum fund-raising scene is from the temporary to the permanent, from the 'occasional' to the 'forever' fund-raising, the year-on-year search for money for programmes, activities, acquisitions and other things that have to be paid for when the core funding isn't enough, or when, put more positively, the investment in fund-raising, kick-started by a capital campaign, has proved to have a value which justifies its continued place in the museum management team. In the jargon of the trade, it is no longer fund-raising but 'development'.

In this category falls the Museum of Scotland – which is maintaining its fund-raising operation here and in the USA, having secured the funds needed to open the new museum in 1998 – and the National Portrait Gallery, whose first very successful campaign in the 1980s pre-dated the Lottery but which now has a development office which was built on that success (and which in turn has attracted Lottery money for further capital works). And there are the museums that haven't gone down the Lottery route at all, but have sustained a

The tower at the Museum of Scotland. The Museum was opened in November 1998. Courtesy of National Museum of Scotland.

fund-raising campaign by building durable networks among key supporters. In this category, the Design Museum in London stands out, as do many independent museums which have their Friends, membership schemes and relationships with charitable trusts securely in place.

For organisations that get little or no government money – the Royal Academy of Arts in London being the most obvious example – success in the search for sponsorship and donations and the efficient management of the Friends is the difference between financial stability and instability. Continued investment in the development function is evidence of the centrality of the development function (the Royal Academy now has a fund-raising team of 16 people and the Tate Gallery's teams are even larger). Given that the Tate is on record as saying it must double its revenue earnings by the time it opens the new gallery at Bankside in 2000, we should not be surprised at the expansion of its paid staff in the areas of marketing, membership and fund-raising.

Market research in particular, until recently disregarded, or 'bolted on', is now very occasionally becoming a systematic part of the fund-raising function. Finding out what donors want and need is crucial to keeping them involved and maintaining them as active supporters. Regular evaluation of sponsored activities keeps sponsors motivated, since the value of the relationship is clearly demonstrated to them in business terms. The pricing and benefits packages of individual and corporate membership schemes are being regularly adjusted to take account of a competitive market place.

In March 1999 the National Gallery in London, which has a much-admired development office, advertised a position as head of marketing. The National Gallery isn't short of visitors, but will need good data about its visitors, whether individual or corporate. Without data feeding into the fund-rasing department, it is hard to prove the 'reach' and hence the value of a partnership with the gallery.

Fund-raising within the museum sector is now more widely understood – what it is, how it works, and what can be expected. In 1995 the Museums and Galleries Commission published Russell Willis Taylor's *Fundraising for Museums and the Arts* which offered a guide to fund-raising for the uninitiated: 'Fund-raising should not be considered as a short term or quick-fix solution to an institution's problems ... it is an ongoing activity that requires long term commitment.'[2] The book anticipated some of the Lottery's demands when it said: 'Fundraising is an opportunity for many organisations to look at themselves in a new way. In presenting a case for support to a company, Trust, or individual, organisations must be clear and confident about their reasons for being.'[3]

Taylor's book, which included interviews with a number of fund-raising professionals in museums, conveyed the subtleties and particular demands of fund-raising and concluded that it is 'in one sense, a very clear type of audience development, the process of communicating with people clearly enough to make them want to give money'.[4]

Why do we read so many stories about certain museums and galleries in the national and local press – written and 'spun' by public relations agencies to tell the world about the museum in question? It is about the positioning of the museum in relation to all those that might be able to give it money – about the 'brand values' of the museum. This may involve 're-branding' the museum with a change of name or mission statement. It is interesting to note that in their mission statements museums now focus not on objects and buildings

but on people and experiences. It is people who give money and it is the reason why others give money in support of museum activities.

The need for a marketing function in a museum that wants to raise money is self-evident. Any institution that is going to fund-raise will need:

- a strong case for support/vision, clearly stated (this will involve a marketing or PR team)
- a demonstration of financial need (this includes transparency and the ability to produce audited accounts if asked)
- strong paid and unpaid leadership on the board and staff (can the board members network for the institution?)
- the financial resources to go down this route.

Fund-raising costs money and cannot be done without budgets.

Victor Middleton's report for the Association of Independent Museums *New Visions for Independent Museums* (1998)[5] describes the transition of a number of museums from local authority to trust status. The re-alignment of the executive function at Sheffield Museums and Galleries Trust has created a senior executive team which comprises an exhibition and collections manager, finance and administration manager, a marketing and audience development manager and an operational services manager. This is an organisation that would now be in a position to fund-raise from the private sector, and Victor Middleton says that its 'revitalised management culture has secured collaboration with key partners'.[5]

Fund-raising for museums today is about knowing how to play the hand of cards the museum or gallery has been dealt, and how to play them in a cost-effective manner. Where is the money for this particular museum or gallery, and what will it take to secure it? Some museums will always do better with business partnerships than others. In order to secure sponsorships, museums must be able to offer benefits that are of value to business (access to data, to spaces for corporate entertaining, to public relations opportunities, to business networks, etc.) and business must have money to spend, which will tend to mean that this option is feasible only in the larger towns or cities. Partnerships with certain businesses are most easily secured by museums with product or industry links or with messages currently of interest to the business community – education being a prime example. Access to data is the area where the marketing function and the development function intersect. The profile of visitors and users is something that business partners need.

The Natural History Museum and the Science Museum are able to link messages about 'education', 'the environment' and 'science and technology' in ways that Glaxo, Wellcome, Rio Tinto and Toshiba, among others, are able to buy into. The Design Museum and museums of contemporary art such as the Whitechapel and the Serpentine, on the other hand, send out their messages to design and graphic agencies, information technology companies and other 'niche' industries interested in identifying with the 'cutting edge'. In the Design Museum's literature it is stated: 'the Design Museum is unique... it is where public and industry meet to experience design and architecture'.[6]

Businesses can be educated to see the value that museums can offer within a community – as a learning resource, as an after-school club and as a magnet for tourists – if the evidence is there that it is all of these things. The New Art Gallery in Walsall has made approaches to a number of local businesses for partnership funding on the basis that 'our prominent location near service and retail sector companies means that the work of the gallery and of course the extra spend that the gallery will bring to Walsall is of particular interest ... Marks & Spencer has been involved from the beginning.'[7]

For many museums and galleries the new money is going to come from individuals. The Tate Gallery has plans to double the number of its Friends, as does the Museum of Scotland. Tyne and Wear Museums Scheme Friends has revitalised itself as a popular and dynamic body. For Walsall, on the other hand, Friends will not generate much money 'with a modest joining fee we do not see this as a major fundraising tool. Friends however are a crucial part of our audience development strategy and our focus will be to encourage local involvement in the new building.'[8] Their involvement, in turn, will lead to continued success in raising money from trusts and companies, who see that the New Gallery fulfils a genuine local need.

It seems clear that fund-raising and marketing are now both becoming embedded in the museum culture, by whatever route they have come to be there. In some museums the fund-raising came first and the marketing second (this is true of some free entry museums, such as the National Gallery). In most museums the marketing/development function came before fund-raising; in some they have arrived together, both stimulated by the requirements of the National Lottery to prove (a) audience demand, and (b) ability to revenue-fund any Lottery-funded capital developments. In larger museums both teams form part of a management structure that allows

them to work closely with each other. There is however, a long way to go. Victor Middleton says:

> While some museums have made great progress in their own visitor research, it is widely acknowledged that there are serious gaps in information on all the important criteria that measure the role of museums in society and their use of public funding.[9]

This lack of information impacts on fund-raising. Without the material to provide the 'advocacy arguments' for museums, successful fund-raising is unlikely to take place, and will certainly not take place through charitable trusts and companies.

Some museums think that in appointing a marketing professional they are dealing with the fund-raising side too. But marketing and fund-raising are not the same and should not be confused. In Russell Willis Taylor's words, they look similar 'in as much as they are about corporate outreach and corporate communications to the outside world. Both are sales activities.'[10] But they are different in terms of their goals and their time-frames. Marketing is a 'broad brush approach', whereas fund-raising is a 'niche' approach; marketing is about big numbers of people targeted generically, while fund-raising is about smaller numbers of individuals, targeted in a personalised, customised fashion. Marketing can solve problems now, development is about the future well-being of an institution as well as its present reality. Both are labour-intensive and they demand different skills.

Fund-raising is not just about money, any more than marketing is about press and public relations. As Russell Willis Taylor says:

> Developing new audiences, bringing in new ideas, having the ear of influential people, keeping a high profile within the community; these are all things that a well thought out fundraising programme can bring along with money. But most of all, it creates investors and investors care what happens to places where they put their money. Managed properly and kept informed, a wider circle of people who care about the organisation's future is a powerful and re-assuring resource.[11]

Like marketing and public relations, fund-raising in museums and galleries has come a long way in a short period of time. It's where many of the jobs in museums are to be found, and it is a route to the top of the management ladder. A successful museum in the 21st century will be maximising its income, whether through marketing, public relations, trading or fund-raising. Success in playing its hand of cards will be rewarded with continued core funding. Fund-raising is now forever, just as marketing is.

Notes

1. Dickman, S. (1995). *The Marketing Mix: Promoting Museums, Galleries and Exhibitions*. Museums Australia (Inc), Melbourne, p.1.
2. Taylor, R. W. (1995). *Fundraising for Museums and the Arts*. Museums and Galleries Commission, p.3.
3. Ibid., p.5.
4. From letter to authors.
5. Middleton, V. (1998). *New Visions for Museums in the 21st Century*. Association of Independent Museums, p.25.
6. Extract from Design Museum fund-raising literature.
7. Extract from Walsall information literature.
8. Letter to authors.
9. *New Visions for Museums*, p.8.
10. *Fundraising for Museums*, p.xx.
11. Ibid., p.xx.

Appendix 1 Extract, Museums and Galleries Commission Museum Visitor Study (MORI 1999)

This extract is reproduced with the permission of the Museums and Galleries Commission and MORI. The full report is available from the MGC (price £15 plus £1.25 p&p).

This report presents the findings of a research conducted by MORI on behalf of the Museums and Galleries Commission with support from the Campaign for Museums. The research was organised in two phases: a quantitative survey of the UK population, followed by a number of in-depth telephone interviews.

Omnibus questions were placed on MORI's and UMS' (Ulster Marketing Surveys) Omnibus surveys. In Great Britain a nationally representative quota sample of 1845 adults was interviewed by MORI/Field & Tab across 155 constituency-based sampling points. In Northern Ireland a representative sample of 610 adults was interviewed by UMS. Interviews were carried out face-to-face in respondents' homes using CAPI (Computer Assisted Personal Interviewing) between 19 and 22 February 1999. Data have been weighted to reflect the national population profile.

Museum-going habits

Why do people go to museums and galleries?
Figure 1 illustrates the reasons given for respondents' most recent visit to a museum or gallery. The main influencing factor for all types of visitors is interest in the subject of the museum/collection. Temporary exhibitions also attract many visitors, especially students (26%) and frequent museums goers (29%).

When do people go to museums and galleries?
The majority of respondents tend to visit museums and galleries during their holidays in the UK or abroad (see Table 1). The majority also tend to visit when special exhibitions/lectures or events are on (either targeted to the adults or their children).

A minority use museums and galleries to get information without going to visit them, while another group tend to use them as social place (e.g. to go and have a coffee with friends).

Figure 1 Reasons for visiting museums and galleries

QM8 Which of the factors, if any, on this card, encouraged your most recent visit?

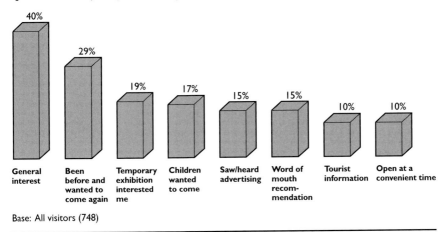

Base: All visitors (748)

Table 1 Timing of visits

QM3 Which, if any, of these statements best describes the circumstances in which you tend to go to/use a museum or gallery?

	%
I go when I am on a holiday or short break in the UK.	55
I tend to visit when there is a special exhibition/lecture/event which interests me.	52
I go when I am on a holiday or short break abroad.	39
I try to regularly visit different museums/galleries near where I live.	33
I tend to visit when there is a special event which appeals to the children.	27
I have a favourite museum or gallery which I visit as often as possible to see its collections.	16
I frequently use the web/internet sites of museums/galleries instead of physically visiting them.	6
I regularly contact museums and galleries in writing, by phone or through the internet for information/educational purposes.	5
I regularly go to a museum or gallery just to use its café/restaurant or gift shop.	5

How often do people go to museums and galleries?

The average number of visits per annum stands at just under three. One quarter of visitors (24%) go to a museum or gallery on five or more occasions each year (see Figure 2).

Figure 2　Frequency of visiting

QM4　In the last 12 months, how many times have you been to a museum or art gallery?

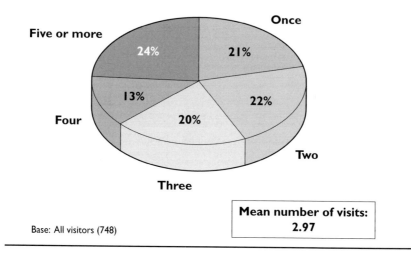

Base: All visitors (748)

Mean number of visits:
2.97

Barriers to visiting

Attitudes to learning and life stages influence the way one will use or not use museums and galleries. There are also some practical factors preventing visits (see Figure 3).

Figure 3　Reasons for not visiting museums and galleres

QM2　Which, if any, of these reasons describe why you have not been to a museum or art gallery in the last 12 months?

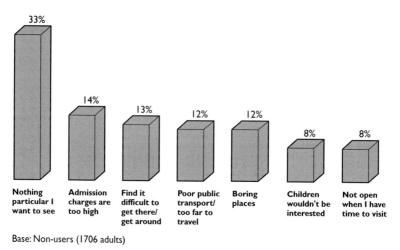

Base: Non-users (1706 adults)

Lack of awareness and interest

The main motivation given for the last visit to a museum or gallery is interest either in the collection (40%) or in a temporary exhibition (19%). On the other hand, the main reason given for not going is that 'there is nothing particular I want to see' (33%). Given the wide variety of museums and galleries, this latter response suggests that a certain proportion of the public is not aware of what museums and galleries are offering. For instance 30% of those with a Masters degree or PhD, although typical potential users, feel there is nothing they want to see.

It is encouraging to note the widespread success of promotion and personal recommendation in creating visits. Fifteen per cent of those visiting museums and galleries say that their most recent visit was encouraged by 'advertising'. The same proportion say someone recommended the museum or gallery to them, and 10% found out about it through tourist information. This reinforces the point that good communications can produce visits.

Admission charges

A minority (14%) quote high admission charges as a barrier to visiting museums and galleries. Respondents with children are slightly more likely to give this answer (20%). There are, however, no significant differences between social classes and age of respondents giving this response.

Furthermore, most visitors perceive that where they had to pay charges, their visit still represented good value for money. The majority of visitors interviewed (63%) had to pay an admission charge on their last visit to a museum or gallery. Among those who did so, 56% felt that their visit presented 'very good value for money', and another 33% said it was 'fairly good value'.

© MGC/MORI 1999

Appendix 2 RESOURCES

Note: Telephone codes for Cardiff, Coventry, London, Portmouth, Southampton and Nortern Ireland will change as of 22 April 2000

Awards
A major new initiative will combine the Museum of the Year award (National Heritage) with the Gulbenkian awards (Museums Association). For details, contact the Museums Association (see Information and publications, below).

- **Society for the Interpretation of Britain's Heritage (SIBH)**,
 c/o 12 The Grove, Newcastle upon Tyne NE12 9PE, UK. Tel: 0191 266 5804

Broadcast monitoring
See Press cuttings and broadcast monitoring, below

Exhibitions and conferences

Museum-related conference and exhibitions
- Association of Independent Museums (see below) – conference in May
- Museums Association Conference (see below) with an exhibition area – usually in September
- Museums and Heritage Show – usually in February
- **Museums and Heritage Show**, The Town House, Leigh, Worcester WR6 5LA, UK. Tel: 01886 833505. Fax: 01886 833144. E-mail: jbrown@enterprise.net

Tourism-related exhibitions
- **British Travel Trade Fair**, Reed Exhibition Companies, Oriel House, 16 The Quadrant, Richmond, Surrey TW9 1DL, UK. Tel: 020 8910 7910 Fax: 020 8910 7879. Website: http://travel.reedexpo.com
- **World Travel Market** As for BTTF
- There are also numerous holiday exhibitions for schools, consumers and group travel organisers. Check with your local tourist board

Information and publications
The Museums and Galleries Commission in the UK and the American Association of Museums produce lists of helpful publications on a

number of topics, including marketing. (As of April 2000 the Museums and Galleries Commission will be succeeded by the Museums, Libraries and Archives Commission.)

- **American Association of Museums**, 1575 Eye Street, NW, Suite 400, Washington DC 20005, USA. Tel: 202 289 1818. Fax: 202 289 6578. Website: www.aam.us.org

- **Association of Independent Museums (AIM)**, c/o London Transport Museum, Covent Garden, London WC2E 7BB, UK. Tel: 020 7379 6344. Fax: 020 7565 7255. E-mail: info@gal-of-justice.demon.co.uk Website: www.AIMus.org.uk

- **The Campaign for Museums**, 35–37 Grosvenor Gardens, London SW1W 0BX, UK. Tel: 020 7233 9796. Fax: 020 7233 6770. E-mail: cfm@24hourmuseum.org.uk Website: www. museumsweek.co.uk and www.24hourmuseum.org.uk

- **Department for Culture, Media and Sport**, 2/4 Cockspur Street London SW1Y 5DH, UK. Tel: 020 7211 6200. Website: www.gov.uk

- **ICOM – International Council of Museums**, Maison de l'Unesco, 1 rue Miollis, 75732 Paris, Cedex 15, France. Tel: 00 33 1 47340500. Fax: 00 33 1 4306 7862. Website: www.icom.org

- **Museums Association**, 42 Clerkenwell Close, London EC1R 0PA, UK. Tel: 020 7608 2933. Fax: 020 7250 1929. E-mail: info@museumsassociation.org Website: www.museumsassociation.org

- **Museums Documentation Association**, Jupiter House, Station Road, Cambridge CB1 2JD, UK. Tel: 0122 331 5760. Fax: 0122 336 2521. E-mail: mda@mda.org.uk Website: www.mda.org.uk

- **Museums and Galleries Commission**, 16 Queen Anne's Gate, London SW1H 9AA, UK. Tel: 020 7233 4200. Fax: 020 7233 3686. E-mail: n.poole@mgc.co.uk Website: www.museums.gov.uk

Media analysis

- **BRAD**, Directory for the advertising industry. Tel: 020 7505 8458. Fax: 020 7505 8336. E-mail jodyh@brad.co.uk

- **Cutting Edge**, Media evaluation software. Tel: 020 7592 0919. Fax: 020 7808 7237. E-mail: sales@cuttingedge.uk.com

- **Mantra** Tel: 0120 639 6665. Fax: 0120 639 6667. E-mail: mantra@aol.com

- **Mediatrack** Tel: 020 7430 0699. Fax: 020 7404 4207.
 E-mail: enquiry@mediatrack.co.uk

Media directories and press release distribution

- **PIMS** Tel: 020 7354 7020. Fax: 020 7354 7053.
 E-mail: ctayulor@pims.co.uk

- **PR Planner**, Two Ten Communications. Tel: 020 7490 8111.
 Fax: 020 7490 1255. E-mail: release@prnewswire.co.uk

Media training

Contact the Institute of Public Relations (see Training and professional development, below) for a recommended list.

Press cuttings and broadcast monitoring

- **Durrants** Tel: 020 7674 0200. Fax: 020 7674 0222.
 E-mail: contact@durrants.co.uk

- **News Index** Tel: 020 7242 4747. Fax: 020 7242 6644.
 E-mail: inquiries@newsindex.co.uk

- **Paperclip** Tel: 020 8549 4857. Fax: 020 8547 1646.
 E-mail: paperclip.partnership@btinternet.com

- **Tellex Monitoring** Tel: 020 7963 7600. Fax: 020 7566 3152.
 E-mail: sales@tellex.press.net

- **The Broadcast Monitoring Company** Tel: 020 7377 1742.
 Fax: 020 7377 6103. E-mail: sharon.wright@ft.com

Promotions

- **Adult Learners Week**, National Organisation for Adult Learning (NIACE), 21 De Montfort Street, Leicester LE1 7GE, UK. Tel: 0116 2044 232.
 Fax: 0116 223 0050. Website: www.niace.org.uk

- **Museums Week**: The Campaign for Museums, 35–37 Grosvenor Gardens, London SW1W 0BX, UK. Tel: 020 7233 9796. Fax: 020 7233 6789.
 E-mail: info@campaign.co.uk Website: www.museumsweek.co.uk

- **Science Week**, British Association for the Advancement of Science, 23 Savile Row, London W1X 2NB, UK. Tel: 020 7973 3500. Fax: 020 7973 3051.
 Website: www.britassoc.org.uk

- **Volunteer Week**, *National Centre for Volunteering, Regent's Wharf, 8 All Saints Street, London N1 9RL, UK.* Tel: 020 7520 8900. Fax: 020 7520 8910. *Website: www.volunteering.org.uk*

- **Gallery Week**, *engage, The National Association for Gallery Education, 1 Herbal Hill, Clerkenwell, London EC1R 5EJ, UK.* Tel: 020 7278 8382. Fax: 020 7278 7092. E-mail: info@engage.org

- **Museums and Galleries Month 2000** (combines Museums Week and Gallery Week for the month of May 2000)
 The Campaign for Museums (see above)
 engage (see above) *Website: www.24hourmuseum.org.uk and www.may2000.org.uk*

Research

- **Bedfordshire Museums** market research resource pack - Prove It. Contact: Museum Development Officer, *c/o Bedford Museum, Castle Lane, Bedford MK40 3XD, UK.* Tel: 0123 435 4954. Fax: 0123 427 3401. E-mail: mdo@bedfordshire-museums.org.uk
 Website: www.museums.bedfordshire.gov.uk/info

- **Museums and Galleries Commission** conducts various studies, including (with MORI) new annual museum research (see Information and publications, above, and Appendix 1).

- **Davies, Dr Stuart** (1994). *By Popular Demand.* Museums and Galleries Commission.

- **Tourist boards** for visitor research.

- **American Business Information (ABI)** *Tel: 800 555 5335. Website: www.infousa.com*

Tourist boards

In the UK

- **British Tourist Authority**, *Thames Tower, Blacks Road, Hammersmith, London W6 9EL, UK.* Tel: 020 8846 9000. Fax: 020 8563 0302. E-mail: info@bta.org.uk *Website: www.visitbritain.org.uk*

- **English Tourism Council**, c/o British Tourist Authority, Thames Tower, Blacks Road, Hammersmith, London W6 9EL, UK. Tel: 020 8563 3000. Fax: 020 8563 0302. Website: www.englishtourism.org.uk

- **Northern Ireland Tourist Board/Irish Tourist Board**, St Anne's Court, 59 North Street, Belfast BT1 1NB. Tel: 028 9023 1221. Fax: 028 9024 0960. Website: www.nitb.com

- **Regional Tourist Boards** – contact the relevant national board.

- **Scottish Tourist Board**, 23 Ravelston Terrace, Edinburgh EH4 3EU, UK. Tel: 0131 332 2433. Fax: 0131 343 1513. E-mail: info@stb.gov.uk Website: www.holiday.scotland.net

- **Wales Tourist Board**, Brunel House, 2 Fitzalan Road, Cardiff CF2 1UY, UK. Tel: 029 2049 9909. Fax: 029 2048 5031. E-mail: info@tourism.wales.gov.uk Website: www.visitwales.com

In the USA
Contact your local convention and visitors bureau

Training and professional development

Marketing and public relations organisations

- **Chartered Institute of Marketing**, Moor Hill, Cookham, Maidenhead, Berkshire SL6 9QH, UK. Tel: 0162 842 7500. Fax: 0162 842 7499. E-mail: marketing@cim.co.uk Website: www.cim.co.uk

- **Institute of Public Relations (IPR)**, The Old Trading House, 15 Northburgh Street, London EC1Y 0PR, UK. Tel: 020 7253 5151. Fax: 020 7490 0588. E-mail: info@ipr.org.uk Website: www.ipr.press.net

- **Public Relations Society of America**, 33 Irving Place, 3rd Floor, New York, NY 10003-2376. Tel: 212 995 2230. Fax: 212 995 0757. Email: ppc@prsa.org Website: www.prsa.org

- **PRCA Public Relations Consultants Association**, Willow House, Willow Place, London SW1P 1JH, UK. Tel: 020 7233 6026. Fax: 020 7828 4797. E-mail: chris@prca.org.uk Website: www.prca.org.uk

Museums and charitable organisations

- **Area Museums Councils** (The Secretary), c/o SEMS, Ferroners, Barbican, London EC2Y 8AA, UK. Tel: 020 7600 0219. Fax: 020 7600 2581. E-mail: London@sems.org.uk

- **The Cultural Heritage National Training Organisation**
 (Museums Training Institute), *Glyde House, Glydegate, Bradford BD5 0UP,*
 UK. Tel: 0127 439 1056. Fax: 0127 439 4890. E-mail: jacqui@chnto.co.uk
 Website: www.chnto.co.uk

- **Directory of Social Change**, *24 Stephenson Way, London NW1 2DP, UK.*
 Tel: 020 7209 4949. Fax: 020 7209 4130. E-mail: info@d-s-c.demon.co.uk
 Website: www.d-s-c.demon.co.uk

- **Institute of Leisure and Amenity Management Services**, *ILAM*
 House, Lower Basildon, Reading RG8 9NE, UK. Tel: 0149 187 4854.
 Fax: 0149 187 4801. E-mail: events@ilam.co.uk Website: www.ilam.co.uk

Market research organisations

- **British Market Research Association**, *16 Creighton Avenue, London*
 N10 1NU, UK. Tel: 020 8374 4095. Fax: 020 8883 9953.
 E-mail: admin@bmra.org.uk Website: www.bmra.org.uk

- **CACI Ltd (Acorn)**, *CACI House, Kensington Village, Avonmore Road,*
 London W14 8TS, UK. Tel: 020 7602 6000. Fax: 020 7603 5862.
 E-mail: marketing@caci.co.uk Website: www.caci.co.uk

- **Data Protection Register**, *Wycliffe House, Water Lane, Wilmslow,*
 Cheshire SK9 5AF, UK. Tel: 01625 545700. Fax: 01625 524510.
 E-mail: data@wycliffe.demon.co.uk

- **Direct Marketing Association (UK) Ltd** (general information),
 Haymarket House, 1 Oxendon Street, London SW1Y 4EE, UK.
 Tel: 020 7321 2525. Website: www.dma.org.uk

- **Market Research Society**, *15 Northburgh Street, London EC1V 0AH, UK.*
 Tel: 020 7490 4911. Fax: 020 7490 0608.
 E-mail: info@marketresearch.org.uk Website: www.marketresearch.org.uk

Useful websites

In addition to those listed above for each organisation.

- **Gateway to all UK museums and galleries:**
 www.24hourmuseum.org.uk (The Campaign for Museums)

- **Gateway to UK tourism:**
 www.visitbritain.org.uk (British Tourist Authority)

References

Ambrose, T and Runyard, S. (eds.)(1991) **Forward Planning.** Routledge.

To Charge or not to Charge? (1998). Survey commissioned and undertaken by the Glasgow Caledonian University. Museums and Galleries Commission.

Chapman, D. and Cowdell, T. (1998). **New Public Sector Marketing.** Financial Times/Pitman Publishing.

Dickman, Sharron (1995). **The Marketing Mix: Promoting Museums, Galleries and Exhibitions.** Museums Australia (Inc), Melbourne.

Dodd, Jocelyn and Sandell, Richard. (1998). **Building Bridges.** Museums and Galleries Commission.

French, Ylva (1994). **Public Relations for Leisure and Tourism.** Financial Times/Pitman.

Middleton, Victor (1998). **New Visions for Museums in the 21st Century.** Association of Independent Museums.

Myerscough, J. (1998). **The Economic Importance of the Arts in Britain.** Policy Studies Institute.

Runyard, Sue (1994). **Low-cost Visitor Surveys.** Museums and Galleries Commission.

Runyard, Sue (1993). **Museums and Tourism: Mutual Benefit.** Museums and Galleries Commission.

Runyard, Sue. (1994). **Quality of Service in Museums: Customer Care Guidelines.** Museums and Galleries Commission.

Taylor, Russell Willis (1995). **Fundraising for Museums and the Arts.** Museums and Galleries Commission.

Index

Note: page numbers in italic script indicate illustrations; page numbers in bold face indicate tables or figures.

Index compiled by Dr Frank Merrett.

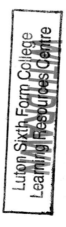